THE LOST PHOTOGRAPHS OF CAPTAIN SCOTT

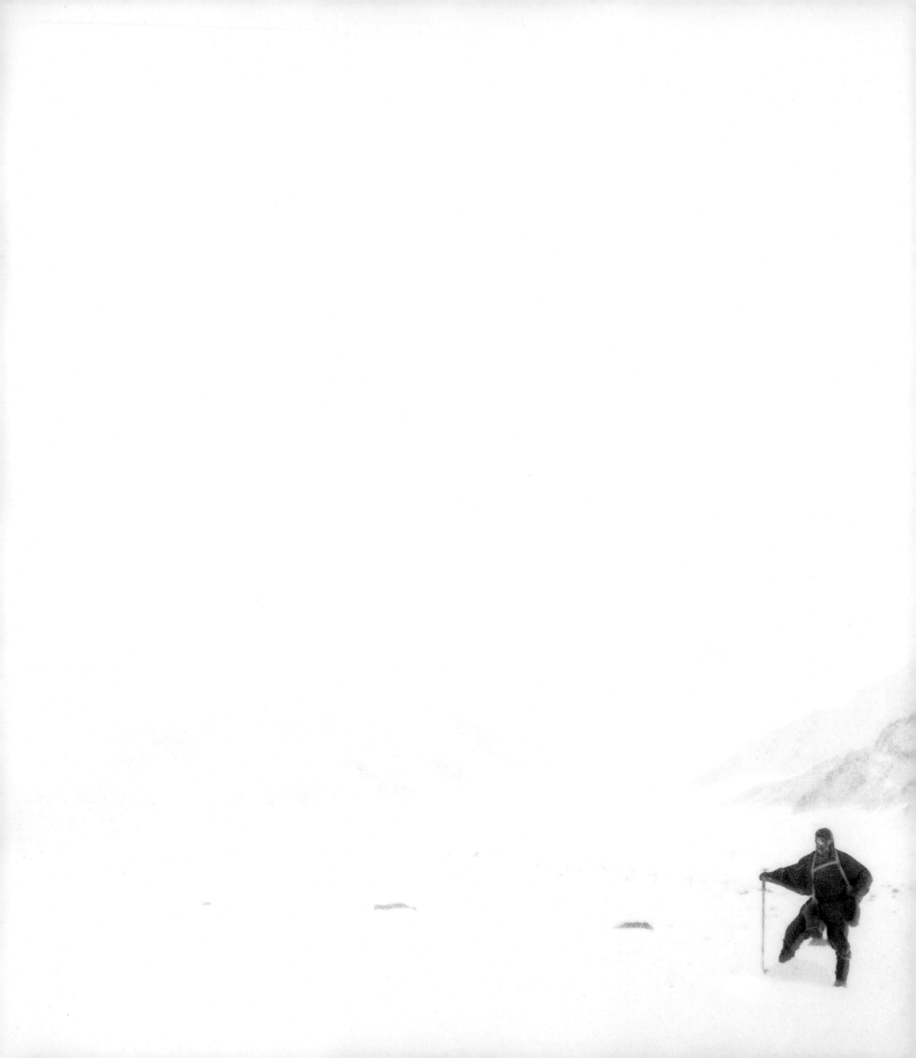

THE LOST PHOTOGRAPHS OF
CAPTAIN SCOTT

**UNSEEN PHOTOGRAPHS FROM THE
LEGENDARY ANTARCTIC EXPEDITION**

DAVID M. WILSON

Little, Brown and Company

New York Boston London

Previous page:
On the Ferrar Glacier: Spring Journey, September 1911 (S108)

Captain Scott took this photograph of one of the expedition
members, probably meteorologist George Simpson,
disappearing in fog.

Little, Brown and Company
Hachette Book Group
237 Park Avenue, New York, NY 10017
www.hachettebookgroup.com

First American Edition: October 2011
First published in Great Britain by Little, Brown Book Group, October 2011

Little, Brown and Company is a division of Hachette Book
Group, Inc. The Little, Brown name and logo are trademarks
of Hachette Book Group, Inc.

The publisher is not responsible for websites (or their content)
that are not owned by the publisher.

ISBN 978-0-316-17850-1
LCCN 2011921793

10 9 8 7 6 5 4 3 2 1

Design by Osborne Ross

Maps by John Gilkes

Printed in China

CONTENTS

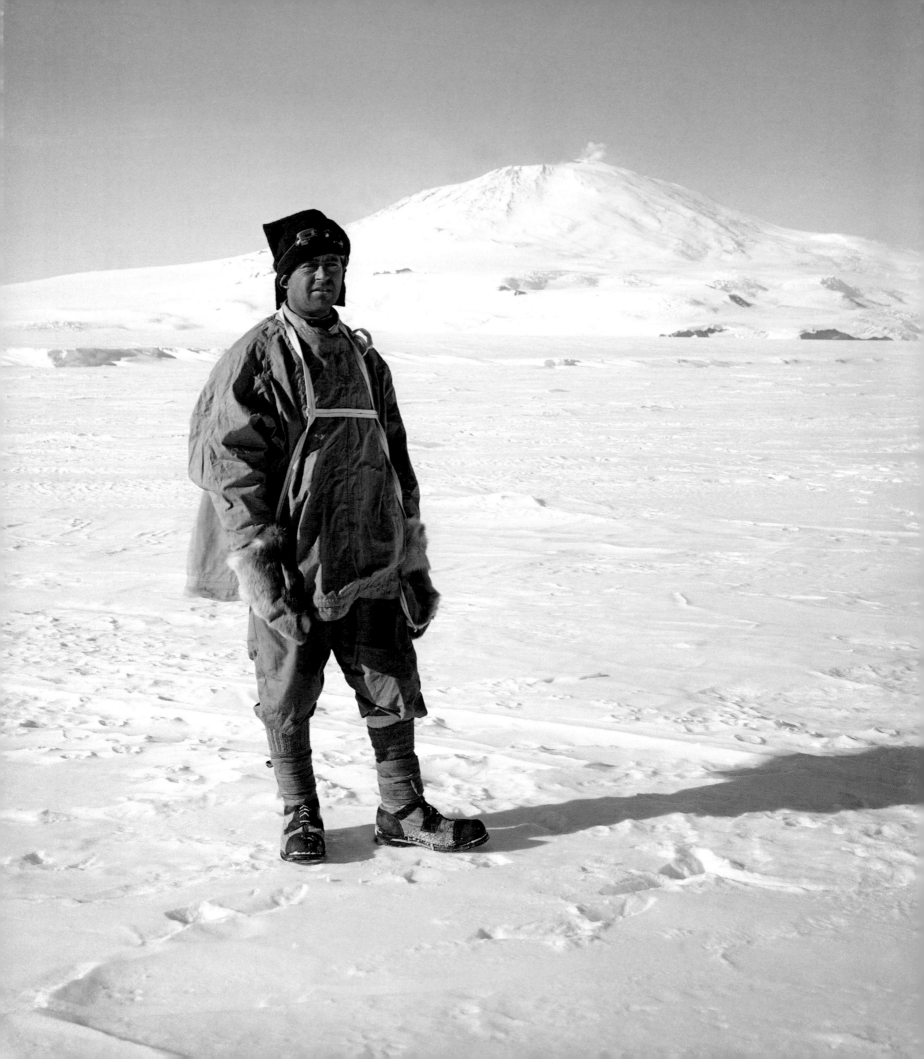

PROLOGUE

Lying in his sleeping bag, Captain Robert Falcon Scott was riven with anxiety. All he could hear was the 'raging' and 'screaming' of the blizzard; there was nothing to do but wait. Outside the tent a scene of whirling drift rendered further progress impossible. Scott was facing complete failure. No amount of cold-weather training could have prepared him for this, he wrote, for this was no normal blizzard and Scott knew it. He was deep towards the heart of the Antarctic, heading for the South Pole, and it was far too warm. The temperature had risen to 33°F (0.6°C) and instead of the normal dry-powder, this snow was slushy, thick and sticky. It rendered everything sopping wet. The tent was soaked through, the bamboo tent poles were running water onto the occupants below, woollen clothing was waterlogged and men lay in their reindeer-skin sleeping bags in pools of water. It was the stuff of nightmares, one that haunts the dreams of every polar explorer: to find their gear saturated. Then its thermal efficacy is retarded and human life imperilled; and what if it froze before they had a chance to dry out? The sailors were getting restless. They knew a crisis when they saw one. To ease the tension, Petty Officer Keohane recited silly rhymes:

The snow is all melting
and everything's afloat
If this goes on much longer
We shall have to turn the tent
upside down and use it as a boat
[Tuesday 5 December 1911][1]

Scott let his frustrations out in his diary. Why? What does this weather mean? How is this possible? His questions were not metaphysical but the frustrations of a scientific mind bereft of answers. And what of Amundsen, the Norwegian who was racing to beat him to the Pole?

Is there some widespread atmospheric disturbance which
will be felt everywhere in this region as a bad season, or
are we merely the victims of exceptional local conditions?
If the latter, there is food for thought in picturing our small
party struggling against adversity in one place whilst others
go smilingly forward in the sunshine.
[Tuesday 5 December 1911]

Food for thought. Scott could not know it but his second hypothesis was the more accurate. His team was bogged down near the bottom of the Beardmore Glacier. Amundsen, albeit in heavy snow rather than sunshine, was already hundreds of miles ahead on the Polar Plateau, in comfortable temperatures of -26°F (-15°C).[2]

Outside, the imperturbable cavalry officer Captain Oates was sitting with the ponies. Not for him the sodden tent. Every time he had re-entered it for a rest, it was only to bring more dripping snow in to his companions, so he chose to go out into the blizzard and shelter with the ponies. They might only be 12 miles (22 km) short of the Beardmore Glacier but he knew that he was expected to get the ponies all the way there.[3] Now the surface of the Great Ice Barrier (Ross Ice Shelf) was melting and covered with 18 inches (46 cm) of slush. Into this the ponies were foundering, while the swirling sleet covered them with ice. He laboured to keep them alive. A short distance away in the dog camp, Transport Officer Cecil Meares was watching the dogs. Huskies are bred for the cold and do not cope well with warm, wet conditions. Scott's animal transport was in serious jeopardy. There was nothing that he could do but trust the experts to do their jobs and hope for the best. Along with these soggy conditions came a critical delay to their progress. They were obliged to eat into the special rations they had put aside for the Polar Plateau before they had even reached it. Scott and his team were, as he put it, 'camped in the "Slough of Despond"'.

After four days, the blizzard abated. Captain Oates shook himself off and grimly wrung the water out of his clothing, his sleeping bag and his tobacco. The others followed suit. Oates' observations upon the situation were described by witnesses as 'dry, picturesque and to the point'.[4] Even the sailors looked at the dashing cavalry officer with considerable astonishment at the depth and quality of his 'emergency vocabulary'. Captain Oates was clearly not the one.

They could have picked anybody. The blue jackets of His Majesty's Royal Navy were not shy in laying blame at the door of character weakness. Could it be the Skipper, leading them inexorably southward? Or Scorbutic Bill, the beloved Doctor Wilson, always on the lookout for signs of scurvy? Lieutenant Bowers with his birdie nose? Or one of their own? Perhaps Taff Evans, the giant petty officer and captain's favourite? They would all lie dead before the tale was done, and for a hundred years following more reams would be written guessing the reasons why than on any other aspect of polar history. But the blue jackets knew the reason why. They knew it in their hearts and in their souls and they knew it at the time. It was always the reason that unexplained bad luck befell a ship at sea and there was no doubting that it was bringing bad luck upon them now. There was a Jonah among them.[5]

As they dug the huge drifts of snow away from camp, and in the corners of their wet tents over mugs of tea, the sailors were muttering. The biologist Apsley Cherry Garrard noticed. 'The sailors began to debate who was the Jonah,' he wrote some years later.[6] Yet who could he be? In the end it was obvious: during the expedition they had already witnessed several incidents of 'bad luck' brought on by the one with the evil eye. Who was the Jonah? 'They said he was the cameras.'

Portrait of Captain R. F. Scott in front of Mount Erebus, 26 January 1911 (Ponting 148)

It was Scott who conceived a radical imaging programme for his expedition and he invited the renowned photographer Herbert Ponting to make photography an integral part of scientific exploration in the Antarctic. Ponting took several famous portraits of Scott during the expedition, including this one.

INTRODUCTION

Lost. How could Captain Scott's photographs ever have been forgotten and lost? It seems somewhat careless, to say the least. They form an invaluable record from one of the greatest epic tales in the history of human exploration. Yet, for all the biographies and newspaper articles about Captain Scott over the past hundred years, these important images became neglected, gathering layers of dust in the basement of a major photographic agency, until they were quietly sold off in a New York auction room in 2001. They re-emerged in London some years later, during a conversation over a glass of gin and tonic: 109 small silver-gelatin contact prints, 4 inches by 3.25 inches (10 cm x 8 cm) in size and stored in a standard black plastic photograph folder, three to a page.

The folder is not the original housing for the photographs but a sign of the cursory manner in which they were marketed. Other signs of casual treatment are also evident. Each photograph had once been carefully developed, ordered and labelled, being given its own unique S-number: 'S' for 'Scott'. They formed part of one of the greatest photographic catalogues ever compiled, the Ponting-Debenham index.[1] All this is gone. The S-numbers now used are self-evidently not the original numbers, their identifications are absent and their ordering almost unaccountably misguided.

For all their disorder, at least the prints have survived in good physical condition; their negatives have simply disappeared. The most likely fate of the original negatives may be guessed from notes on the backs of the photographs: 'neg. missing, May '67'. This implies that, like so many other nitrocellulose film products from the period, their perpetual survival was taken for granted while they quietly disintegrated, or, perhaps worse, spontaneously combusted. The chemical instability of early film in poor storage conditions is notorious. It is a miracle, then, that these photographs have survived at all. Investigate them closely and it becomes clear how much of a miracle. Some of the photographs known to have been taken by Captain Scott are missing from the collection, perhaps stored as negatives rather than prints. Some of the Scott photographs seem to have been lost for ever.

Lost and forgotten. Perhaps it is not surprising. Captain Scott lost the race to the South Pole to Roald Amundsen and then died on the way back. Careless, that, or so the story goes, as for a hundred years legions of authors have thrown up numberless overexcited theories as to why. Somewhere in the muddle of it all, the truth was obscured. Since Scott's reputation has been treated somewhat perfunctorily over the years, why not his photographs? Or perhaps, if Scott's blue jackets were right, something more sinister has been at work. 'The sailors began to debate who was the Jonah. They said he was the cameras.'

A Jonah. In that eerie thought psychological worlds collide,

archetypes challenge rational enterprise, the brooding power of the subconscious threatens chaos out of order: 'Cast the cameras away!' 'The evil eye brings the curse!' Barely vocalized, yet brooding in the sailors' minds. What fate awaits cursed photographs and a pole venture stalked by bad luck? It is rumoured that sailors had killed Jonahs for less, even officers.

Yet Scott's was always intended as a scientific and rational endeavour and the cameras an important part of it. Throughout his career Scott was employed within the progressive vanguard of the Royal Navy; indeed, it is hard to truly grasp Scott's character without understanding that he was a successful naval officer with all that this entails. He served as a torpedo lieutenant when torpedoes were still a pioneering military development; also in naval intelligence, and he thrived through the modernization of the navy during the Fisher reforms, which replaced hereditary privilege with meritocracy.[2] He had a promising career ahead of him, being the most junior officer in command of an independent battleship, HMS *Bulwark*, shortly before he took leave, in 1909, to lead his second and final Antarctic expedition. For this, he pioneered the development of tracked motor sledges from which were derived the tanks of the First World War and many contemporary forms of polar transport. The demand of the blue jackets to cast the cameras away, if it had been seriously vocalized, would have been a charming old superstition, an alien enigma to Scott as much as to us – and laughed off.

So much for Jonahs. Besides, carelessness with important images of exploration has contemporary equivalents. In the United States, NASA recently had to admit that it had lost invaluable primary image data of the first landing of men on the Moon – and in just forty years.[3] That too seems somewhat careless … and not a mention of a Jonah anywhere. Yet – and yet – the invocation of the ancient ways of the sea are enough to raise hairs on the backs of necks, and we cannot help but wonder …

Previous page and left:
The discovery of Captain Scott's long-lost photographs allows us to view the crucial months of September–December 1911 through his eyes, including the first stages of the journey to the South Pole. They also show Scott's personal development from amateur cameraman to a photographer worthy of his teacher, Herbert Ponting.

THE JOURNEY SOUTH – NEW ZEALAND TO THE ANTARCTIC

At the turn of the twentieth century, expeditions to the Antarctic were long and challenging voyages into the unknown. It took four months for *Terra Nova* to sail from Cardiff to Lyttelton in New Zealand via South Africa and Australia, and then a further five weeks' sailing from New Zealand to reach Ross Island. With storms at sea and thick pack ice to navigate, these were dangerous undertakings in themselves.

Keeping a large expedition supplied so far from civilisation and in such extreme conditions required *Terra Nova* to make multiple relief voyages from New Zealand to the Antarctic between 1910 and 1913.

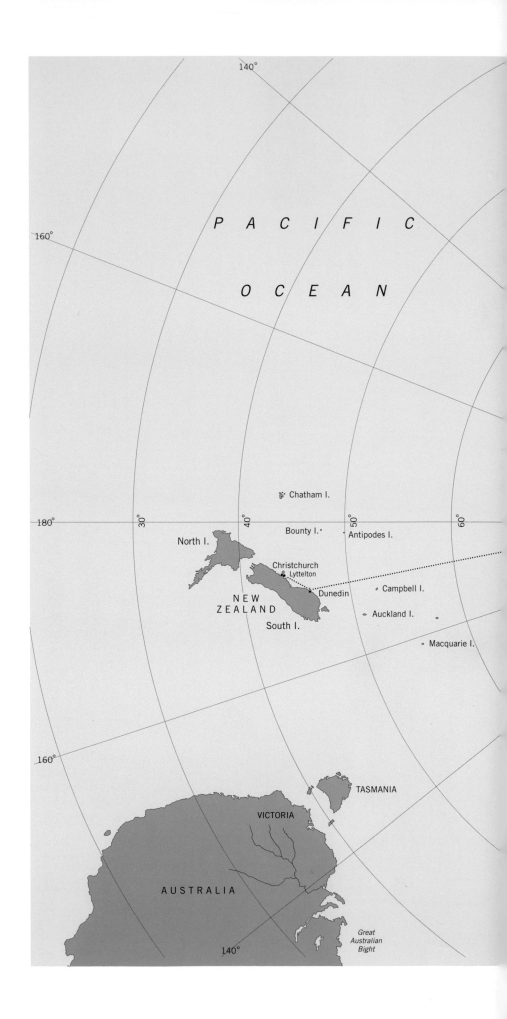

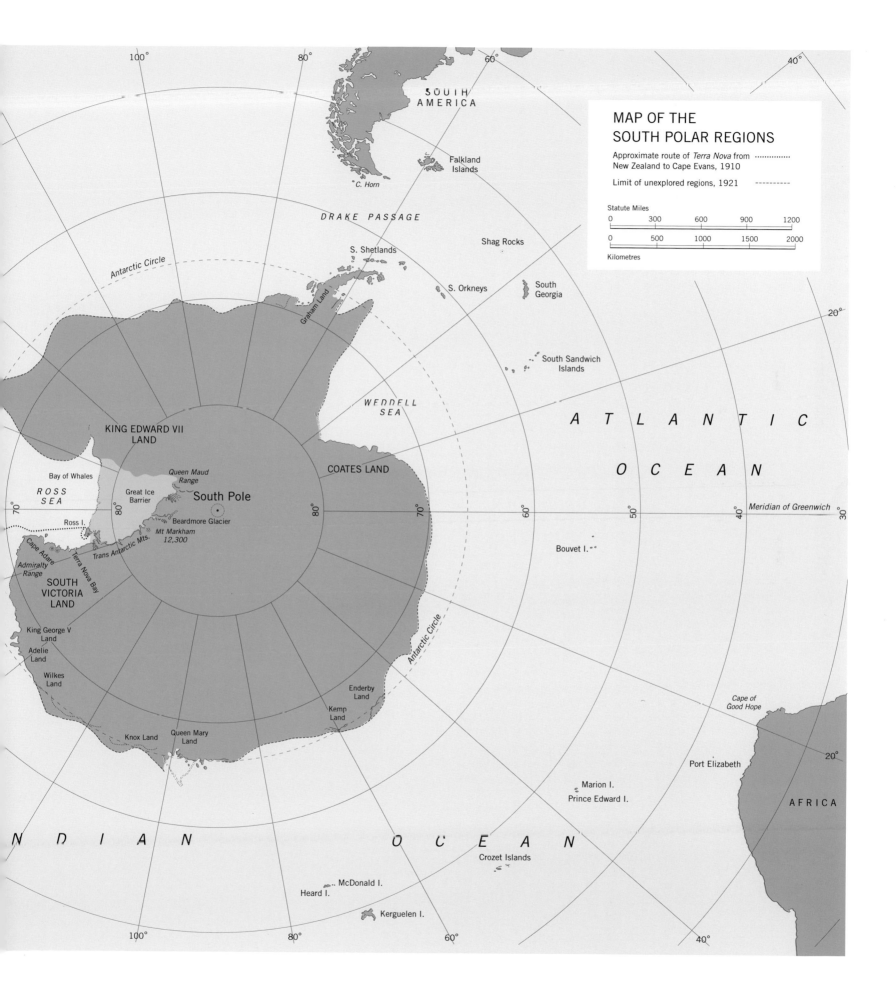

MAP OF THE
SOUTH POLAR REGIONS

Approximate route of *Terra Nova* from ⋯⋯⋯⋯
New Zealand to Cape Evans, 1910

Limit of unexplored regions, 1921 - - - - - - - - -

Statute Miles

| 0 | 300 | 600 | 900 | 1200 |

| 0 | 500 | 1000 | 1500 | 2000 |

Kilometres

SOUTH
AMERICA

Falkland
Islands

° C. Horn

DRAKE PASSAGE

Shag Rocks

S. Shetlands

Antarctic Circle

S. Orkneys

South
Georgia

Graham Land

South Sandwich
Islands

WEDDELL
SEA

ATLANTIC

KING EDWARD VII
LAND

COATES LAND

OCEAN

Bay of Whales

Queen Maud
Range

ROSS
SEA

Great Ice
Barrier

South Pole

70°

80°

80°

70°

60°

50°

40°

30°

Meridian of Greenwich

Ross I.

Beardmore Glacier

Mt Markham
12,300

Cape Adare

Trans Antarctic Mts.

Bouvet I.

Admiralty
Range

Terra Nova Bay

SOUTH
VICTORIA
LAND

King George V
Land

Antarctic Circle

Adelie
Land

Enderby
Land

Cape of
Good Hope

Wilkes
Land

Kemp
Land

Knox Land

Queen Mary
Land

Port Elizabeth

20°

Marion I.

Prince Edward I.

AFRICA

N D I A N

O C E A N

Crozet Islands

McDonald I.

Heard I.

Kerguelen I.

100°

80°

60°

40°

17

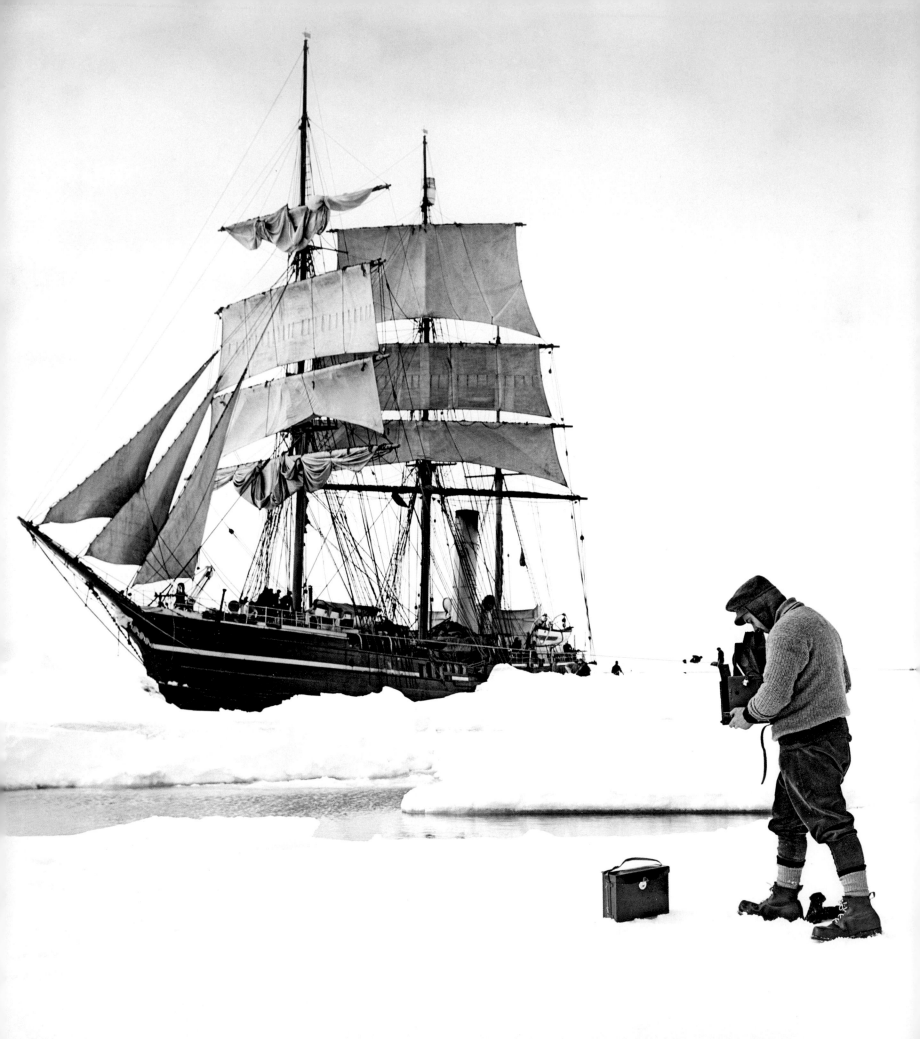

PRELUDE TO THE POLE

It was planned as a thoroughly rational enterprise. It was like going to Mars, or beyond. Yet on the day that human beings step on Mars they will have maps; the explorers who set out in the early part of the twentieth century to explore the Antarctic had almost none. They were travelling to the largest unexplored blank space on the land-map of the Earth in answer to the clarion call of the scientific societies, issued at the International Geographical Congress of 1895:

That this Congress record its opinion that the exploration of the Antarctic Regions is the greatest piece of geographical exploration still to be undertaken. That in view of the additions to knowledge in almost every branch of science which would result from such a scientific exploration the Congress recommends that the scientific societies through-out the world should urge in whatever way seems to them most effective, that this work should be undertaken before the close of the century.[1]

Consciously or unconsciously, President Kennedy would echo that rallying cry sixty-seven years later in a speech that proved just as great a catalyst for the Space Race, by which man achieved the Moon.[2] Yet the men who went to the Moon in 1969 knew more about where they were going than those who answered the call to the Antarctic of 1895. It wasn't even known for sure whether a continent existed in the blank of the map, or a mere group of islands. With the lack of maps, length of journey and absence of communication, only an expedition to the far-flung reaches of outer space would be comparable today.

The dawn of what is now called the Heroic Age of Antarctic Exploration saw the launch of a plethora of European expeditions seeking to answer major scientific and geographic questions of the day. Public interest was immense and the newspapers strove to meet an almost insatiable demand for coverage. Huge crowds cheered the expeditions off and huge crowds welcomed them home. The British, the Swedish, the French and the Germans all launched national Antarctic expeditions between 1901 and 1904 and, despite a competitive nationalism, coordinated their scientific work in order to maximize the benefit of the research, pioneering the concept of Antarctica as a continent for science and international cooperation, as it remains today.

Under the leadership of the then Commander Robert Falcon Scott RN, the British National Antarctic Expedition aboard SS *Discovery* sailed for the Ross Sea, south of New Zealand, in 1901. It was the last great expedition of the Victorian era but was executed in the new world of Edwardian progressiveness and lay on the cusp of huge cultural change. It was to be the first of Scott's two Antarctic expeditions and is the genesis of the Scott photographs. If you want to understand why Captain Scott's photographs were ever taken

and why they were subsequently lost, it all starts here, for his *Discovery* expedition was in many ways the crucible of the Heroic Age and all that flowed from it. It starts, however, not with a camera but with pencil and paper.

Imagine standing on an icy plain. The sun is shining and scorches already burned lips and face, peeling them raw. Nevertheless, it is very cold, 5°F (-15°C), more than enough to chill to the bone. In the distance are mountains, never before seen by any human being. There is a job to do. It is most important to the success of the expedition that records are obtained. While your colleagues take angles with sextants or theodolites for future maps, the most effective record is to make an accurate sketch with pencil and paper. To see clearly, goggles are removed, along with thick mittens. Sketch quickly. As the sensation is frozen from fingers, it is time to stop; hands are placed into warm armpits to restore circulation. Pain. Then it is time to sketch again. Repeat process. And then the real excruciation begins. Snow-blindness: sunburn of the eyes. You are left writhing in agony.

I was leading, but after 3 hours got such a violent attack of sunglare in my eyes that I could see nothing. Yet I had worn grey glasses all the time sketching, and grey glasses as well as leather snow goggles on the march. I put in some drops and for the remaining five hours pulled behind with both eyes blindfold. They were very painful and streaming with water.[3]

Tomorrow there will be more new mountains and more sketching to be done and all without complaint, for the cause of science overrides individual discomfort. Such was the work of the expedition artist, Dr Edward Wilson, who accompanied Captain Scott as junior surgeon, vertebrate zoologist and artist during the *Discovery* expedition.

If the Royal Navy had conquered the world with cannon fire and the grit of British blue jackets, it had mastered it with pencil and paper. The Royal Navy attached such importance to visual records from all parts of the globe that the education of Royal Navy officers included training in scientific and geographical sketching, particularly seascapes and topographical profiles of the coast. Often, talent was brought aboard ships from outside the navy, but a school was also established at Christ's Hospital, in Sussex, as early as 1693 to ensure adequate training (and from which the school of English landscape painting emerged through Alexander Cozens, a teacher there from 1750 to 1754). The discipline of expedition or exploration art truly became established, however, during the expeditions of Captain Cook, in particular by William Hodges (1744–97), who was invited by Cook to sail aboard His Majesty's ships *Resolution* and *Adventure* between 1772 and 1775 to improve the imaging from his voyages. It was Hodges' revolutionary fusion of traditional scientific, cartographic and artistic techniques which was to

In the pack ice, December 1910
(Ponting A195)

The first professional photographer in the Antarctic, Ponting was 'in awe' of its icescape and successfully transferred this into his work, defining the imagery of the polar regions for decades to come. Here, Ponting takes a portrait of himself photographing the *Terra Nova* stuck in the pack ice.

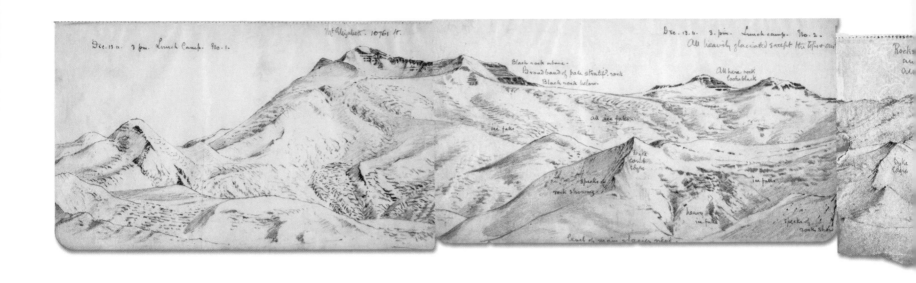

Dec. 13 11. 3 pm. Lunch Camp. No. 1.

Mt Elizabeth. 10761 ft.

Dec. 13. 4. 3 pm. Lunch camp. No. 2.
All heavily glaciated except the lower end

Black rock above.
Broad band of pale stratif. rock
Black rock below.

All here rock
looks black

all ice falls

ice fall

Specks of
rock showing

ice fall

heavy
ice fall

Specks of
rock sho

level of main glacier névé

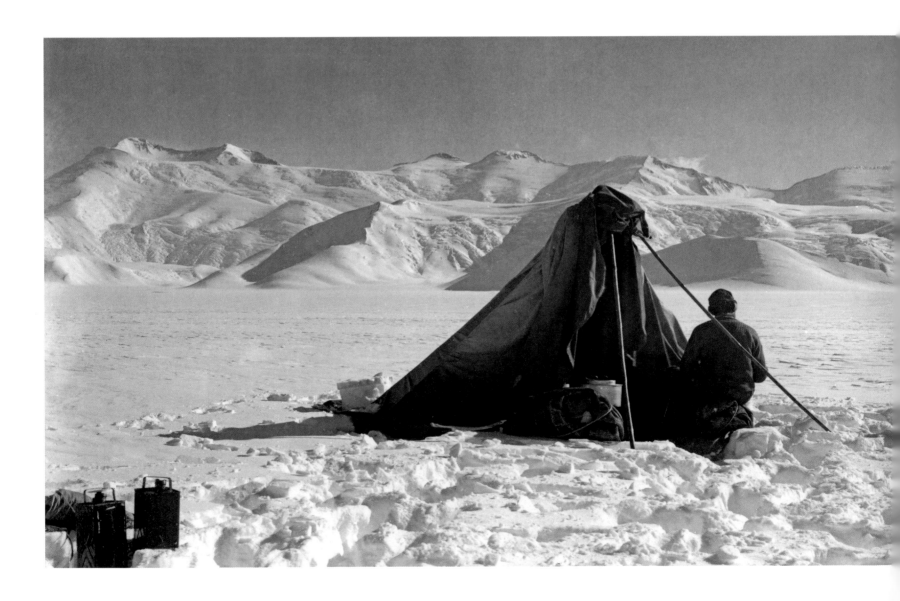

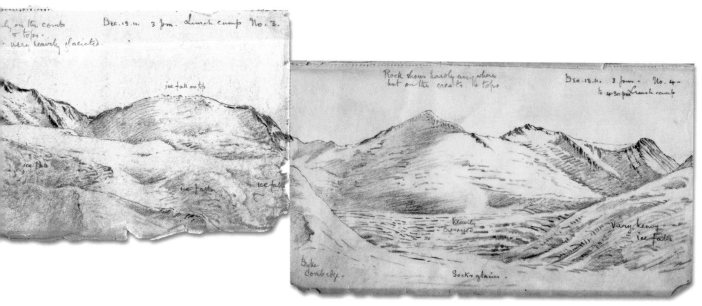

Sketch by Dr Edward Wilson

...

Comparing Scott's photograph (below) of Wilson sketching the mountain ranges and tributary glaciers of the Beardmore Glacier with Wilson's drawing of the same scene is to appreciate the extraordinary revolution taking place in the method of recording geographic and scientific data, as the camera replaced the pre-eminence of the pencil. The imaging programme was the most ambitious yet conceived for the polar regions, with high standards achieved in both scientific drawing and photography.

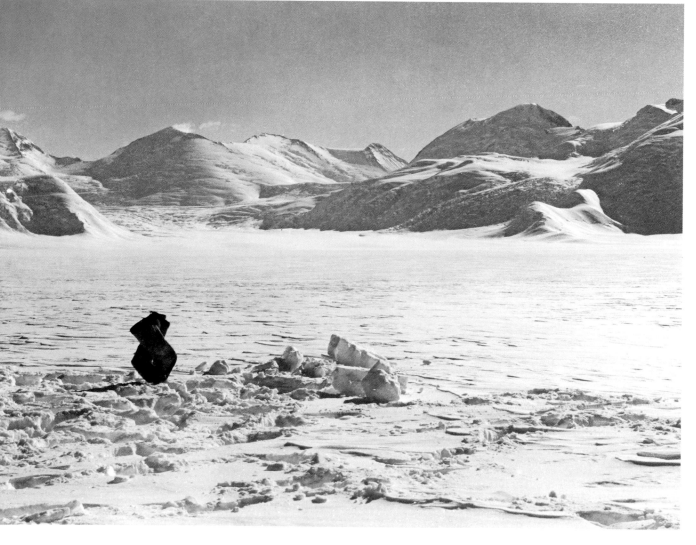

Dr Edward Wilson sketching on the Beardmore Glacier: Mount Elizabeth (left) to the Socks Glacier and Mount Fox (right), lunch camp, 13 December 1911 (S32; S33)

...

crystallize the method and define the form of exploration art for most of the nineteenth century. It was also to define the imagery of the newly emerging Antarctic. On 17 January 1773, Cook's expedition crossed the Antarctic Circle for the first time and permanently laid to rest any myth of the postulated Southern Land being a benevolent tropical paradise. Instead, the images of ice and snow that Hodges and the other shipboard artists brought back to Europe created the new myth of the Great White South and set the agenda for the artists who were to follow for over a century.[4]

The historic line of the great voyages of Royal Naval exploration which ran from Cook ended with Scott. While the British National Antarctic Expedition aboard *Discovery* wasn't officially a Royal Naval expedition, it was run on naval lines with largely naval personnel. After Scott, the Royal Navy became more concerned with defeating Germany than with exploration, which became specialized into its increasingly small Hydrographic Division. The *Discovery* expedition was also the final journey into the unknown in which art was to be the most effective method of visual record. This was certainly down to historic developments in visual recording but it was also critically down to Captain Scott himself. Wilson was to be among the last of his kind.

In the long line of naval tradition, Scott himself had been taught to draw and paint during his naval education, and his midshipman's log contains several watercolours by him. He drew sketches in his diary throughout his life, and cartoon penguins for children.[5] His sketches reveal an artistic sensitivity that often fails to be recognized; it would later show in his photographs. It should not be much of a surprise that he married a sculptress, Kathleen Bruce, in 1907.

Scott, however, was a forward thinker; he was interested in scientific progress and the latest technological inventions. It was his vision that led to the decisions which would define the imaging of the Antarctic for the next century, as surely as Cook's had defined the imaging of the previous one.

The development of modern photography from 1825 did not replace the work of the expedition artist as rapidly as might have been expected. Photographs quickly became popular in the Victorian drawing room but the complexity of operating the equipment and the general lack of detail in the images made early photography unsatisfactory as a mode of scientific and geographic record. It wasn't until a century after Hodges, in 1874, that the first Antarctic tabular icebergs were photographed from the deck of the maritime research vessel HMS *Challenger*. During the same period the camera started to be used on expeditions into the American West. Nevertheless, the constraints of the photographic process, particularly the absence of colour, left much to be desired. For all its limitations, however, photography was developing

as a popular hobby, which increasingly meant that scientists and officers were as likely to photograph as to sketch. Many officers did both.

By August 1900, when Scott was appointed to organize the British National Antarctic Expedition aboard *Discovery*, photography was already established as part of the equipment of modern Antarctic exploration. Most other expeditions accepted photography's limitations and relied almost entirely on it for their imaging programmes. It is true that many of them also took artists, but they painted and drew for primarily aesthetic reasons (and might be best regarded as early examples of what has evolved in contemporary National Antarctic Programmes into writers and artists schemes). Scott aimed for more, appointing both Edward Wilson in the old tradition of exploration artist and arranging a photographic programme.

Scott found himself with barely a year to get the expedition organized and facing considerable political challenges. As a result, he was so busy that photography was not a matter to which he could personally attend. He therefore delegated it, along with much other technological gadgetry, to his chief engineer, Reginald Skelton:

My Dear Skelton, just a line to advise you, if you have the time and opportunity, to work up the subject of photography. It will, I think, prove a matter of interest to you and of great service to the expedition ...[6]

Skelton did just that and became the official photographer to the British National Antarctic Expedition 1901–04. The conditions for Antarctic photography were not, however, any easier than for sketching. A camera weighing 30 lbs (13.6 kg) and the additional weight and fragility of the glass plates used for negatives made it a laborious enterprise. With similar risks of snow-blindness, the whole process was compounded by metal mechanisms that froze bare skin at a single touch in the intense cold.

Scott maintained an interest in the imaging programme throughout. It was critical to the results of the expedition. However, as far as can be ascertained, he left sketching and photographic enthusiasms to others. Many of the officers had brought cameras and were busy photographing, so it fell to Skelton to keep them organized, both in the darkroom and in terms of their results. Every photograph taken by every photographer aboard *Discovery* was catalogued and listed in what has become known as the Skelton Index.[7] Every photograph has a catalogue number which identifies the photographer and in most cases the location, date and subject matter. The Skelton Index makes the photographic archive of *Discovery* particularly valuable. Few other expeditions of the period delivered such a scientifically useful

photographic record, even those which ought to have followed the precedent.

Scott was delighted and tried to persuade the geographical authorities to publish the photographic results. In March 1905 he wrote to Sir Clements Markham, President of the Royal Geographical Society, suggesting that Skelton be given a commission to collect all the expedition photographs in a book, with a short description of each; in other words, to publish the Skelton Index. This, Scott argued, would greatly enhance the scientific results of the expedition, particularly if the photographs were arranged in order of scientific interest and if the location where each photograph was taken was marked on a map.[8]

The project, as Scott envisaged it, was never completed. Instead Edward Wilson was invited to edit a more modest *Album of Photographs and Sketches with a Portfolio of Panoramic Views*, which was published in 1908.[9] Nevertheless, it was a combination of photographic and artistic work that no doubt started both Scott and Wilson thinking about the possibilities for next time. There would have been no Scott photographs without the Skelton Index and the resulting album.

That it wasn't produced as Scott had envisioned was down to two factors: the first lay in the limitations of photography itself, particularly for topographical work, meaning that Wilson's sketches were still superior scientific records. For all Scott's enthusiasm, the photographs were not exceptional and did not sell well at the Bruton Gallery exhibition of the expedition's work. Edward Wilson's paintings, however, did. The second lay in money and politics: a national enterprise on the scale of the *Discovery* expedition had plenty of problems with both. The essence lay in a furious row among the great and the good as to what constituted 'proper' exploration.

Traditionally, an explorer is broadly defined as a person who investigates unknown regions; a scientist is a person who investigates unknown natural phenomena; while an adventurer is defined as a seeker of fortune, undertaking risk in a daring enterprise. In general terms, this is certainly true. However, on such a simplistic definition an adventurer may be confused with a scientist or an explorer, for seekers of fortune like to be first and profit from the ambiguity. A deeper understanding might run as follows: for the scientist or explorer, risk is worthwhile for the sake of the expansion of human knowledge, in the investigation of unknown regions or natural phenomena. The emphasis is on research. Adventures may be had and records may fall in achieving 'firsts', human limits may be tested in the process, but these are secondary to the objective of achieving significant scientific and geographic progress for the benefit of mankind.

This is their vocation. Maps, scientific reports or other material records are the benchmarks of success. Personal wealth and fame may or may not follow and may or may not be welcome. If death is met, it is an unfortunate personal tragedy but a cost worth paying for a greater communal good. For an adventurer the emphasis is selfishly inverted. Risk is worthwhile if it means 'being first', in testing personal limits and in record setting. The emphasis is on personal success. Wealth and reputation are actively sought; adventure is their entrepreneurial business. New discoveries may be made but maps, scientific reports or other material records are secondary, except in so far as they may be used for self-promotion. Death is preferably avoided, as it tends to interfere with the enjoyment of fame.

This fundamental difference between explorers and adventurers is frequently blurred, often because the important differences in motivation are hard to establish. Was Neil Armstrong standing on the Moon the result of scientific exploration or the result of political adventurism? Sometimes it is blurred because of the complex layerings that occur where egos get confused with communal endeavours and vice versa. Sometimes individuals straddle or jump the line. Often, however, the conflation is deliberate: science gets tacked on to adventurism for a veneer of public credibility; more rarely adventurism is tacked on to science. Either way, such veneers are generally added for fundraising purposes. However, for all the obfuscation, it is not usually impossible to ascertain where the balance of interest lies.

Why does this matter? Superficially, it does not. Scientific explorers and adventurers may both be seen as pioneers, either may inspire and each reveal fundamental aspects of the human condition. Both have merits and may be lauded; and both may serve the national interest. Yet these two different aspects of human endeavour were to tear the heroes of the Antarctic apart. Their motives, their methods and their achievements were very different. Moreover, the rift which they opened still divides the Antarctic community to this day. Historians repeat the bitter arguments of the past, while contemporary scientists and adventurers continue the mutual contempt into the present. Many contemporary scientists would happily see the 'adventure tourists' abolished from the Antarctic continent and have it preserved exclusively for science. Adventurers cannot understand why scientists won't give their endeavours support and recognition.

What does this have to do with the Scott photographs and their eventual fate? Everything. It is this rift into which Captain Scott fell.

But not yet. To begin with, he negotiated around it with extraordinary deftness. Before a commander for *Discovery*

considered his 'real work'. Over and over again, he emphasized to his team that they mustn't cheat science for the pole, nor vice versa.[20] Scott was preparing to ride the rift. The pole was his duty to the public, to national and personal ambition, but science remained his passion. The personal interest and energy which Scott put into the scientific programme was considerable.

Scott wasted no time in assembling a serious scientific team. His *Discovery* colleague Dr Edward Wilson was appointed chief of the scientific staff and, following from Scott's insights during that expedition, a professional photographer was immediately sought to expand the role of photography in Antarctic exploration. Scott was not interested in this simply for publicity – any competent Royal Navy officer or scientist could, and had, managed that. Nor was he interested in it simply as a means to raise funds for the expedition. Although Scott was aware of its importance to lecturing and media coverage, with the monies these brought, the ultimate commercial possibilities escaped him, and, indeed, almost everyone else. The full commercial success of cinema was a thing of the future. Scott's interest lay elsewhere, in the much harder task of finding a photographer who would complement and expand the scientific and geographic programme of his expedition. What Scott sensed was the potential, in the same way that he sensed the potential in the development of tracked motor sledges with the dream that they might replace pack animals in the polar regions. The camera had not yet performed as a serious apparatus for scientific exploration at the poles – the pencil was still superior – yet somehow Scott must have realized that it could do so, or he would not have gone to so much trouble. It is in his vision for pioneering these technological developments that Scott's genius lay, and in them he was many years ahead of his time. His was the first Antarctic expedition to employ a professional photographer in a pioneering scientific capacity. Over a hundred photographers applied to do the job. One, however, stood out above all others.

Herbert George Ponting had met Cecil Meares during some of his recent travels in Asia, where Meares had acted as his translator. Recently appointed to Scott's Antarctic expedition as transport officer, Meares introduced Ponting to Scott in 1909. Ponting appeared ideal to Scott: he was already considered one of the finest travel photographers of the age and thought of himself as a photographic artist. Ponting was equally taken with Scott, having read *The Voyage of the Discovery* from cover to cover. However, Ponting was not expecting to go to the Antarctic and was in fact negotiating a contract for a two-year tour of the British Empire for the Northcliffe press. As Ponting recalled:
[*Scott*] *talked with such fervour of his forthcoming journey; of the lure of the southernmost seas; of the mystery of the Great Ice Barrier; of the grandeur of Erebus and the Western*

Mountains, and of the marvels of the animal life around the Pole, that I warmed to his enthusiasm. He told me of his plans for scientific research – for geology, zoology, biology, meteorology, physiography, and for photography … Scott finally stated that he considered photography was of such importance in exploration that it was his intention to make a special department of the art, and he asked me if I would like to take charge of the enterprise …[21]

It was, as the *Scientific American* recorded, 'practically a new commission from science'.[22] Ponting was so excited by the challenge that he dropped his lucrative plans for an Empire tour for the uncertainties of the Antarctic. He undertook to deliver Scott's vision and made it his own.

I told him that all my previous travels had been made in the interests of geography; that I felt that this was a chance, such as would never come to me again, to turn the experience that I had gained to some permanent benefit to science, and that I was convinced that if I went, and were given a free hand to utilise my experience as I thought best, the photographic results might prove to be not only of great educational value, but a valuable asset to the enterprise. He seemed pleased and thanked me for taking this view …[23]

It may be considered an indication of how serious Scott was about his photographic programme that he paid Ponting a higher wage than other scientific staff.

Ponting spent months in preparation, ensuring that the best available photographic equipment was acquired to meet the challenge.[24] For strength and compactness, 'Sibyl' cameras with f4.5 Tessar lenses were made for the sledging parties by Messrs Newman and Guardia, who also provided Ponting with a special 'B' camera of his own design. Sanger, Shepherd and Co. made the cameras for photomicrography, and there were numerous professional lenses, two cinematographic cameras (a J. A. Prestwich and a Newman-Sinclair) and a fully equipped darkroom – the list of the best available photographic equipment was a considerable one. In addition, he received sponsorship from Gaumont, the French company, to make a moving film. Scott's second-in-command, Lieutenant Edward Evans, was to describe it as a 'colossal photographic outfit'. It is doubtful, however, whether either Ponting or Scott, for all their visionary aspiration, had yet anticipated the revolutionary nature of the task in which they were now engaged.

The British Antarctic Expedition sailed from Cardiff on 15 June 1910 aboard SS *Terra Nova*, via Cape Town and Melbourne to Lyttelton, New Zealand. It was here that various parties to the expedition finally joined the ship, including Ponting. For all that it was a British expedition, no fewer than ten nations were involved in Scott's effort, either through

A portrait by Scott of Herbert Ponting at work with the cinematograph (S13b)
......................................

Scott became hugely excited by Ponting's work. His film of Scott's expedition pioneered today's wildlife documentaries as well as making exciting scientific discoveries. When shown, it revolutionized the relationship of the general public to the polar regions. Ponting's work was the first to successfully communicate the harsh and sublime reality of its desolate landscape to the outside world.

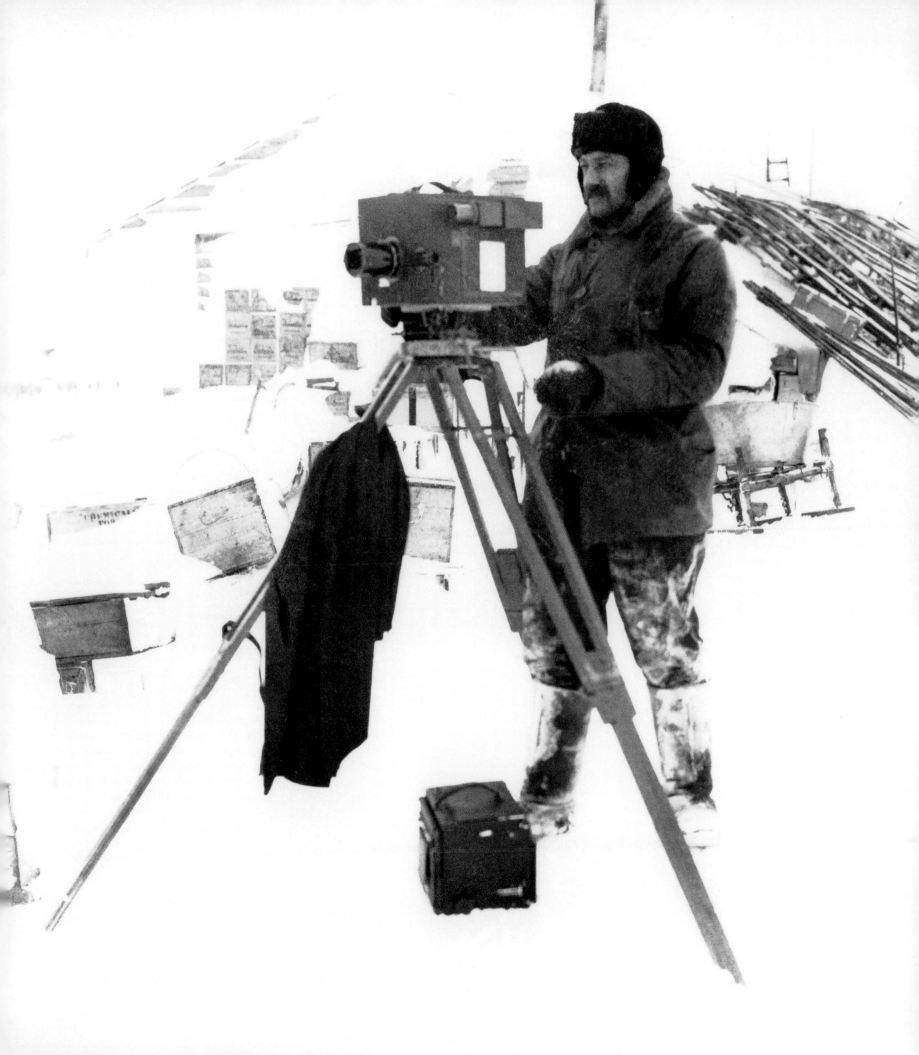

sponsorship or the nationalities of his personnel; more if you count support offered by the ports of call of *Terra Nova* during her outward and return voyages. They weren't all from the British Empire either: dog and stable hands from Russia and the Ukraine and a Norwegian skiing expert made Scott's last expedition an international endeavour. There had even been talk of making 1910–12 another international geophysical programme and for Scott to pool his scientific results with the French, Germans, Australians and Japanese who also headed south on Antarctic expeditions at this time. But in the end, despite amicable arrangements for cooperation, it came to little.[25]

The overloaded ship departed Lyttelton south to the Ross Sea on 29 November 1910. Ponting was very seasick but persevered with his work, Scott noting that he was 'developing plates with a developing dish in one hand and a basin in the other' (Thursday 1 December 1910). His enthusiasm nearly resulted in disaster:

On the third day out from New Zealand I had the ill-luck whilst endeavouring to make my way for'ard in a rather wobbly and unseamanlike manner, to stagger as the ship rolled, nearly precipitating my finest hand-camera overboard. I saved it by a hairs breadth; but in the effort, I slipped and fell amongst the timber stowed amidships, nearly breaking my left leg.[26]

If anyone had listened, would they have heard the echo of Jonah murmuring in the wind? They were rather too busy, however, trying to save the ship, as she nearly foundered in a ferocious gale. Ponting had to spend several days laid up, while simultaneously trying to save his photographic equipment from being flung around his cabin.

On 9 December, *Terra Nova* entered loose pack ice and Ponting first encountered the world of which he was to become the photographic master:

In all my travels in more than thirty lands, I had seen nothing so simply magnificent as this stupendous work of Nature. The grandest and most beautiful monuments raised by human hands had not inspired me with such a feeling of awe as I experienced on meeting with this first Antarctic iceberg.[27]

He was soon to have as much sublime icescape as he could manage. 'We now had a period of bad luck,' Ponting wrote, as *Terra Nova* had a particularly difficult three weeks negotiating the pack ice of the Ross Sea.[28]

Ponting was in his element, working with dedicated focus to realize his artistic vision both with his still cameras and, for action shots, the cinematograph. His talent lay not just in his considerable technical ability but in being able to translate his sense of awe into his photographs. More than this,

however, his creativity had few expectations to work to. Ponting was not the first expedition photographer in the world, but the portrayal of other continents was already long fixed and their photographic imaging conformed to preconceived visions. While elements of polar iconography had been set by earlier expeditions to the Arctic and Antarctic, in particular by Hodges with Cook, the vision and execution in photography had been limited. *Scientific American* described all polar photography prior to Ponting in dire terms:

The flat pictures of snow expanses and posed portraits of fur-clad explorers with dog sledges brought home by some of the most distinguished of explorers have been hardly more than commonplace, even though taken under the most trying of conditions. In real value, pictorial or scientific, they have served but little better than the quaint engravings of conventional icebergs and auroras of a hundred years ago.[29]

To all intents and purposes the template of the imagination was still open; the visual iconography of the Great White South remained half defined. Ponting took the work of his predecessors and re-formed it. He filled it with wonderment and, in so doing, although he did not fully realize it, he was defining a new paradigm, the vision of a new frontier, Antarctica, for generations to come.

It was because of Ponting's dogged pursuit of his own work that he was sometimes accused of not helping out others or with the general tasks. However, Ponting was habitually a loner of nervous temperament and initially seems to have found the age difference between himself and the younger scientists and other officers difficult to surmount. Some tension also developed in his early relationship with Scott, as Ponting's photographic agenda did not always easily reconcile to that of the expedition. Such competing agendas is a difficulty familiar to any expedition to this day. With the cancellation of the landing at Cape Crozier, at the eastern limit of Ross Island, due to the prevailing swell and late running of the expedition, Ponting had to give up his dream of photographing one of the great natural wonders of the world, the Great Ice Barrier, formed by the edge of the Ross Ice Shelf, for which he 'had come over a third of the circumference of the globe'.[30] It was a considerable disappointment, but the expedition was in such good spirits that minor tensions such as these were soon forgotten. In general, Scott gave considerable support to the photographic programme and to the scientists. Charles Wright, the physicist and glaciologist, recalled that the scientists could always get Scott's support even if it got in the way of other things on the expedition.[31]

Whenever he could, Scott was as good as his word and gave Ponting a free hand to get on with his job, sparing him

general chores. As the expedition base was set up at Cape Evans, on the western coast of Ross Island, Ponting was excused landing duties in order to photograph. However, by now this was sparking some unspoken resentment and the result of this was a lack of willing helpers to unload his photographic equipment from the ship – although he happily set about building his own darkroom – and also of volunteers to help drag his gear on photographic outings.

It was on one of these early outings that bad luck struck Ponting again. On his way to photograph some icebergs, he spied a school of eight killer whales and rushed to the ice edge in order to photograph them. Just as he arrived the ice heaved up underneath him, as whale after whale rose under the ice in order to split it. As the whales encouraged his dropping-in for lunch, Ponting ran from piece to piece of the heaving ice with the whales' teeth right behind him and only just made it to safety. Scott, who had observed the episode, was deathly pale when he caught up to him: 'My God!' he said. 'That was about the nearest squeak I ever saw.' [32] Ponting tried to photograph the killer whales again the next day from the safety of the ship, leaning over the poop rail, only for the lens board from his camera to fall overboard and with it his best lens, a 9-inch (23-cm) Zeiss double Protar, lost in 200 fathoms (366 m).

The incident of Ponting and the whales set tongues seriously wagging. There was little doubt as to who was wearing the Jonah Medal on this expedition. The Jonah Medal was a standing joke from *Discovery* days:

It had been noticed for some time, that several of the Ship's Company carry ill luck and misfortune with them wherever they go. Did any one of these men go out to the fish-trap, it would come up empty, or with a miserable one or two half dead ones at the bottom; if they played cards, their partners invariably found they were on the losing side, and so with everything in which they were concerned. It was therefore resolved to find the veriest Jonah by the means of a card tournament, and to bestow upon him a medal … The fights for the Jonah Medal were many, fast, and furious, and it was held in turn by nearly all on the Mess-deck; however, no one failed to pass it on within the three days limit, until the recipient of it came to be Thomas Crean, who still holds it. [33]

No one was about to mess with the ever popular Irish stalwart, Tom Crean, loyally serving Captain Scott in the Antarctic once again. Besides, now they didn't have to play cards to find the Jonah, they seemed to have the real thing. Aboard *Discovery* the Jonah Medal had remained a cause of merry teasing, but any old salt will tell you, sucking hard through his teeth, the Jonah doesn't like to be mocked; he watched and he waited – and this time, he sent whales … What might have started as a merry joke with Ponting

as the butt grew into a taller tale with every incident. In quick succession to the whales: Ponting and his sledge of photographic equipment nearly went through thin ice to the bottom of the sea; he was nearly run over by a runaway pony and sledge and was so intent on focusing his camera that he didn't see it coming; and Tryggve Gran, the Norwegian skiing tutor, took a nasty fall while showing off his skiing prowess for the camera. By this point the dangers of photography were becoming apparent to all and Ponting was frequently questioned as to the nature of his 'evil eye'. Not every accident could be attributed to it: he seems to have escaped blame for the loss of one of the three motor tractors through the ice and *Terra Nova* hitting a rock while manoeuvring. Nevertheless, Ponting must have been relieved when *Terra Nova* headed north for the winter with the muttering of its superstitious crew, leaving the Shore Party to its Antarctic vigil. Not all of the lower deck left, however. Nine remained to support the Shore Party at Cape Evans and the jibes continued from his fellow officers. A special verb was devised: 'to Pont', meaning 'to pose until nearly frozen, in all sorts of uncomfortable positions' for Ponting's photographs. [34] Ponko, as Ponting became known affectionately, was becoming a source of raised eyebrows.

Pioneering enterprises, however, have pioneering costs and Ponting noted that he had never before worked in such a physically challenging photographic environment. For those who have never been to the Antarctic, it is hard to imagine how difficult it is to take good photographs. The diversity of light intensity, its rapid change and extreme variance, even within a single image, makes it very difficult to obtain a correct exposure. All too often one part of a photograph is correctly exposed and the rest is destroyed through over- or underexposure. Even today, a photographic tutor is an essential feature aboard any good cruise ship to ensure that visitors are able to capture their memories as they would wish.

Compound these tribulations with those of the nature of the equipment used one hundred years ago and the challenges involved in photographing the Antarctic are even harder for a contemporary reader to imagine. From the perspective of our point-and-click digital age, which has forgotten what even something as basic as a negative is, the complexity of what was involved in the photographic process seems bemusing. The large, cumbersome cameras and lenses were certainly capable of producing a high-quality image – superior, in fact, to those of most modern digital cameras. However, the science of sensitometry was still evolving. Celluloid film was starting to emerge as a replacement for heavy and fragile glass plates but for a professional image, many photographers, including Ponting, still used plates. In either case, the material tended to be orthochromatic, which is highly sensitized to the blue end of the colour spectrum,

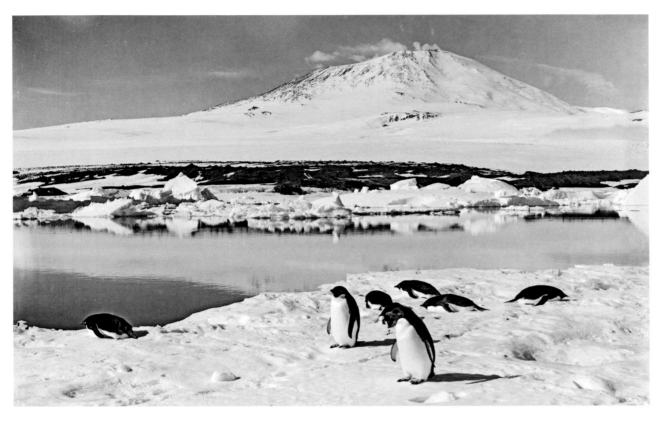

Mount Erebus with Adélie
penguins, January 1911
(Ponting 91)

.......................................

At first, Ponting brought the
Victorian tradition of picturesque
landscape photography to the ice-
and snow-scapes of the Antarctic.
He worked painstakingly, with
extraordinary patience in extreme
conditions, to compose every
image. Here, the distribution of
the penguins carefully echoes
the shape of the great volcano,
which is then echoed in its own
reflection, drawing the eye into
the magnificence of the scenery.
Ponting spent untold hours in
frigid conditions waiting for such
pictures to emerge naturally.

Sastrugi on the Barne Glacier,
21 February 1911
(Ponting 194)

.......................................

Ponting later moved beyond
the ideal concept of Victorian
photography. In capturing the
form, shape and texture of
ice he became a precursor of
photographic modernism. The
resulting stark images were not
to Edwardian taste and were
generally ignored on his return
to Europe.

leading to overexposure of skies and snow without the use of colour filters. Other photographic media were starting to emerge but were not widely available. This meant that taking a photograph was a complex operation. It was very difficult to get good results without considerable experience in the use of the camera, use of filters and knowledge of the photographic media being implemented, as well as an understanding of conditions and timing of exposures. Ponting waited for months to get the clear, windless day that he required for a particularly difficult series of panoramic shots:

An equivalent focus of nearly six feet [183 cm] would have to be used – six magnifications of an eleven-inch [28 cm] lens, which took the extreme limit of the extension of my camera. A six-times colour filter would be necessary in conjunction with an orthochromatic plate, and a medium diaphragm. Photographic enthusiasts will understand that to use such a combination on a windy day would be to court certain failure.[35]

Such complex equipment also meant that any photographic excursion was weighed down with materials – cameras, lenses, tripods, filters, film packs or heavy plates – before it started. Put all this onto a sledge, even with minimal survival or camping gear, and pulling it was not a lightweight proposition. Considerable care was also needed to set shots in the freezing cold, with lenses or filters to swap and films or plates to change, in conditions which would cause frostbite if metal or glass were incorrectly handled. Even for Ponting, with his vast photographic experience, this provided a challenge. He frequently suffered minor frostbites from metal contact while photographing. Ponting added significantly to his stock of traveller's tales:

It is not only the difficulty of the light. That is soon mastered. The temperature is where the real trouble comes from. If you take off your glove and put your naked hand near the lens, instantly the lens is covered with a film of ice that no mere rubbing will remove.

Sometimes moisture, condensing into the finest particles of ice, will get inside the lens – then you are through. A grave danger anent the camera is the brass knobs. If by accident, you touch with your bare hand any part of the brass of the apparatus, it will burn you like a red hot iron. On one occasion I was focusing under my cloth when I happened to moisten my lips. The point of my tongue came in contact with the metal and instantly froze there; the shock was so great that I went over backward, and when I recovered, I found that I had lost the tip of my tongue, which remained frozen to the camera.[36]

All in all, the trials of photographing in such an environment at this time were considerable. The results, however, were

revolutionary, as the camera took over from the pencil as the most accurate means of recording geological landscapes on polar expeditions. Even the onset of winter darkness did not stop Ponting's work, and he developed magnesium-flash techniques for the first extensive photographic work executed during the polar winter. Yet Ponting was also creating something which would change the form of twentieth-century landscape photography. Each photograph was carefully framed and posed as he built up a photographic catalogue which represents the very epitome of Victorian picturesque landscape photography. The more he photographed, however, the more his images moved from the concept of the perfect vista towards a concentration entirely upon shape and form, especially in his images of ice and snow. In this he is the precursor of modernism, one of the defining twentieth-century movements in art and photography. That these images were not among his most popular on his return says more of the aesthetic expectations of his Edwardian audience than of his photographic genius. Scott, however, was very pleased.

Of the many admirable points in this work perhaps the most notable are Ponting's eye for a picture and the mastery he has acquired of ice subjects; the composition of most of his pictures is extraordinarily good, he seems to know by instinct the exact value of foreground and middle distance and of the introduction of 'life,' whilst with more technical skill in the manipulation of screens and exposures he emphasises the subtle shadows of the snow and reproduces its wondrously transparent texture. He is an artist in love with his work, and it was good to hear his enthusiasm for results of the past and plans of the future. [13 April 1911]

It wasn't all an unmitigated success. Despite the enormous efforts made to procure the correct photographic apparatus, Ponting was unable to photograph the Aurora Australis to his satisfaction and was unhappy with his trials of colour images. However, Ponting was something of a perfectionist and he often struggled to get the results he wanted. For every image that he kept several were taken and thrown away. Fortunately, he was also patient. These were characteristics that he shared with the expedition artist, Dr Edward Wilson. It is a sign of the times that Wilson, although an artist, was intimately familiar with the latest developments in photography. His father, Dr Edward Thomas Wilson of Cheltenham, helped found one of the oldest camera clubs in the country, the Cheltenham Photographic Society, and had pioneered techniques of photomicrography.[37] Indeed, Edward Wilson took photographs in the Antarctic while aboard *Discovery* as well as sketching. Ponting and Wilson became huge admirers of one another's work and sparked ideas off each other in the progression of what evolved into the greatest illustrative project then conceived in the Antarctic regions. Wilson would criticize Ponting's

photographs and Ponting, in turn, Wilson's paintings. Each worked to get the best out of the other, and they proposed to hold a joint exhibition of their work upon their return home.

The entire expedition programme flourished in the multidisciplinary atmosphere of the hut at Cape Evans, even through the months of winter darkness, from April to September 1911. Scott's British Antarctic Expedition was a huge undertaking.

The hut was divided into three sections: Ponting's darkroom, in which he lived and worked, which gave him a huge amount of privacy compared to anyone else; the 'Wardroom' for the officers and the 'Mess Deck' for the crew. In the Wardroom, the scientists were hard at work, collecting and analysing data in numerous branches of science: two Australians, Frank Debenham and Griffith Taylor, were busy with geology; the Canadian Charles Wright at physics and glaciology; George Simpson at meteorology; Edward Nelson and Apsley Cherry Garrard at biology; Edward Atkinson as doctor and parasitologist; and all overseen by Edward Wilson, as chief of the scientific staff, artist and assistant doctor. With Ponting as photographer, it was the largest scientific team yet assembled on an Antarctic expedition. In addition were the transport officers, busy working on sledging preparations for the next season: Bernard Day, as motor engineer; the Norwegian Tryggve Gran as ski instructor; Cecil Meares as dog handler; Lawrence Oates in charge of ponies; Henry Bowers as storeman; and Edward Evans as deputy expedition leader. In support of the work of the officers were the seamen in the Mess Deck: Thomas Clissold as cook; Frederick Hooper as steward; the Russian Demetri Gerof as dog driver; the Ukrainian Anton Omelchenko as groom; and a number of Royal Navy blue jackets, several of whom had accompanied Scott aboard *Discovery* and were experienced sledgers: Edgar Evans, William Lashly and Irishmen Thomas Crean, Patrick Keohane and Robert Forde. In all, twenty-five men wintered at Cape Evans, under the command of Scott as expedition leader.

However, the team at the Cape was not the sum of Scott's expedition. An entirely separate party, the original Eastern Party and subsequent Northern Party, was wintering in the hut at Cape Adare. The party had been meant to explore King Edward VII Land, at the eastern side of the Ross Sea, but circumstance led to its wintering at Cape Adare, at its north-western extent, and exploring the coast of Victoria Land instead. Under the command of Lieutenant Victor Campbell RN were Murray Levick, doctor and biologist; Raymond Priestley, geologist; and three Royal Navy blue jackets: George Abbot, Frank Browning and Harry Dickason. They would achieve heroic adventure, deprivation and scientific accomplishment as great as any of the other parties.

Even *Terra Nova*, safely out from the ice and back in New Zealand, was not to be idle, with the officers and scientists of the Ship Party under Lieutenant Harry Pennell RN executing oceanographic and biological work, both when transiting to and from the Antarctic and during hydrographic cruises around the offshore islands of New Zealand. So there were three different scientific parties operating as part of Scott's British Antarctic Expedition, two shore parties and the Ship Party.

Everyone at Cape Evans was spurred on by the personal interest of Scott in every aspect of his work. Wilson thought Scott 'most capable' with 'a really balanced head on his shoulders', which is no faint praise from a man who mingled with some of the best minds of Cambridge.[38] Indeed, most of Scott's scientists, many of whom were also from Cambridge, had a similar respect for Scott's breadth and sharpness of mind and for his genuine interest in their work, even if they were sometimes frustrated by his naval officer's temperament, which could be impatient, demanding and ill-tempered. However, it forced the best from his extensive team.

'With Scott you had to be exact,' Frank Debenham noted, having collected geological specimens on a nearby hill and shown them off back in the hut, where he referred to a specimen as hornblende. The next day he was referring to it again in front of Scott and called it 'gype' [augite?] but Scott called him to account over it at once: 'Look here Debenham, this won't do, you scientists have to be precise, we want things explained so that we can understand them, you called that Hornblende yesterday, I know you did,' and Debenham had to admit that he hadn't been precise.[39]

Scott insisted on each scientist giving regular lectures throughout the winter, ensuring a certain interconnectivity in the scientific programme, as well as providing general interest and entertainment. After the geologist Griffith Taylor had given a lecture on physiography, Scott said that he thought the field too novel to be accepted at once and wanted to hear if it agreed with established principles of geology. The next morning, however, he came to Taylor in a whirl: 'Taylor, I dreamed of your lecture last night. How could I live so long and not know something of so fascinating a subject?'[40] Scott himself wrote and gave a paper on 'The Great Ice Barrier and the Inland Ice'.[41] He might not have studied for scientific credentials but he possessed a scientist's mind, questioning and precise. Even when he was worrying about his pole plans Scott was concerned about this part of the programme. Having given his polar briefing to his team, Scott was overheard talking to Wilson by Debenham: 'That's that, but by Jove, Bill, won't it be fun when we have got all this out of the way and can do some real scientific work!'[42]

It was during these winter lectures that Ponting's status on the expedition greatly improved. Ponting showed his photographs of Japan and the more recent results of his Antarctic efforts to date. It was as if this photographic artist had just taken the sheet off a finished canvas – his colleagues were stunned. With Ponting behind the best available cameras of the day, a whole new dimension to the recording and understanding of the Antarctic was under way. Scott's vision was being fulfilled beyond his own wildest expectations.

Ponting had already given some photographic lessons to members of the expedition, principally to biologist Murray Levick, before he had headed off to winter with the Eastern Party, in much the same way as Wilson gave lessons in sketching techniques. What Ponting now succeeded in inspiring, however, was something different: an explosion of excitement and interest in photography among the officers and scientists at Cape Evans. He had opened their eyes to the possible, along with the realization that Ponting was only one man and could not be everywhere. If the standard of the photographic work on future scientific field parties was to be up to scratch, then further training in the proper professional use of the photographic field equipment was needed.

[*Scott*] *came to my room one day and told me he realised that it would largely devolve upon himself to illustrate the Polar journey. Then, in that nice way in which he always asked a favour of anyone, he said that I should render a very great service to the Expedition if I would take him and a few others in hand, and coach them in photography. I replied that nothing would give me greater pleasure …*[43]

The expedition went photography-crazy and Jonahs be damned. Ponting had a veritable queue of eager pupils. Leading the way, his excitement barely confinable, was Captain Scott himself.

The freezing of the sea. Looking to Cape Barne from Cape Evans, mirage effect, 3 March 1911 (Ponting A29)

This haunting image is full of majestic melancholy. By placing the camera at this spot, Ponting invites the viewer to feel the isolation of Scott and his men, who now will face the wrath of an Antarctic winter without communication from the outside world.

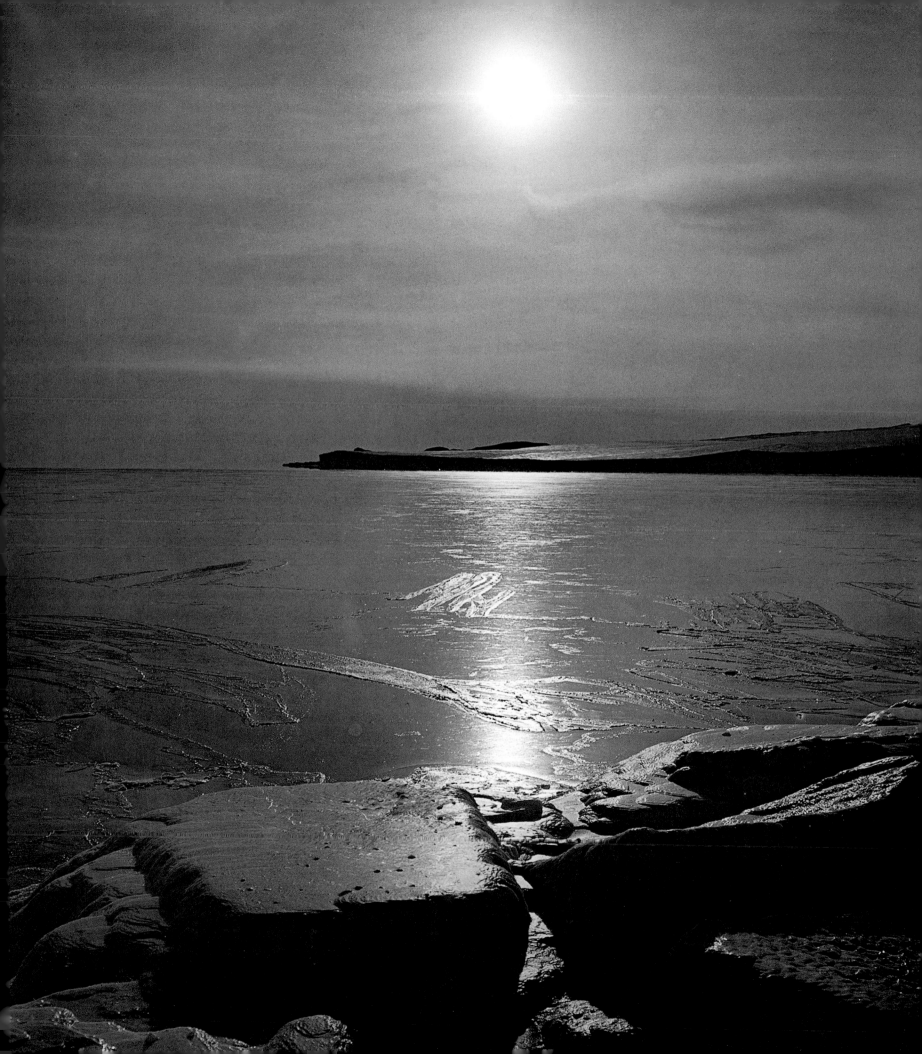

THE WESTERN COAST OF ROSS ISLAND

Scott set up his base at Cape Evans, which was named for his second-in-command. Many of the features marked are shown in the Scott photographs, or are referred to in the accompanying narrative. Cape Evans, Cape Barne and Mount Erebus feature prominently.

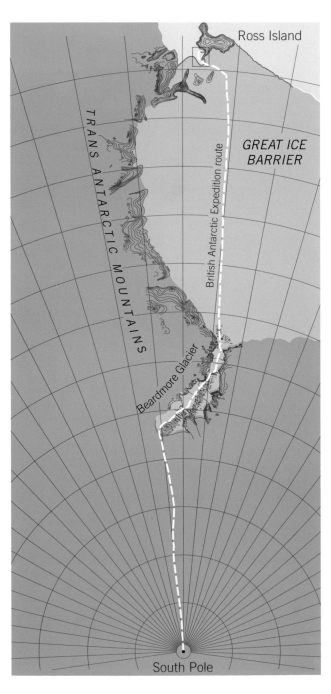

Ross Island

GREAT ICE BARRIER

British Antarctic Expedition route

TRANS ANTARCTIC MOUNTAINS

Beardmore Glacier

South Pole

Small box on inset map shows location of area on map opposite

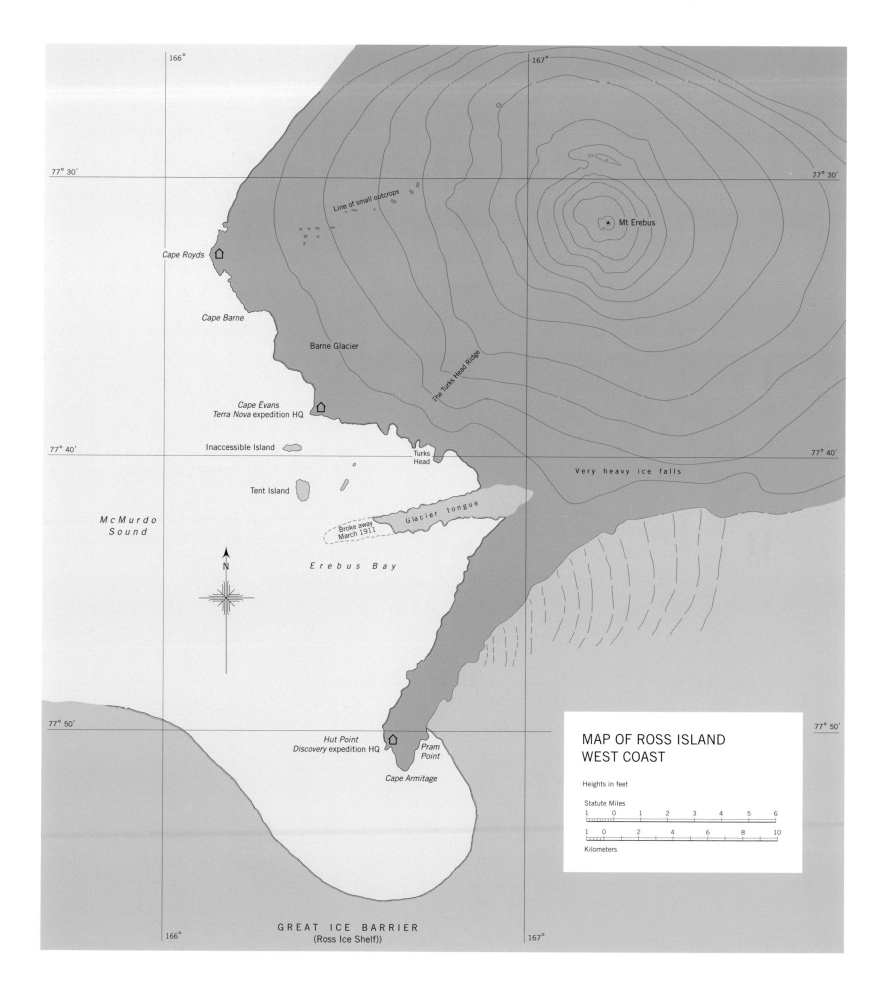

166° 167°

77° 30' 77° 30'

Line of small outcrops

Mt Erebus

Cape Royds

Cape Barne

Barne Glacier

The Turks Head Ridge

Cape Evans
Terra Nova expedition HQ

Inaccessible Island 77° 40' 77° 40'

Turks
Head

Very heavy ice falls

Tent Island

*McMurdo
Sound*

Glacier tongue

Broke away
March 1911

Erebus Bay

N

77° 50' 77° 50'

Hut Point
Discovery expedition HQ

Pram
Point

Cape Armitage

MAP OF ROSS ISLAND
WEST COAST

Heights in feet

Statute Miles

| 1 | 0 | 1 | 2 | 3 | 4 | 5 | 6 |

| 1 | 0 | 2 | 4 | 6 | 8 | 10 |

Kilometers

GREAT ICE BARRIER
(Ross Ice Shelf))

166° 167°

well. Scott's plans were not designed for speed, but simply to attain the pole, and he knew that failure to achieve his primary objective would undermine all his other work: the public and the press were baying for the pole, not scientific discoveries. Regardless, Scott intended to fulfil his promise to the British public by planting the flag at the pole and to conduct a full programme of scientific exploration, for all that it might cost his reputation dear. In a somewhat prescient note he wrote:

I don't know what to think of Amundsen's chances. If he gets to the Pole, it must be before we do, as he is bound to travel fast with dogs and pretty certain to start early. On this account I decided at a very early date to act exactly as I should have done had he not existed. Any attempt to race must have wrecked my plan, besides which it doesn't appear the sort of thing one is out for … Possibly you will have heard something before this reaches you … I'm afraid you must be prepared for the chance of finding our venture much belittled …[7]

Scott continued with his preparations: 'After all, it is the work that counts, not the applause that follows.'

There was a great deal to accomplish and little time to do it in. To ensure that the best possible photographic record was achieved, Ponting gave his time and advice generously to all, but perhaps most of all to Scott. During their photographic excursions and over hours in the darkroom, they became firm friends. Fine days around Cape Evans witnessed all of Ponting's pupils out and about, struggling to master the complex process of taking photographs, and this in between making final preparations for the forthcoming season's sledging parties. Limited time for photography was a fact of life for all and would be more so out in the field. Ponting knew it and was quick to pass on as many techniques to deal with these challenges as he was able.

Knowing the importance of the Polar and other journeys being thoroughly illustrated, I spared no effort to communicate every short cut to efficiency that I knew. With such exceptional 'pupils', remarkably fine results were soon being produced by all.[8]

The progress of Ponting's pupils was rapid. It is unclear that any of Scott's extant photographs date from this earliest two weeks of training, but within that time Scott and Bowers became confident enough to take the cameras on a field trial without Ponting. Photographic forays around Cape Evans were a necessary aspect of training but Scott knew very well that they were not sufficient. The Antarctic is an unforgiving place and wherever possible Scott tried to ensure that every aspect of the sledging rations and equipment was tested in the field and improved upon: three variations of field rations had been tried out during the Winter Journey made

by Wilson, Bowers and Cherry Garrard to Cape Crozier, and the results analysed to produce the best rations practicable, while the Pole Journey plans were based on an analysis of weather data by his meteorologists.[9] Scott's approach to the photographic operation developed by Ponting was similar: it needed to be tested in the field, not simply around the hut. It would be no use, once miles from Cape Evans, to find that some critical aspect of training or equipment was insufficient.

To-day I have been trying a colour screen – it is an extraordinary addition to one's powers. Tomorrow Bowers, Simpson, Petty Officer Evans, and I are off to the West. I want to have another look at the Ferrar Glacier, to measure the stakes put out by Wright last year, to bring my sledging impressions up to date (one loses details of technique very easily), and finally to see what we can do with our cameras. I haven't decided how long we shall stay away or precisely where we shall go; such vague arrangements have an attractive side. [Thursday 14 September 1911]

No doubt the Spring Journey did provide Scott with the short break that his diary hints that he was keenly anticipating. He was obviously looking forward to seeing the region of the Ferrar Glacier once again. No doubt, too, he was genuinely interested in Wright's glacial stakes and how far they might show that the glacier had moved.

But for all of his end-of-winter spirits in his diary, the journey had serious intent. Scott was ensuring that the camping, sledging and photographic operations were fit for purpose and that he himself was fit for the trail. In the course of this he was also able to resupply the depots for the forthcoming explorations of the Western Party. He was also testing his men. His diary is full of his positive analysis of their performances; in particular, he was constantly impressed by Bowers. The Spring Journey did not occur in isolation, however: short-distance sledging parties were out in force at this time, trail-hardening men and animals, topping up supplies at depots, executing surveying work and testing cameras or other equipment.

In the end the Spring Journey lasted for thirteen days. The party covered 152 geographical miles (281 km) over ten sledging days, a progress of just over 15 miles (28 km) daily. The glacial stakes had been duly measured and shown to have moved between 24 and 32 feet (7–10 metres) in seven months. Scott was delighted, too, with their photographic achievements:

Bowers and I exposed a number of plates and films in the glacier which have turned out very well, auguring well for the management of the camera on the Southern Journey. [Sunday 1 October 1911]

Nevertheless, he was still inexperienced as a photographer and his results were not all as successful as he would have wished.

After noon on the 25th we made a direct course for C. Evans, and in the evening camped well out in the Sound. Bowers got angles from our lunch camp and I took a photographic panorama, which is a good deal over exposed. [Sunday 1 October 1911]

Thirteen of Scott's photographs from the Spring Journey have survived, including the photographic panorama mentioned by Scott in his diary. The series of three photographs taken from the sea ice of McMurdo Sound looks back towards the Western Mountains and the Ferrar Glacier, from the Blue Glacier to Cape Roberts (S2, S9, S122, panorama, pp. 98–9). Just as Scott states, it is overexposed but nonetheless very interesting. This is Scott's first attempt to capture on film the landscape panoramas which Wilson so successfully drew with his pencil. Except at Scott's specific request, Ponting rarely took panoramas; perhaps they disturbed his sense of aesthetic composition. Several of Ponting's pupils did take them, however, encouraged, maybe, by Scott's own first example. Many of Scott's later panoramas were very successful and some can be compared to Wilson's drawings of the same features. These confirm the accuracy of Wilson's pencil. Nevertheless, a good photograph of geological features allows for greater accuracy of detail than even the best sketch and is also more easily reproduced and disseminated, all leading to the camera transcending the pencil. However, this only became possible post-Ponting. Prior to his influence, polar photography had tended towards the delivery of insufficiently good images, of which Scott's Spring Journey panorama is not untypical.

The Spring Journey photographs show features familiar to Scott and named by his *Discovery* expedition: the sweeping Ferrar Glacier (S4, p. 89); the Royal Society Range with the Overflow Glacier (S3, p.10); or the Cathedral Rocks (S7, pp. 12, 95). The Kitticarrara Glacier (S6, p. 93; S112, p. 90) was newly named, however, by a geological party the previous autumn for a sheep station in New South Wales. Frank Debenham was running out of names for newly discovered geographical features. It caused some dispute between members of the party, with Petty Officer Evans in particular believing that it broke the 'rules' on feminine naming. It was allowed at the time, but Scott's death meant that such names were never replaced, leaving the temporary designations as permanent features on Antarctic maps.[10] It is tempting to think that Scott might have been thinking of a new epithet as he photographed it but there is no proof. It is more likely that he was entirely concentrating on getting his exposures right. The photographs of the Spring Journey show that in a couple of weeks, Scott had already achieved a standard of photography equivalent to that of previous expeditions.

To be of any use, it was not only the process of taking such photographs that needed to be meticulous. The photographer ideally needed to make notes on location, conditions, exposures and settings to ensure that Ponting would be able to develop them to best advantage when the plates or films were returned to base for him to develop, or, in his absence, to Debenham, who was rapidly turning into his star pupil and photographic deputy. Such commentaries also ensured that the pictures were properly labelled and so fit for scientific purpose. If such reports were ever written by Scott they are not thought to have survived. He often made annotations in his diary, noting when he took photographs, but not always. Scott and Bowers frequently photographed together, however, and some of Bowers's meticulous records have survived, providing insight into Scott's work.

List of photographs taken: 21st September …

10. Kitti Glacier – sun in larva – glacier in shadow – 32F 4 secs
11. Film. Up Glacier Cath. rocks etc. Sight bad – same exp
12. Overfloe – Sun in it but fog 32F 3 secs – [11]

Ironically, while some of Bowers' notes for Ponting have survived, many of his photographs appear not to.

On their return to Cape Evans only a few weeks remained before the departure of the main summer parties. Preparations became increasingly intense and Scott was able to polish the finer points of photography with Ponting only as time permitted. The surviving photographs taken by Scott around Cape Evans represent a few hours' work over several days, but they provide a wonderful record of this period. Scott would often go photographing with Ponting himself, so many of the Scott photographs of October 1911 can be cross-referenced to Ponting's. In some images, Ponting can occasionally be seen photographing away himself (e.g. S116, p. 190), as can Scott, where he has caught his own shadow in the image (e.g. S100, p. 73). More often, Ponting is the principal subject of his pupil's efforts. Scott's sequence of Ponting photographing as a blizzard descends around him is an astonishing study of the master photographer at work (S13 sequence, pp. 11, 58). It also provides one of the most graphic illustrations by any photographer of the way climatic conditions affect ordinary tasks in the Antarctic. Other studies by Scott of Ponting photographing at the foot of Mount Erebus (S18, p. 10; S19, pp. 34–5) are worthy of Ponting himself: a classic piece of landscape photography, showing a considerable improvement from the Spring Journey photographs.

It is unclear when the Mount Erebus sequence, along with the photographs taken along the Ramp (the morainic outcrop linking Cape Evans to Mount Erebus), were taken. Possibly it was on 6 October, when Scott wrote:

The photography craze is in full swing. Ponting's mastery is ever more impressive, and his pupils improve day by day; nearly all of us have produced good negatives. Debenham and Wright are the most promising, but Taylor, Bowers and I are also getting the hang of the tricky exposures. [Friday 6 October 1911]

However, Sunday 8 October 1911 was a significant day for expedition photography for several reasons. Scott noted in his diary:

A very beautiful day. Everyone out and about after Service, all ponies going well. Went to Pressure Ridge with Ponting and took a number of photographs. [Sunday 8 October 1911]

The pressure ridge extended across the sea ice to the Barne Glacier and provided an interesting ice subject for a photographic tutorial, not least because what was being photographed was the form of ice. This sequence of the Scott photographs (S26, p.74; S80, p. 81; S81, p. 82–3) is remarkable not so much for the quality of the images, although in the intense glare of the sun on the snow they are an achievement (and this was clearly the challenge), but because they can be matched up so perfectly with Ponting's images of the day. So we have Ponting's images of Captain Scott photographing (Ponting 344 with Scott, pp. 24–5), alongside Scott's image of Ponting photographing (S26, p. 74; S81, p. 82–3), along with the photographs that they both took of the ice crack (Ponting 190, p. 80 without Scott; S80, p. 81), Scott's image having the empty plate holder intruding into the picture. It is almost possible to hear the great photographer coaching Scott regarding the techniques of photographing in such intense glare as they walk the ice together. It is clear, too, that Ponting enthusiastically shared a vision for photographing shape and form, rather than vista, so Scott was being taught at the cutting edge of modern photography.

Having returned to the hut, no doubt pleased with his morning's tutorial, Scott continued with other work. The weather was so good, however, that Ponting went out and continued photographing. With him he took Clissold, the cook, who posed for Ponting on an iceberg, known as the Matterhorn Berg, frozen solid in the sea ice. Ponting was in the middle of taking a series of wonderful photographs when catastrophe struck. With a dull thud, Clissold fell off the berg and suffered serious injury resulting in concussion. It was fortunate that he wasn't killed. The injury to Clissold was

serious enough that he wasn't fit to sledge and Scott had to revise his plans and replace him in the Southern Party.

Scott and Ponting were both busy with their cameras again on 16 October, this time Scott practising alongside Ponting at taking photographs of dogs, men and ponies. Many of their images correspond, once again, and so may be cross-referenced. Not every portrait taken by Scott was up to the mark. The occasional head is cut off, but some of them are fascinating. Against a portrait of Captain Oates, which is imperfect (S58a, p. 188), must be placed one of the best portraits of Captain Oates taken on the expedition (S58, p. 61).

Scott's developing portfolio up to this point shows that he had a natural photographer's eye, sharpened by Ponting's tuition. In the series of photographs taken on 16 October, this emerges even more strongly. Scott began to capture a side of the expedition which Ponting rarely bothered about with his still cameras. Ponting liked his photographs carefully composed and thought out, leaving unposed action sequences for the cinematograph. On the journey south, however, there would be no cinematograph and Scott's work starts to show an emerging interest in the action photograph, rather than in landscape or portraiture. Perhaps they are indicative of aspects of his character, of his desire to rise to the toughest challenge and to capture the excitement of the moment. This was technically difficult photography for the time, hugely demanding even for a professional photographer. Pictures with a moving subject were particularly hard to achieve. Some of Scott's action sequences around Cape Evans are, no doubt, at least partly posed, such as the Ponting blizzard series (S13, pp. 11, 58–9). However, the series of the pony Victor bolting during training with the sledges (S107, p. 66–7; S115, p. 68), with Bowers and the groom, Anton, desperately trying to hang on, is Scott's first attempt to capture 'live action' on a still camera. The movement of the pony and sledge rushing at speed over the snow is wonderfully captured. It also brings aspects of the expedition diaries to life.

The ponies are in fine form. Victor, practically recovered from his wound, has been rushing round with a sledge at a great rate. Even Jehu has been buckish, kicking up his heels and gambolling awkwardly. [Tuesday 24 October 1911]

The high-spirited ponies were often a challenge to their handlers and were a constant worry both to Oates, who was in charge of their care, and to Scott, who was increasingly relying on them for the success of his polar logistics. The ten ponies that had survived into 1911 – Bones, Michael, Snatcher, Nobby, Jehu, Christopher, Jimmy Pigg, Chinaman, Victor and Snippets – emerge as wonderful characters in Scott's diary, as he worries about their every cough, splutter

and whim. They also emerge as the stars in many of Scott's photographs, providing him with endless new subjects, of which his new and evolving interest in 'reportage' was the most notable. Action shots were to become Scott's most important photographic contribution and in these, perhaps more than any other, we see the expedition with Scott's own eyes.

The curse of the camera struck again a few days later. Football had been avoided, to avert unnecessary injury to expedition members at the start of the sledging season. However, Ponting persuaded Scott to have a match for the cameras on 21 October. During the game Frank Debenham suffered a knee injury, which was serious enough to postpone the departure of the Western Geological Party. In fairness, it was the recurrence of an old injury and Ponting had stopped filming by that point, but that didn't stop the gossip growing towards a storm. Ponting began to find the teasing somewhat exacerbating:

The whale incident had, of course, inspired numerous quips about Jonah … This latest mishap revived all the former quizzing about the evil-eye propensities of my camera, and I was once again the butt for no end of twittering about 'the peril of "ponting" for Ponko' … the more I protested … the more persistently these crimes were fastened on to me. But such railleries were always good-natured, and everyone in the Hut was subjected to them whenever the slightest occasion presented.[12]

Nevertheless, many a joke masks a serious friction, diffusing anxiety and quieting unconscious discomfort. Most sailors feared the Jonah and the obvious parallels with the Jonah story cannot have escaped anyone's attention: travel to a far-off land, the storm, the whales. Such a string of coincidences along with the various accidents around the cameras must have seemed increasingly threatening and a real Jonah a convincing prospect for the superstitious mind. Were these the warnings of God himself? Even Scott began to quibble about the casualty rate of the photographic programme.

Perhaps it is as well that all was now ready for the departure of the season's sledging parties, and, in particular, the party that was going to claim the South Pole for the British Empire. Only one last piece of training remained to be accomplished:

When Scott was able at length to secure good results with colour-filters, orthochromatic plates and telephoto lenses, his pleasure was very real indeed; for then he knew he was capable of dealing with any subjects he would meet with on the Beardmore Glacier. Finally, he and Bowers were shown how to release the shutter by means of a long thread,

so that all who reached the Pole might appear in the group to be made at the goal.[13]

Ponting could do no more. His pupils were ready.

51

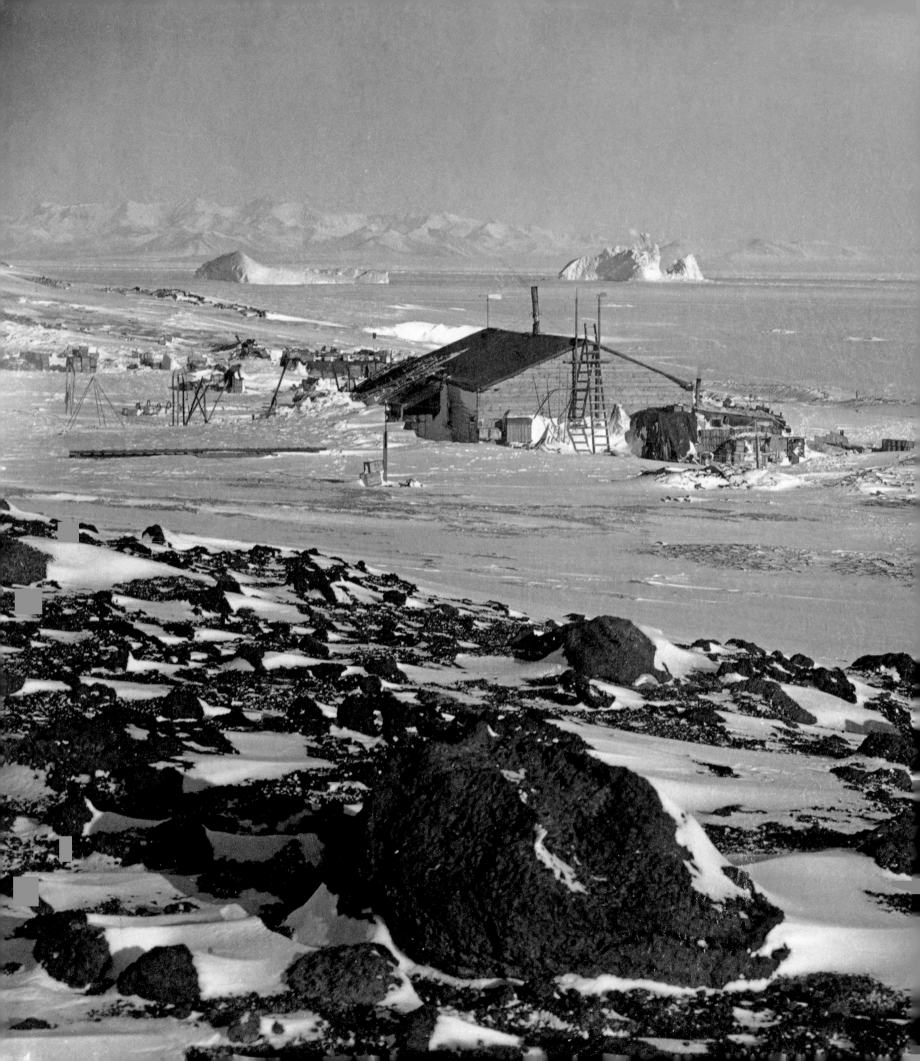

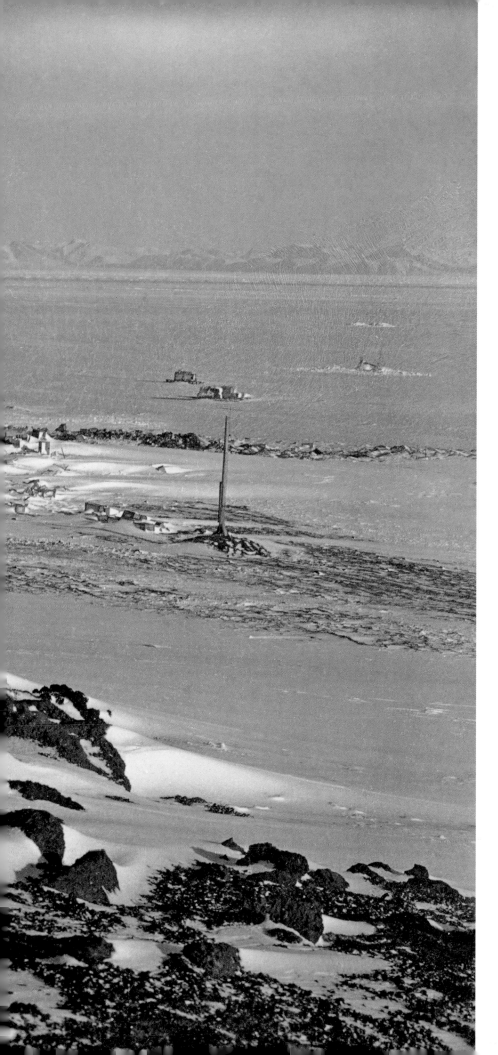

View of the base hut at Cape Evans from the Ramp, looking towards the Royal Society Range, October 1911 (S20)

Scott's remarkable photograph of the Cape Evans hut early in the Antarctic spring delivers one of the great images of the expedition's winter quarters. The icebergs frozen into McMurdo Sound provided Ponting and Wilson with the subject of some of their best-known photographs and paintings over the preceding winter. Also visible are sledges packed with stores, perhaps for pony training, and the scientific field stations on the sea ice.

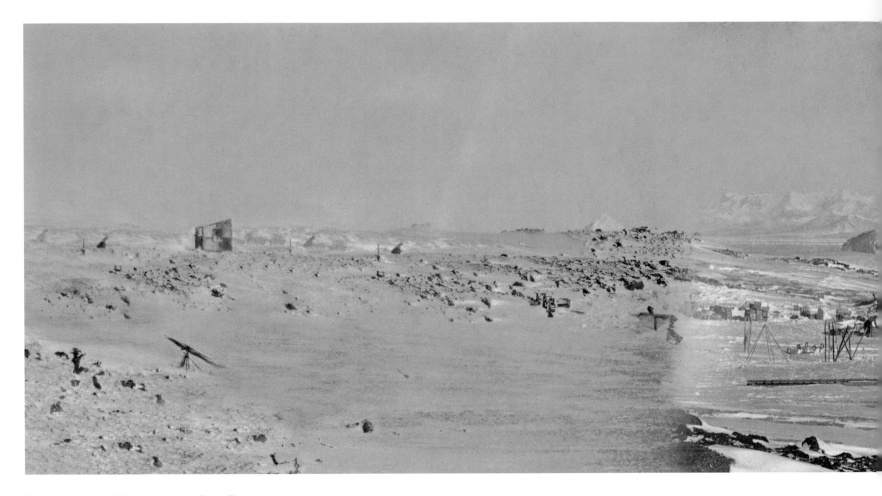

Panoramic view of the base hut at Cape Evans,
looking towards the Royal Society Range, October 1911
(S20 and S12)
..

Ponting's perfect landscape photography appears to have
been too confining for Scott. Early in his training Scott started
to take sequences of photographs to form a panorama,
which demonstrated more easily the overwhelming scale of
the Antarctic scenery. Ponting rarely attempted this unless
specifically requested to do so by Scott. It probably disturbed
Ponting's sense of composition, as some distortion is almost
inevitable in such photography.

Learning to take such panoramas proved a challenge. This
one of Cape Evans, giving a full view of the winter quarters
from Wind Vane Hill and the scientific huts on the left, is
not cleanly joined and the exposure of the two photographs
is not even. However, when edited, the picture provides
a testament to Scott's photographic vision. The hut is set
against the magnificent icy wilderness of the Antarctic, giving
a palpable sense of the isolation of man on the edge of a vast
unknown continent waiting to be explored. Most of the Scott
photographs are reproduced here with only minor editing.
This is the exception, as despite its faults it provides an
important historical perspective.

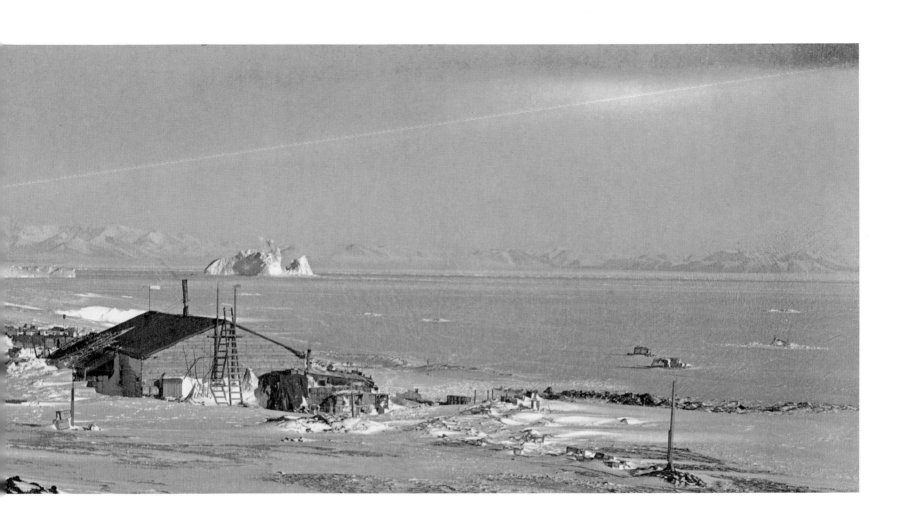

Winter quarters, October 1911 (S54)

..

The hut at Cape Evans, showing the large number of stores stacked outside, including dozens of sledges leaning against the roof, boxes of Fry's cocoa and a bath tub. Such photographs provide a valuable record today, but were principally taken by Scott to practise using lenses, filters and other apparatus. Once on the trail to the pole, and under pressure from time and conditions, only considerable familiarity with the equipment would deliver the quality of image required for scientific purposes. Even in the learning process, Scott gives us an intimate picture of the amount of organization required for his men's survival in the Antarctic.

Overleaf:
Herbert Ponting working his cinematograph in Antarctic conditions, October 1911 (sequence S13, S13a, S13b, S76, S75)

..

As Scott's skills developed, he started to experiment with action photography, not an area in which Ponting much engaged, leaving moving scenes to his cinematograph. That Scott aimed to capture the moment in his photographs, regardless of the extra technological challenges it posed, suggests a desire to meet every challenge. His resulting pictures are unique, graphically illustrating the difficulties which the expedition faced in completing its work; in this case, a flurry of blown snow-powder creating a whiteout, enveloping Ponting. Although this sequence might have been posed to enable Scott to learn the necessary techniques, such moments were also part of everyday Antarctic life.

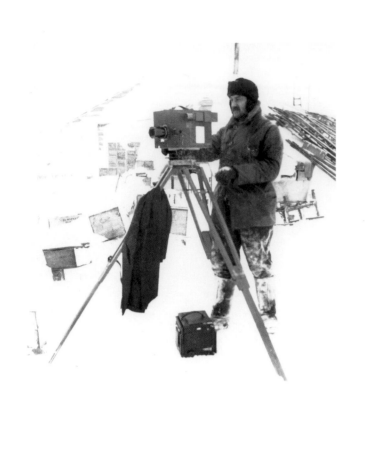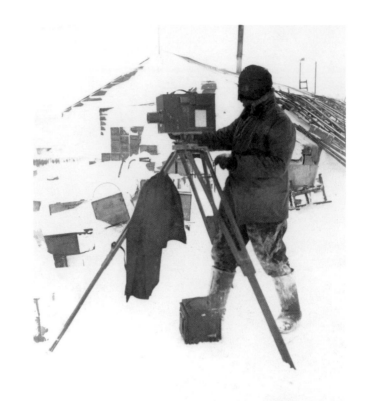
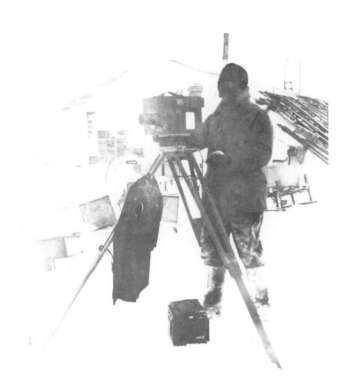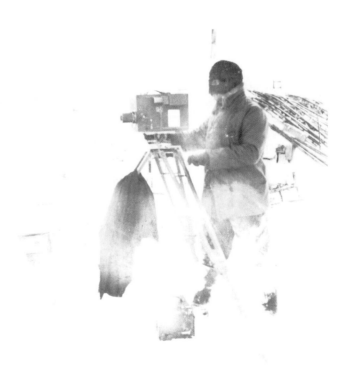

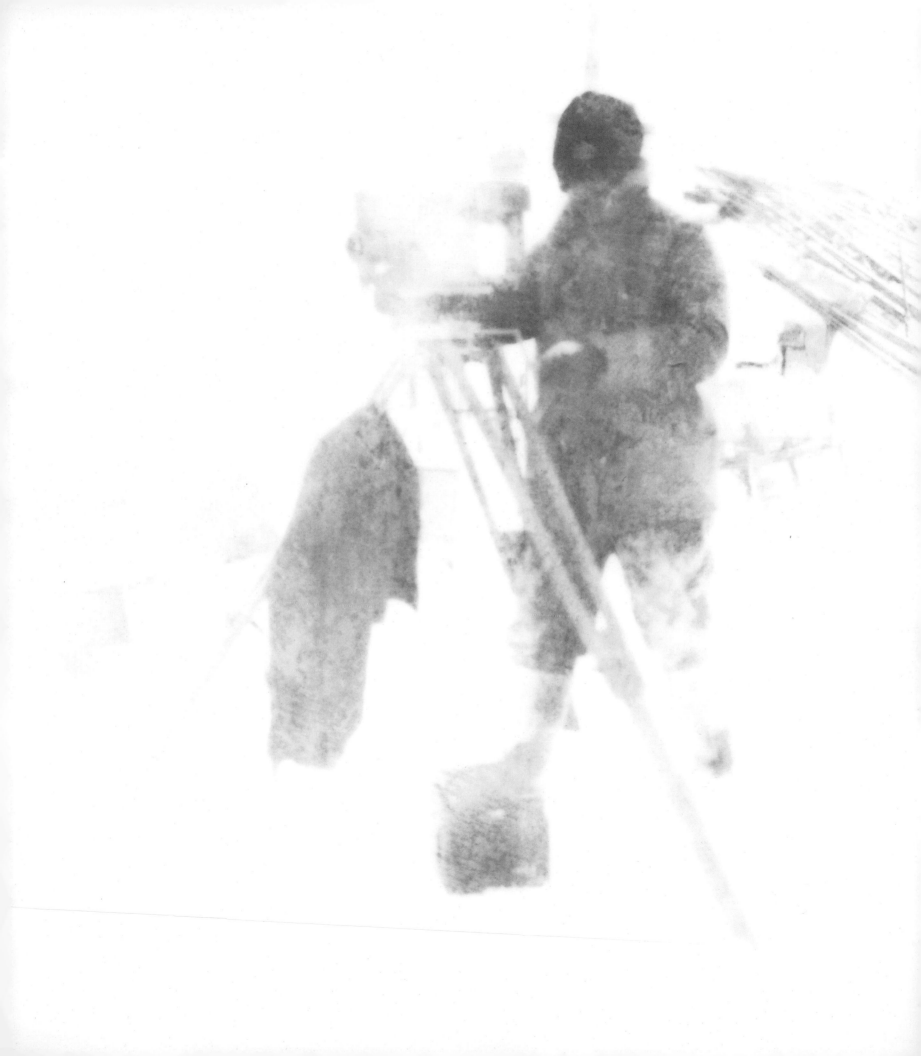

Henry 'Birdie' Bowers in front of Mount Erebus,
October 1911 (S24)

···

Scott has photographed Bowers with a sledge of supplies.
The hut may be seen to the left of the photograph. The
general line of the Ramp lies behind him, with Mount Erebus
in the distance. Bowers was in charge of expedition stores.
His organizational abilities so impressed Scott that he was
kept on with the Shore Party and eventually included in the
Pole Party.

This is a classic piece of landscape photography, with the
scattered stores in the foreground echoing the shape of
Erebus, while the figure of Bowers leads the eye to the great
mountain. Such photographs show the rapidity with which
Scott absorbed Ponting's tutelage.

Portrait of Captain L. E. G. Oates, October 1911 (S58)

···

Ponting taught Scott and his other pupils as much as he
could of the photographic arts in a few weeks. Portraiture
was something at which Ponting excelled. Scott made
two portraits of Oates (S58 and S58a) achieving a
remarkable image in both, but only achieving the correct
exposure in this one.

Captain Oates was from the 6th Inniskilling Dragoons and
in charge of the ponies, which he thought were a bunch
of 'crocks'. Nevertheless, their performance exceeded
expectations, in large part due to his care.

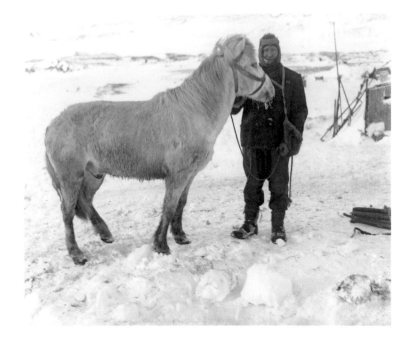

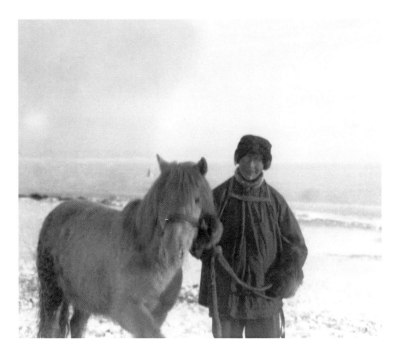

Top left and bottom right:
PO Keohane with Jimmy Pigg (S17; S104)
..

Top right:
PO Evans with Snatcher (S16)
..

Bottom left:
Apsley Cherry Garrard with Michael, October 1911 (S106).
..

Exercising the ponies became one of Scott's favourite subjects for practising his skills. He could experiment with different exposures, timings, lenses and filters and learn how to use them effectively. He frequently worried about the ponies, their every ailment causing him concern, particularly as his transport plans changed focus. Increasingly he came to rely on the ponies, rather than dogs or his experimental motor sledges, to deliver the necessary logistic support to get to the pole.

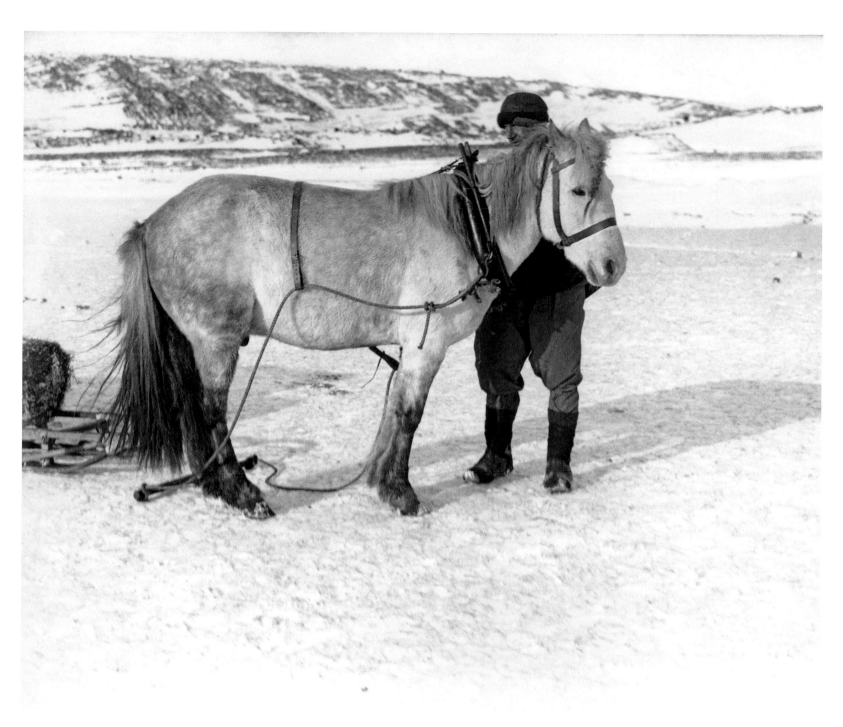

Dr Edward Wilson with Nobby at Cape Evans,
October 1911 (S23)

All the ponies were assigned a specific team member for the
Southern Journey. Throughout the early spring each man
had to exercise his pony regularly with its sledge so that the
ponies got used to their handlers and sledges before leaving
for the South Pole. Here, chief of the scientific staff Dr
Edward Wilson is preparing to exercise Nobby.

Overleaf:
PO Tom Crean with Bones in blowing snow. Dr Edward
Wilson is in the background with Nobby. Cape Evans,
October 1911 (S118)

Irishman Tom Crean was a stalwart of both of Scott's
Antarctic expeditions and later also voyaged to the Antarctic
with Shackleton. He would be awarded the Albert Medal for
saving the life of Lieutenant Evans during the return of the
Second Supporting Party of the Southern (Pole) Journey.

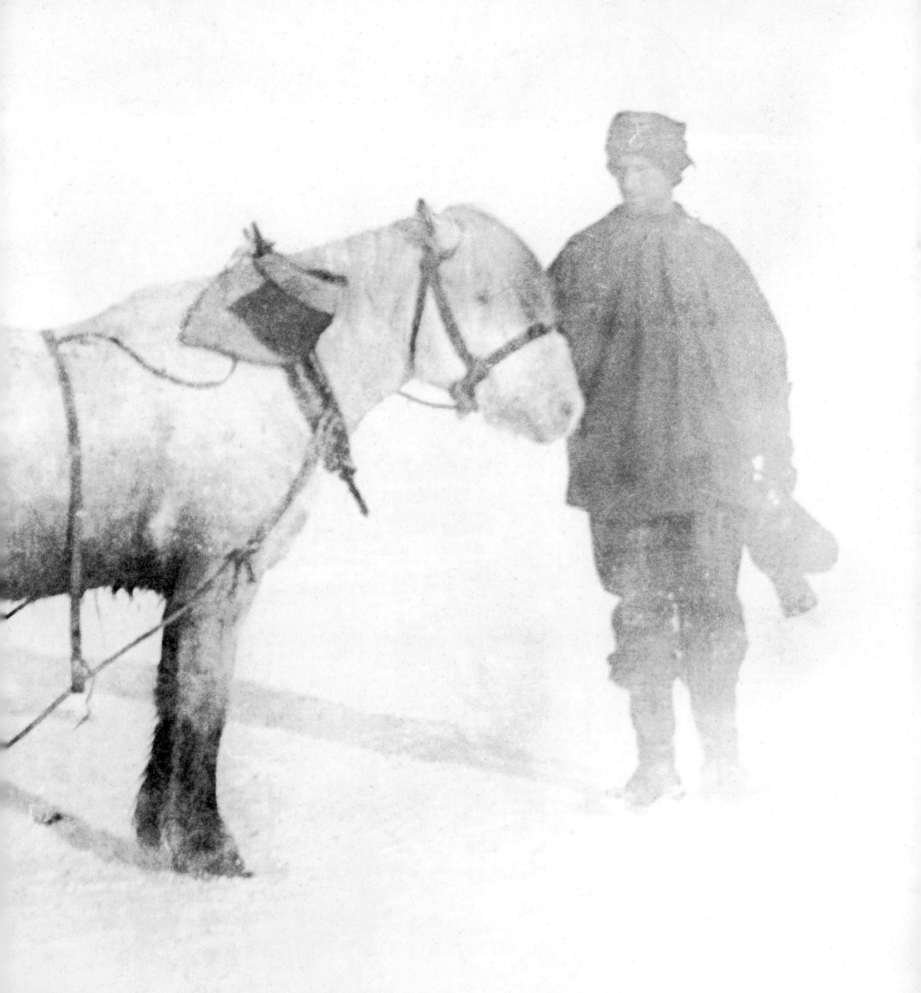

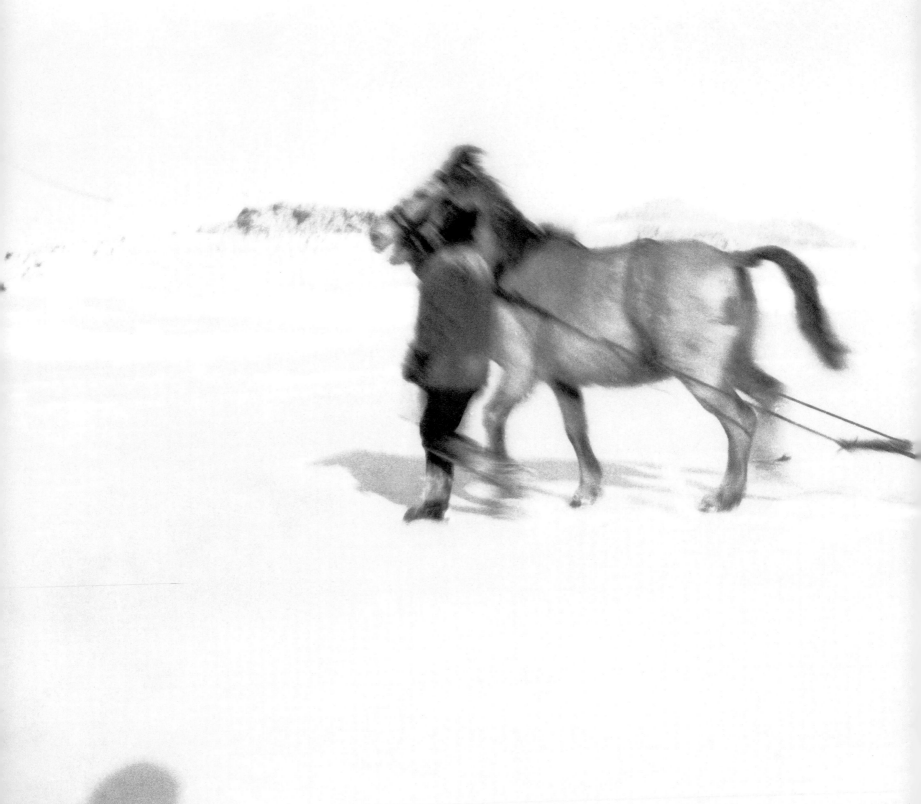

Birdie Bowers chasing Victor. Cape Evans, October 1911
(S107)
···

The ponies are in fine form. Victor, practically recovered from his wound, has been rushing round with a sledge at a great rate. Even Jehu has been buckish, kicking up his heels and gambolling awkwardly.
[Tuesday 24 October 1911]

Scott has caught his shadow in the bottom left of the image – one of the pitfalls of taking pictures in the bright Antartic sunlight.

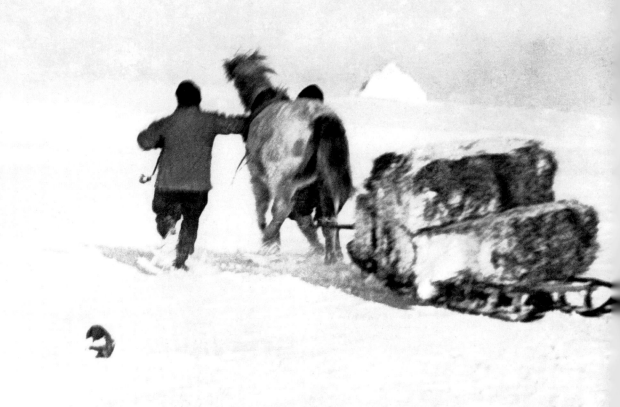

Birdie Bowers and Anton Omelchenko, chasing Victor.
Cape Evans, October 1911 (S115)

It would be hard to find a finer example of Scott's developing taste for action shots and his increasing skill in taking them. In the second image in this action sequence, Bowers and Anton, the Ukrainian groom, can barely control Victor, Bowers' runaway pony. The ponies were skittish after the long Antarctic winter and took time to refamiliarize themselves with the traces. This photograph illustrates better than any other the speed at which ponies and sledges could move across firm, smooth ice. Unfortunately, these were not the conditions Scott was to meet on his march to the pole.

The scientific observation station on top of Wind Vane Hill,
Cape Evans, October 1911 (S77)
...

Significant strides were made in the understanding of
Antarctic meteorology and Southern Hemisphere weather
patterns due to the work of meteorologist George Simpson.
Instrument stations such as these were set up in several
locations and records kept throughout. Scott's personal
interest in the scientific work was considerable; he even gave
a scientific paper during the winter lecture series at Cape
Evans. Scott's photography was a way for him to engage
personally in this aspect of the expedition.

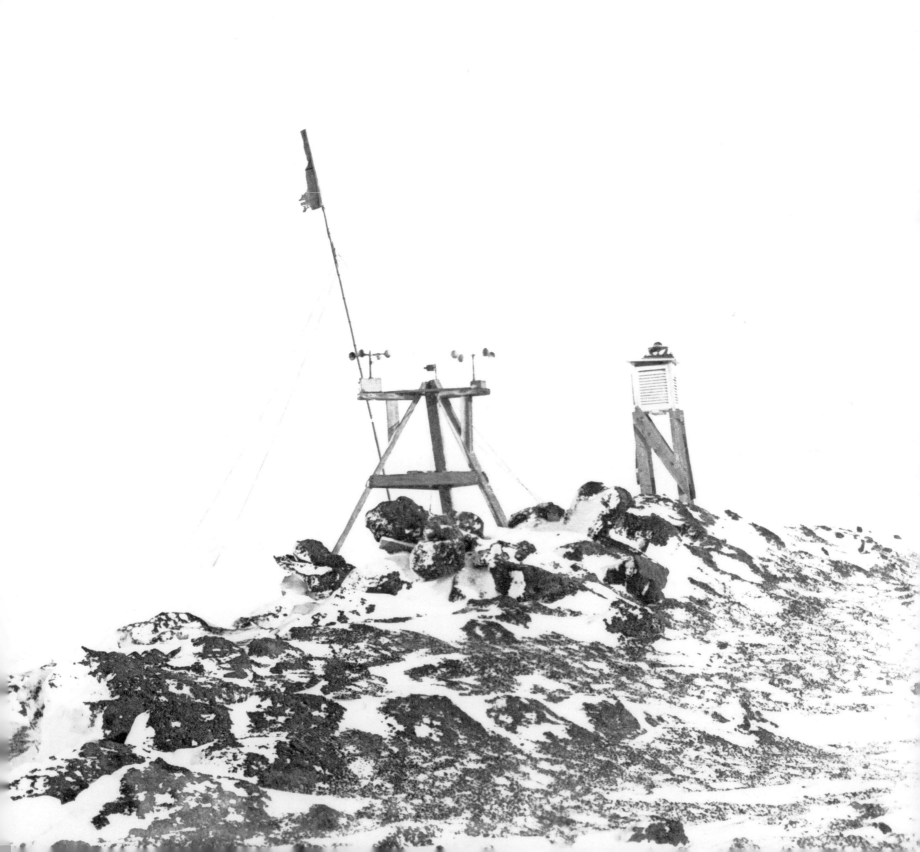

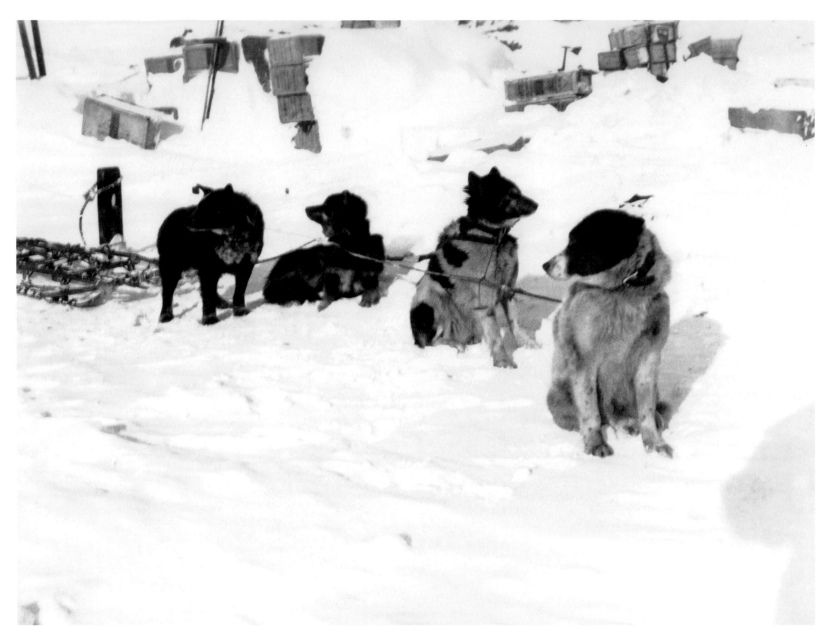

A dog team in training, Cape Evans,
October 1911 (S101)

Scott initially intended to use dogs to reach the South
Pole, and he brought some experienced dog drivers with
him. He only changed his mind when he realized he
would not get them safely over the severe crevasses of the
Beardmore Glacier on to the Polar Plateau. As he wanted
to preserve the dogs for important scientific endeavours the
following season, he began to rely more heavily on the
ponies instead.

Probably Demetri Gerof training a dog team, Cape Evans,
October 1911 (S100)
...

Although Scott's was a British expedition, it had support
and personnel from ten countries, making it an international
effort. The two members from the Russian Empire, dog driver
Demetri Gerof and Ukrainian stable hand Anton Omelchenko,
provided lively dance entertainments on festive occasions.

Herbert Ponting at work on the sea ice near Cape Evans,
8 October 1911 (S26)

Ponting was often the subject of Scott's practice shots,
and is seen here changing plates. The amount of heavy
photographic equipment used on even a short trip is clearly
shown in this photograph, while the icing up around Ponting's
clothing is an indication of the low temperatures in which
they often had to work.

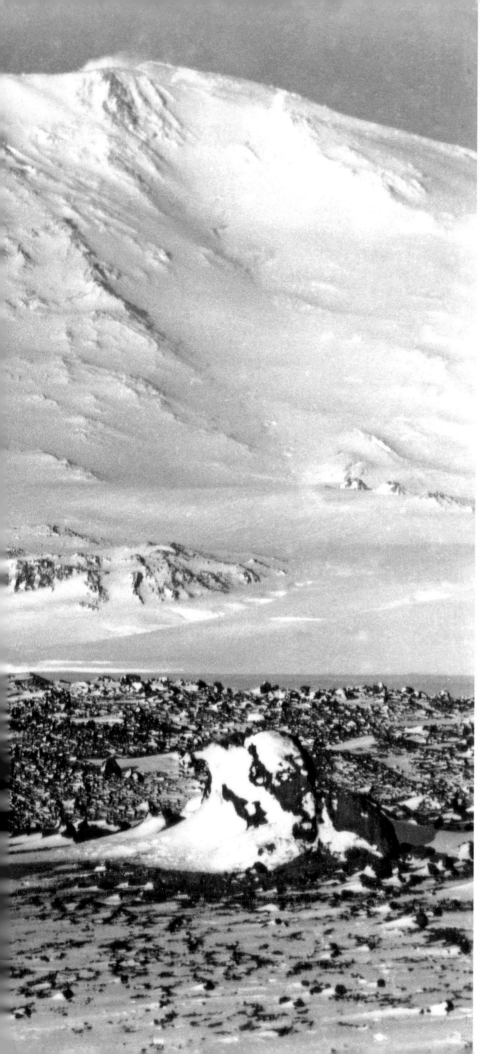

Mount Erebus from the Ramp, October 1911 (S22)

It was almost inevitable that Scott would take photographs of Mount Erebus, as the famous volcano dominated the landscape around his Cape Evans headquarters. Using a favourite technique learnt from Ponting, Scott has chosen the rocks in the foreground to reflect the shape of Erebus's peak.

The two main volcanoes of Ross Island had been named Erebus and Terror after the ships of Sir James Clark Ross's 1839–43 Antarctic expedition. This was the very edge of the known world until Scott arrived at the foot of Mount Erebus on his first Antarctic expedition aboard *Discovery*.

An ice field on the lower slopes of Mount Erebus,
October 1911 (S79)

Scott was not only tutored by Ponting in traditional ideas and
techniques but was also shown the cutting edge of modern
aesthetics, with its exploration of form, shape and texture.
This proto-modernism, which developed in Ponting's work
while in the Antarctic, is clearly something he discussed
with Scott, as witnessed by several of Scott's images and by
comments in his diary.

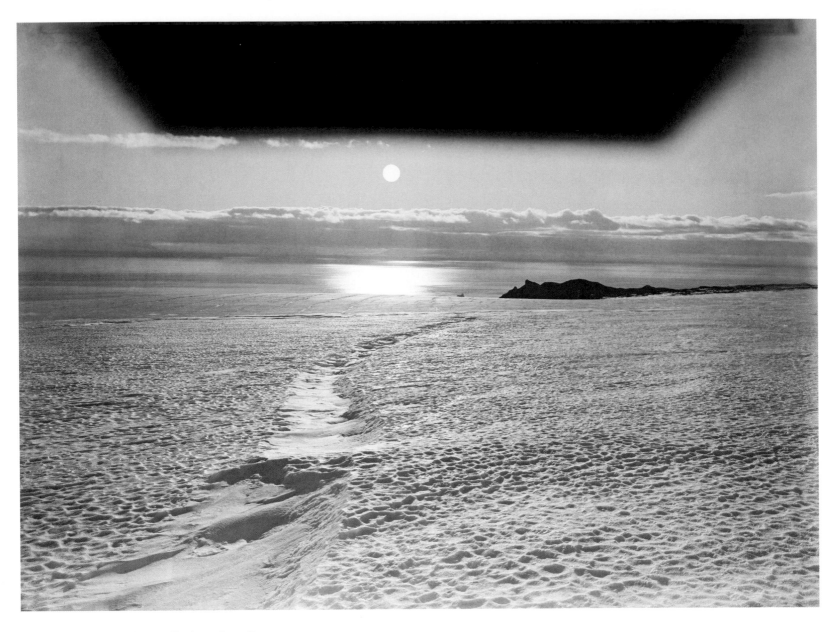

Looking west from the Barne Glacier to Cape Barne,
21 February 1911 (Ponting 190)

Here is a rare example of an 'error' in a Ponting photograph.
It shows the early formation of a pressure crack in the sea
ice, but the master photographer has inadvertently caught
an object – probably a plate holder – which he is using to
shade the lens as he shoots into the sun. Ponting frequently
took numerous shots before he was happy with the results,
throwing most exposures away. In this case, the intrusion
is one that could easily have been edited out prior to
publication, but the photograph is otherwise excellent and
Ponting kept it. It is of interest because Scott makes the
same error during his training (S80).

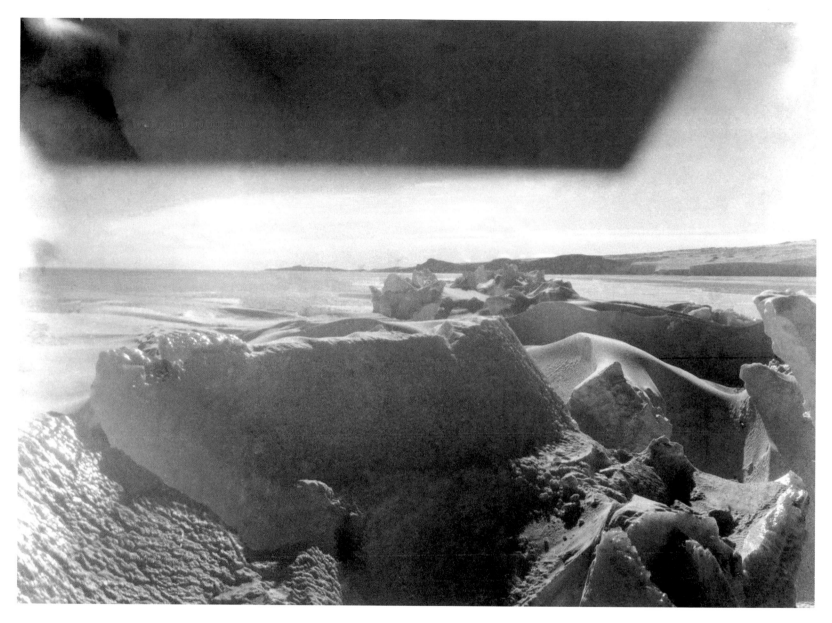

Ice crack, towards Cape Barne, 8 October 1911 (S80)

Scott's photograph of the ice crack is modernist in its aesthetic, showing the build-up of ice pressure from the tides and currents over the preceding winter. He is shooting into the sun and has, as in Ponting's picture opposite, inadvertently caught the shading object. Many of the errors made by Scott while training arose from the complexities of mastering the cumbersome equipment and challenging conditions, rather than from any particular incompetence. Scott also failed to obtain a correct exposure in this picture.

Herbert Ponting photographing the ice crack towards
Cape Barne, 8 October 1911 (S81)

Another picture taken when Ponting and Scott worked
together on 8 October 1911 (S80; Ponting 344, previous
spread). Here Scott shows Ponting at work on that day. The
bright sunlight reflecting off the ice was clearly causing
problems for Scott, who struggled to obtain correct
exposures. With his photograph of the tide crack showing the
use of a plate holder to shade the lens, it is easy to imagine
the tutorial that Ponting was giving Scott on techniques of
halation, on filters and on the challenges of photographing
the form, shape and texture of ice.

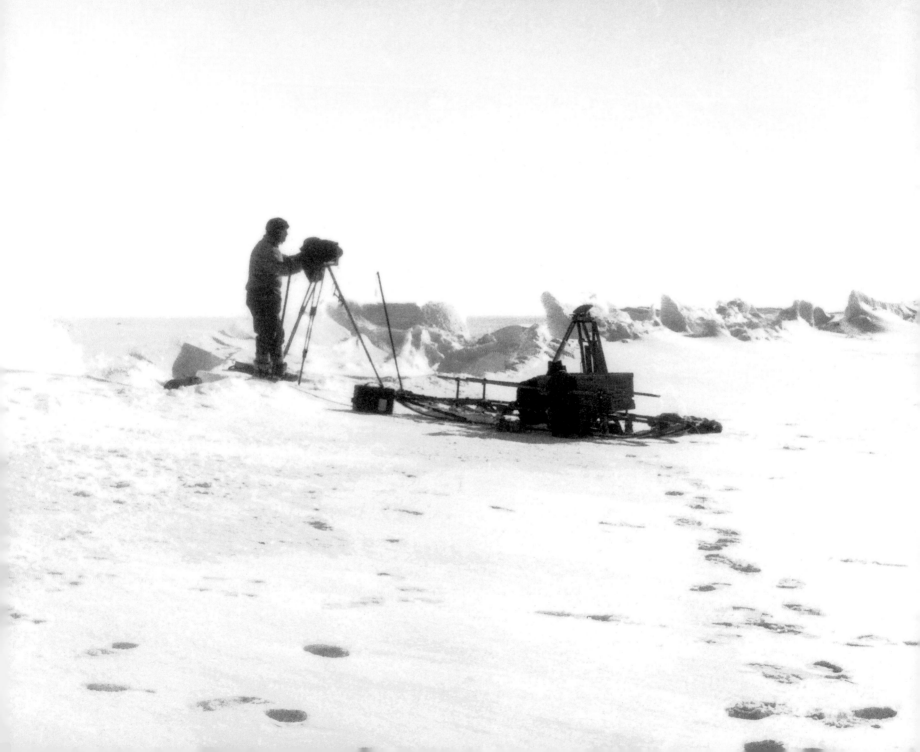

FERRAR GLACIER REGION ON THE WEST COAST OF McMURDO SOUND

....................

Scott made a short Spring Journey with Simpson, Bowers and PO Evans to this area in September 1911. He photographed many of the marked features, most of which were geographical discoveries made during his first expedition (1901–4), although some were named during his second. A major depot of supplies was set up at Butter Point for the use of geological parties into the area, while at Cathedral Rocks, stakes were set out to assess the rate of flow of the glacier.

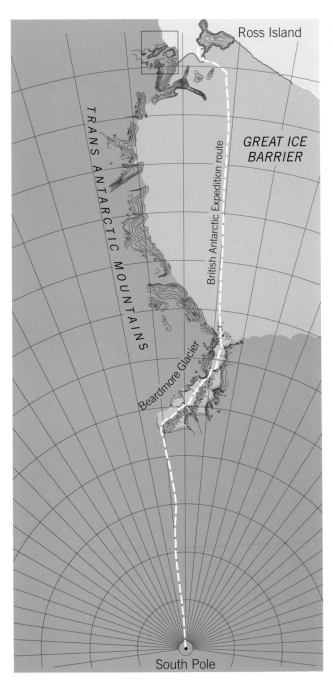

Small box on inset map shows location of area on map opposite

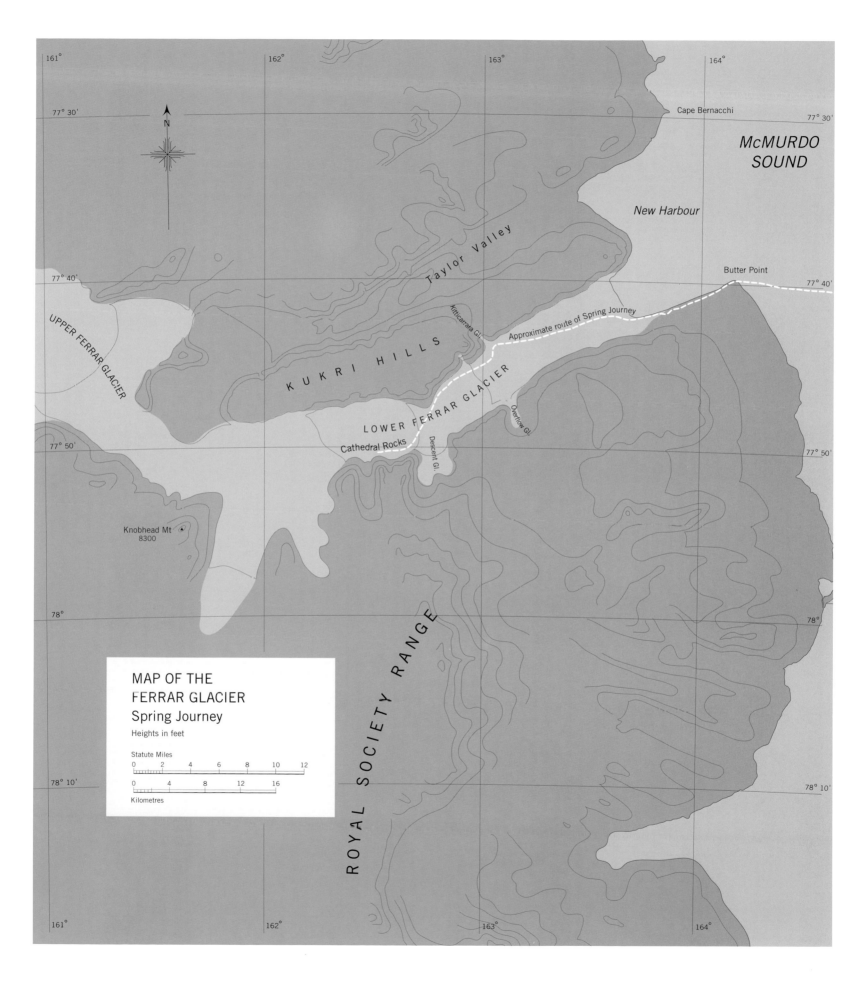

161° 162° 163° 164°

77° 30'

N

Cape Bernacchi

77° 30'

McMURDO SOUND

New Harbour

Taylor Valley

77° 40'

Butter Point

77° 40'

UPPER FERRAR GLACIER

KUKRI HILLS

Kritticarara Gl.

Approximate route of Spring Journey

Overflow Gl.

LOWER FERRAR GLACIER

77° 50'

Cathedral Rocks

Descent Gl.

77° 50'

Knobhead Mt
8300

ROYAL SOCIETY RANGE

78° 78°

MAP OF THE
FERRAR GLACIER
Spring Journey

Heights in feet

Statute Miles
0 2 4 6 8 10 12

0 4 8 12 16

Kilometres

78° 10' 78° 10'

161° 162° 163° 164°

87

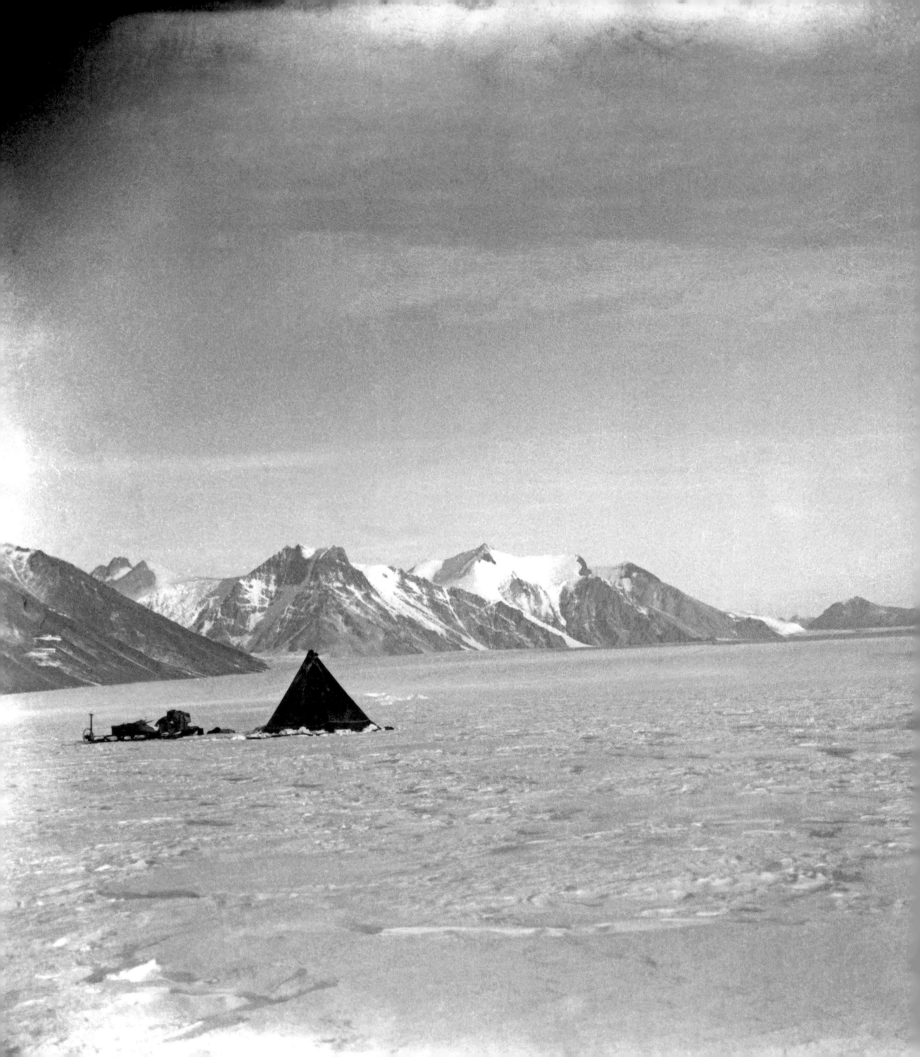

Camp on the Ferrar Glacier, looking up the valley. Spring Journey, September 1911 (S4)

..

Scott left Cape Evans with Simpson, Bowers and PO Evans on 15 September 1911 and headed across McMurdo Sound to the Ferrar Glacier. The Spring Journey had many purposes, one of which was to field-test the cameras. Scott and Bowers were confident enough after two weeks of training with Ponting to try out their new skills. They arrived at Cathedral Rocks on 19 September, photographing along the way. In the left of this image, over the tent, is Descent Glacier, and beyond it, Cathedral Rocks. At the top of the visible glacier valley, Knobhead Mountain is clearly in view.

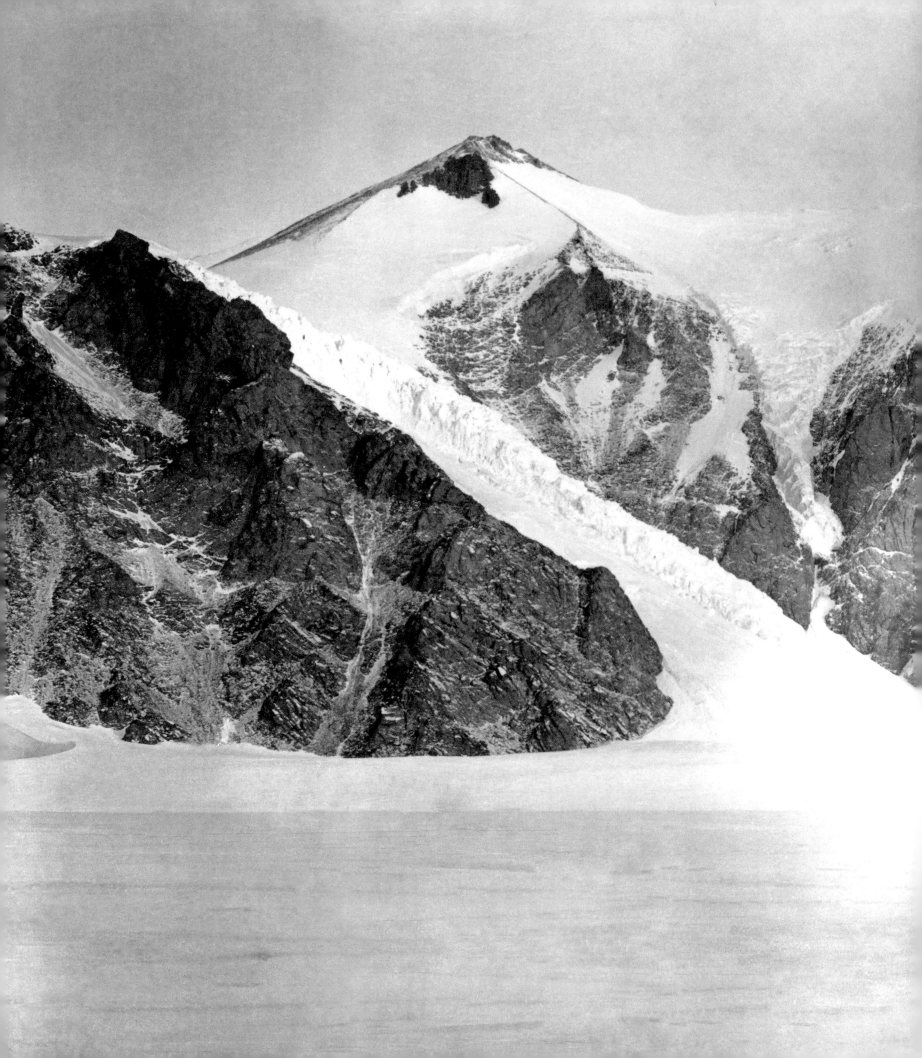

The Kitticarrara Glacier, Spring Journey,
September 1911 (S112)

..

At the lower end of the Ferrar Glacier, flowing through
the Kukri Hills, the Kitticarrara Glacier had been named
by a geological party from Scott's expedition only a
few months previously. Two major journeys of scientific
exploration would be made by geological parties into the
mountains, glaciers and dry valleys surrounding the area
during Scott's *Terra Nova* expedition, in addition to the
relatively short Spring Journey.

Unidentified peak, either Sentinel Peak or Cathedral Rocks,
Spring Journey, September 1911 (S11)
..

The magnificent peaks surrounding the Ferrar Glacier made
enticing subjects for Scott's camera. However, as in many
of the Spring Journey photographs, he has not followed
Ponting's tutorials effectively, neglecting to add a human
feature for scale; nor has he composed the picture with
careful foreshadowing and echoing of the main shapes and
features, leading the eye into the central object of the image
as taught by Ponting. This photograph is typical of the quality
of images from previous polar expeditions.

The Kitticarrara Glacier, Spring Journey,
September 1911 (S6)
..

Scott's experimentation with different exposures,
lenses and filters may clearly be seen in the resulting
photographs. It was the first time that Scott had practised
his new technical skills in the field, by himself, away from
Ponting's on-the-spot advice.

Camp under Cathedral Rocks, Spring Journey,
September 1911 (S7)

In studying these photographs it soon becomes clear where
Scott followed Ponting's teaching and where he didn't.
And here, with the pyramid tent foreshadowing one of the
great peaks of Cathedral Rocks, Scott delivered a splendid
photograph in the picturesque landscape tradition. It was
Ponting's tuition in the fine details of composing good
photographs rather than taking mere snapshots that made
the difference between delivering dull and uninteresting
photographs of limited scientific, historic or aesthetic interest
and pictures that are full of interest from many perspectives.

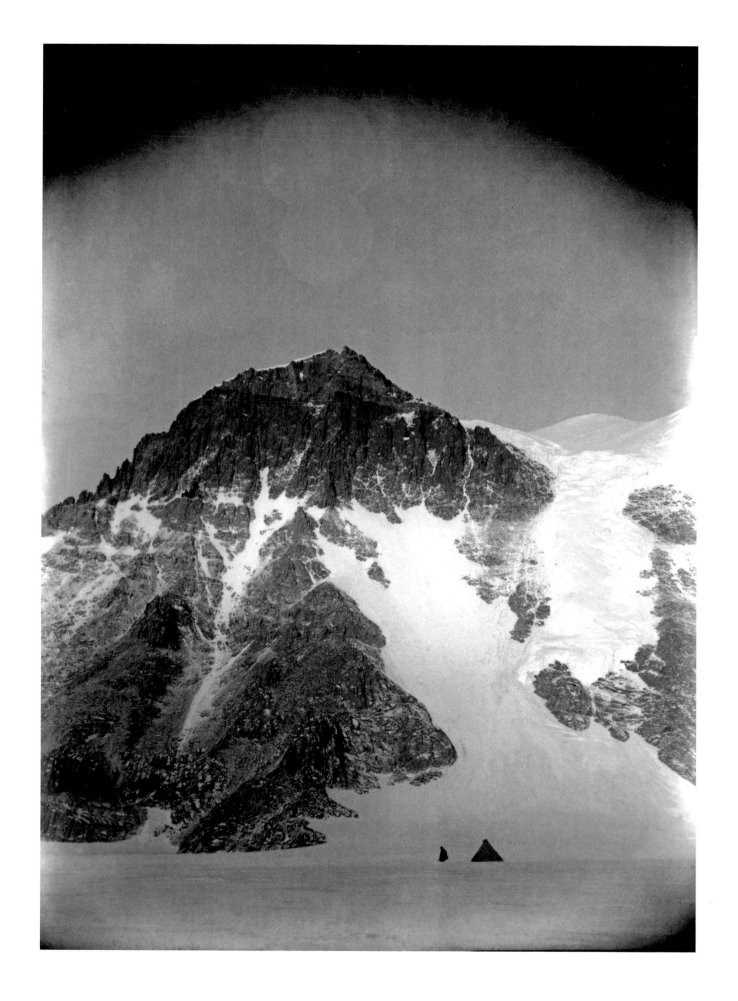

An expedition member, probably meteorologist George Simpson, on the Ferrar Glacier during the Spring Journey, September 1911 (S111)

Scott was generally pleased with the results of the Spring Journey photographs, noting that they had '... turned out very well, auguring well for the management of the camera on the Southern Journey' (1 October 1911).

With a few weeks of training yet to come, Scott had every reason to be optimistic. The vast imaging programme was making good progress towards ensuring that the field parties delivered excellent photographs and sketches during their summer explorations.

A view from the sea ice showing, from the left, the Blue Glacier, the Ferrar Glacier and the Kukri Hills (S2); the Kukri Hills to Victoria Lower Glacier (S9); and the Victoria Lower Glacier to Cape Roberts (S122), 25 September 1911

··

After noon on the 25th we made a direct course for C. Evans, and in the evening camped well out in the Sound. Bowers got angles from our lunch camp and I took a photographic panorama, which is a good deal over exposed.
[Sunday 1 October 1911]

Scott was often brutally honest with himself when writing in his diary and his photographic efforts were not immune from rigorous self-appraisal. For all its faults, Scott's panorama from the sea ice is interesting as it represents one of his earliest attempts to achieve with the camera the detailed panoramas of coast and mountains that Wilson achieved with his pencil.

Despite being rather dull, such photographs are of increasing scientific interest. This sequence appears to show that the Piedmont Glacier, later named for Wilson, was more extensive when Scott took his photograph than it is today.

THE GREAT ICE BARRIER

The journey made by Captain Scott and his supporting parties to reach the South Pole in 1912 has become legend. Leaving from Cape Evans to Hut Point, across the Great Ice Barrier, up the Beardmore Glacier and across the high elevation Polar Plateau, then returning by the same route, they aimed to cover a total distance of 1566 geographical miles, 1802 statute miles or 2900 km.

Many features on the early part of the journey had been named during Scott's first expedition. Cape Wilson and Shackleton Inlet represent the furthest south the party reached then and were named for his companions at the time.

The marked route shows the first part of the Southern Journey made in 1911, from Cape Evans to Hut Point and then across the Great Ice Barrier (Ross Ice Shelf) to the Beardmore Glacier. Scott photographed in several camps along the way and some of the features shown may be seen in his photographs.

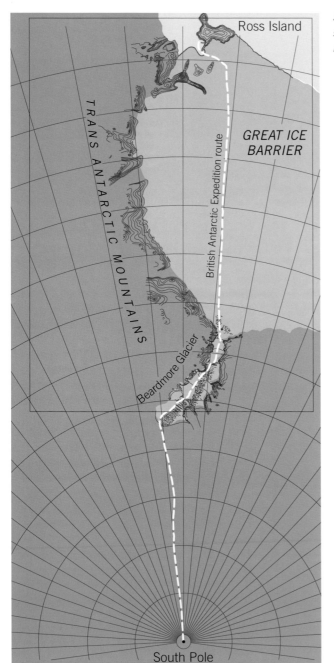

Small box on inset map shows location of area on map opposite

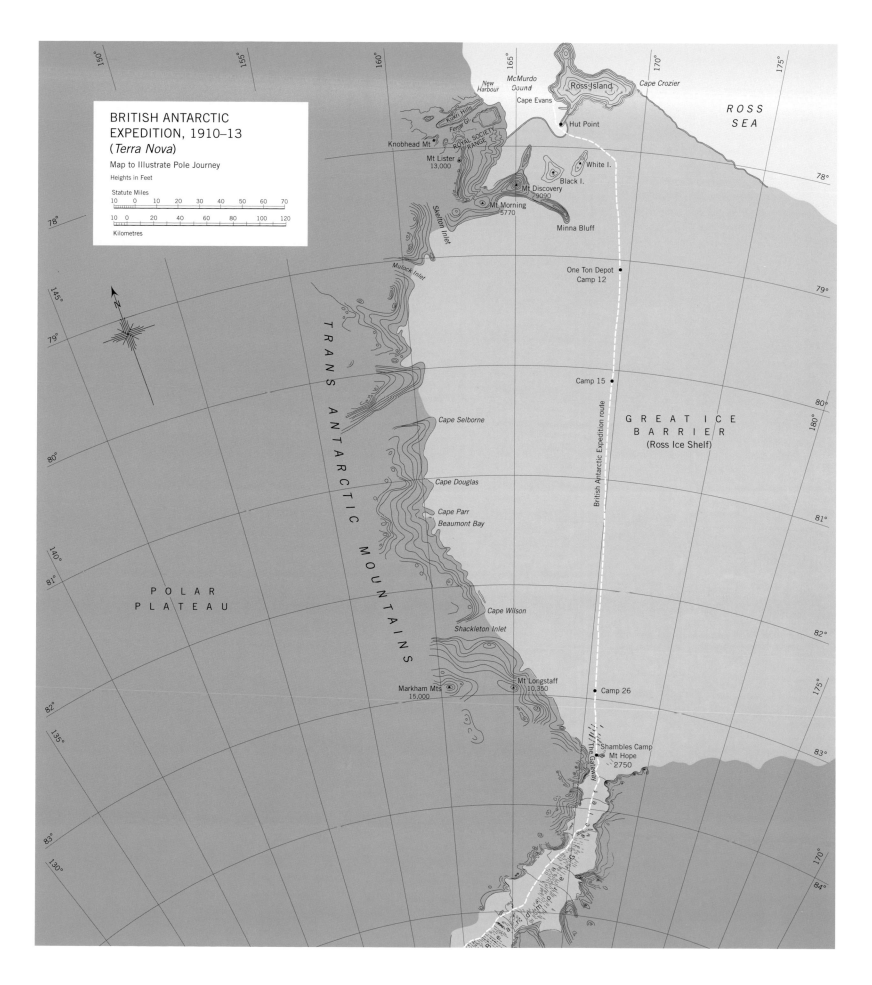

BRITISH ANTARCTIC
EXPEDITION, 1910–13
(*Terra Nova*)

Map to Illustrate Pole Journey

Heights in Feet

Statute Miles
10 0 10 20 30 40 50 60 70

10 0 20 40 60 80 100 120
Kilometres

ROSS
SEA

McMurdo
Sound
New
Harbour
Cape Evans
Ross Island
Cape Crozier
Hut Point
Kukri Hills
Ferrar Gl.
ROYAL SOCIETY
RANGE
Knobhead Mt
White I.
Black I.
Mt Lister
13,000
Mt Discovery
9090
Mt Morning
5770
Minna Bluff
Skelton Inlet

Mulock Inlet

One Ton Depot
Camp 12

T R A N S

Camp 15

GREAT ICE
BARRIER
(Ross Ice Shelf)

Cape Selborne

A N T A R C T I C

POLAR
PLATEAU

Cape Douglas

Cape Parr
Beaumont Bay

M O U N T A I N S

Cape Wilson

British Antarctic Expedition route

Shackleton Inlet

Mt Longstaff
10,350
Camp 26
Markham Mts
15,000

Shambles Camp
Mt Hope
2750
The Gateway

THE POLE JOURNEY

The sixteen men, twenty-three dogs, ten ponies, thirteen sledges and two motor sledges of the Southern Party left Cape Evans over a number of days beginning on 24 October 1911. Being the slowest, the Motor Party left first, followed by the Pony Party on 1 November and the Dog Party three days later. All were soon on their way across the Great Ice Barrier towards the South Pole.

Scott's plans, as laid out in the prospectus, had by now been thoroughly revised. He had long since decided against the option of placing his main base at King Edward VII Land, at least in part because it meant gambling on an unknown route to the pole, for all the speculation that the glaciers up onto the Polar Plateau might be lower at the eastern end of the Ice Barrier. Choosing a known route from Ross Island and his new base at Cape Evans was a way of minimizing risk, since the obstacles to the pole were clear and could be anticipated.

Even as he had established his base at Cape Evans, Scott still had an open mind about the precise arrangements for getting to the pole. He was not set against the use of dogs, as is occasionally asserted. Nor, apparently, was he entirely convinced by Shackleton's use of ponies, regarding them as suitable only for use on the Great Ice Barrier, while his new motor sledges were experimental. On arrival at Cape Evans in the autumn of 1911 it was the dogs that were odds-on favourites to go all the way to the South Pole. Edward Wilson had been delighted to be chosen to drive the dogs for the Depot Laying Journey. As he noted in his diary:

It means a lot of running as they are being driven now, but it is the fastest and most interesting work of all and we go ahead of the whole caravan with lighter loads and at a faster rate. Moreover, if any traction except ourselves can reach the top of the Beardmore Glacier it will be the dogs, and the dog drivers are therefore the people who will have the best chance of doing the top piece of the ice cap at 10,000 feet [3300 m] to the Pole. May I be there! About this time next year or thereabouts! [1]

As Scott's confidant, Wilson knew what was in the Skipper's mind. What changed it was the experience of the animals on the Depot Laying Journey. The fateful moment occurred on Tuesday 21 February 1911. While sledging back to Cape Evans after laying the One Ton Depot, ten out of the team of thirteen dogs being driven by Meares and Captain Scott disappeared down a crevasse, two of them falling 40 feet (12 m) and landing on a ledge. Scott insisted on personally being lowered to rescue them. After this incident, several of his team noted that Scott's faith in the ability of dogs to successfully travel in crevassed areas had been shaken.[2] He rarely discussed taking the dogs up the Beardmore Glacier to the pole again. The only person to have attempted taking

animals up it was Shackleton and he had failed, losing a pony down a crevasse, along with a sledge of vital supplies. The crevasse incident seems to have convinced Scott that the risk that the dogs would meet the same fate as Shackleton's pony on the Beardmore was too high. He didn't think that he would get them home again to undertake the important scientific work that he was contemplating for the second season. It was a very real fear. Douglas Mawson, by now leading his own expedition in another part of the Antarctic, was to lose a man, a dog team and a sledge of essential supplies down a crevasse in an accident devastating to his plans. Scott's was a rational conclusion and was a reasonable assessment of risk, worthy of any modern Health and Safety officer. It is probable that if he had used dogs up the Beardmore, Scott would never have reached the pole at all, although in the light of events, even Scott eventually wondered if it had been the right choice. It has caused considerable debate ever since.

Cherry Garrard would later challenge the armchair critics, of which there have been many:

The practical man of the world has plenty of criticism of the way things were done. He says dogs should have been taken; but he does not show how they could have been got up and down the Beardmore. [3]

Scott was not alone in his assessment: the Beardmore Glacier is one of the largest glaciers in the world and its crevasses are still feared a hundred years later. When looking to lay its new 'road' to the South Pole, the United States National Science Foundation dismissed the Beardmore as a suitable route because the crevassing was too dangerous for vehicles. Instead they chose another glacier.[4] So did Amundsen, who took a huge gamble on the unknown in the hope of finding a more passable glacier onto the Polar Plateau towards the eastern end of the Great Ice Barrier. Scott stuck to his updated plan despite its obvious drawbacks, principally the greater reliance on the ponies, which meant leaving base later than originally planned so that conditions were not too cold for them. Every Antarctic expedition is a balance of risk.

Scott's plan for reaching the South Pole was a simple one, practised by polar explorers for many years: a pyramidal structure of supporting parties, which would detach and return to base once they had delivered their payload, much like the fuel tanks of future space rockets. In this way, Scott hoped to move as many supplies as far south as possible and thus overcome the main reason for Shackleton's failure to reach the pole three years previously: his lack of supplies. By following Shackleton's nearly successful timetable and route with extra supplies, risk was minimized and it was a reasonable assumption that the attempt would succeed. It was, nevertheless, a huge logistic operation.

The route to the pole from Cape Evans was effectively in four stages: first was the short preamble of 11 miles (20 km) across the sea ice to the forward base formed by Scott's old *Discovery* headquarters at Hut Point; the second was the 363-mile (673-km) trek across the Great Ice Barrier to the Trans-Antarctic Mountains, much of which Scott had pioneered himself; the third was the 108-mile (200-km) haul from sea level up to 9000 feet (2743 m), ascending the great Beardmore Glacier discovered by Shackleton; and the final stage was the 301-mile (557-km) sledge across the high-elevation Polar Plateau. The return journey would be along the same route, picking up depots of supplies laid by the supporting parties during their outward marches, for a total journey of 1566 geographical miles, 1802 statute miles or 2900 kilometres.[5] The outward leg of the first two stages, from Cape Evans to Hut Point and from Hut Point to the Beardmore Glacier, was where Scott chose to deploy his animal transport. He doubted that any team of men could man-haul the whole distance to the pole and back, but the animals could give them a good start. Unlike the dogs, the ponies would be shot for food for man and dog, and it was hoped that fresh meat for the men would help to avoid scurvy, which was still an unexplained disease. Scott also hoped that his motor sledges would prove themselves over the Great Ice Barrier. The final two stages, up the Beardmore Glacier and then on to the pole, would be made by man-hauling, as would the entire return journey to Cape Evans.

Every weight on every sledge, for every party, was carefully calculated. This included the equipment needed for an extensive scientific and photographic programme. An attempt on the South Pole it certainly was, but not a dash for a record. As Edward Wilson had outlined previously in a letter home:

No-one can say that it will only have been a Pole-hunt, though that of course is a sine qua non. *We* must *get to the Pole; but we shall get more too … We want the Scientific work to make the bagging of the Pole merely an item in the results.*[6]

The pole effort presented the opportunity for the first serious scientific investigation to be made of the Beardmore Glacier. Shackleton might have discovered it, but he had not taken scientists on his pole attempt and such samples and photographs as he had brought back with him had simply whetted scientific appetites. The Southern Journey parties would take with them lists of requests for scientific work from learned societies around the world and Wilson's polar notebooks carry lengthy notes about what was desired:

Is the Beardmore scarped? How many tributaries enter at Grade? Angle of slope if possible. Dip of any bedding. Are there any parasitic cones or recent volcanics on glaciated

shoulders. Note Dykes or Sills. In the Moraines – how far apart are the rocks. Normal granite and Gneisses need not be collected, only notes made. Axis of folding of Gneiss wanted. Sample of dolerite wanted. Note the intrusions of Granites etc. into Beacon Sandstone. The important things are the Beacon Sandstone, Limestone and Coal beds. Get samples in situ. Make stratigraphical notes if possible …[7]

The instructions, filling several pages of Wilson's notebooks, would not only provide the itinerary for the scientific work, principally in geology and glaciology, executed during the Southern Journey, but also for its imaging programme, which was an important part of the scientific work. Sketches and photographs would provide records towards answering the long list of scientific questions, as well as recording the bagging of the pole. Ponting's training had now given Scott a useful means to participate in the expedition's scientific work, linking his enthusiasm for scientific investigation with the camera.

The plan was to take three cameras to the top of the Beardmore Glacier, to be operated by Charles Wright, Birdie Bowers and Scott himself. Two of the cameras would then be sent back with returning parties, leaving one camera to continue to operate across the Polar Plateau, on to the pole and back again. The Polar Plateau was relatively featureless and so not as interesting as the Beardmore, where the bulk of the photographic and scientific programme was to be carried out; and, in any case, weight on the sledge had to be reduced to a minimum by this point, as only one sledging party would be going to the pole.

Ponting desperately wanted to accompany the Southern Party as far as possible, but it was impractical. Apart from the fact that he was not up to severe physical sledging there was the simple weight of his equipment. As Scott put it kindly to him, 'every ounce that could be carried on the sledges, other than camping equipment, would be food. *Everything must give way to food'.*[8]

In the end, Ponting was given permission to join the Southern Party for the first stage of the journey, as far as Hut Point. From there, he travelled a short distance out onto the Great Ice Barrier, where he filmed and photographed the departure of the pony parties off into a misty distance of snow and ice. As events turned out, it was to be the most poignant film that Ponting was ever to shoot:

As they plodded beside their ponies away into 'the stark and sullen solitudes that sentinel the Pole,' I recorded the scene in moving-pictures, and Uncle Bill [Wilson] *looked back and waved to me. I stood with a feeling of depression and loneliness at heart, until they shrank into the distance, half wondering if ever I should see them again. But I had gazed*

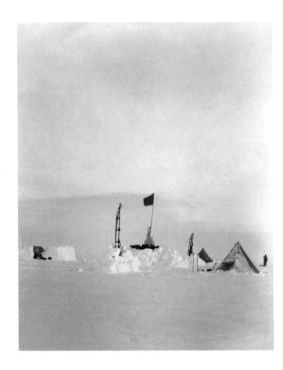

for the last time on the faces of my fearless Chief and friend. They were destined never to return from the heart of the Great Alone.[9]

With Ponting now left behind, it was down to his three pupils with their field cameras to do the work. Ponting could only hope that they had learned their lessons.

As they trudged across the Great Ice Barrier, Scott was very hopeful that the motor sledges would do well. He realized that the future of polar travel lay with them, longing for the day that animals did not have to be so cruelly used. Even Amundsen feared their success, which compelled him to leave his base at Framheim in early September in a rush to beat Scott to the pole. It was too early in the season and the freezing conditions forced him back to base, causing a huge row within his party.[10] He left again a month later, two whole weeks ahead of Scott. He need not have worried, however. Scott's hopes were dashed: both motors broke down a short way across the Barrier and their crews started man-hauling the supplies.

Marching during the twilight hours of the 'night' when temperatures were lowest, the Pony Party rested during the day when temperatures were warmest, so that the ponies were protected as much as possible from the cold. At every camp high 'pony walls' were built to shield them from the wind. This had the unexpected side effect of marking the route across the Barrier for the returning parties with cairns. The party was soon at One Ton Camp, 130 miles (246 km) from Cape Evans, arriving on 15 November. Here they rested

the ponies for a day, giving Scott his first chance to take out his camera. His photographs of One Ton Camp (S66, above left; S88, right; S87, p. 189; S119, p. 191; S120, above) are far from his best work, but they reveal the murky, flat, white light which was to become a feature of his crossing of the Barrier, with sunlit days rarer than previously experienced. It made it harder to focus lenses on top of all the regular challenges of Antarctic photography. However, they clearly show the immense size of the supply depot, with human figures rendered insignificant. Even the ponies, sheltering behind their walls, seem slight against the vast piles of stores buried by snow and marked with sledges and flags, which suggest a feature which could be seen for miles across the flat plain of the Barrier. Cover it slowly in snow, however, and even such a huge depot becomes almost invisible in poor light.

They continued on their way a day later. Scott's diary is full of the trivial anxieties and details of the trail, with every change in surface, every hold-up by a blizzard, every unexpected cough from a pony a potential cause for concern. His plans were calculated on the basis of the failure of both the motors, a casualty rate of up to half the ponies within twelve days of leaving One Ton Camp and delays for blizzards. While the motors and blizzards performed as anticipated, the ponies coped considerably better than expected. This was largely due to Oates' skill as a horseman. He had been pessimistic about their trail-worthiness – considering them to be a bunch of old crocks – which had lowered everyone's expectations.

The Southern Party left Cape Evans towards the geographic South Pole over a number of days from 24 October 1911. Herbert Ponting filmed them leaving Hut Point as they set out across the Great Ice Barrier. The three field cameramen of the party, Scott, Bowers and Wright, were on their own.

Scott began photographing the polar effort as they reached One Ton Depot. As its name implies, this was a significant deposit of food and fuel for men, machines and beasts, which had been laid out in preparation for this journey some months earlier. The sheer scale of the physical effort made by Scott and his team to reach the South Pole is tellingly revealed in Scott's photographs of the depot.

The light on the Great Ice Barrier made photography difficult. For much of their transit, it was like walking into a wall of murkiness, which made it hard to focus the cameras. Scott's images show clearly how easy it was even for a depot of this size to merge into the whiteness of the Antarctic, perhaps never to be found again.

Scott and his Pole Party would die of starvation and exposure eleven miles short of One Ton Depot in just a few months' time.

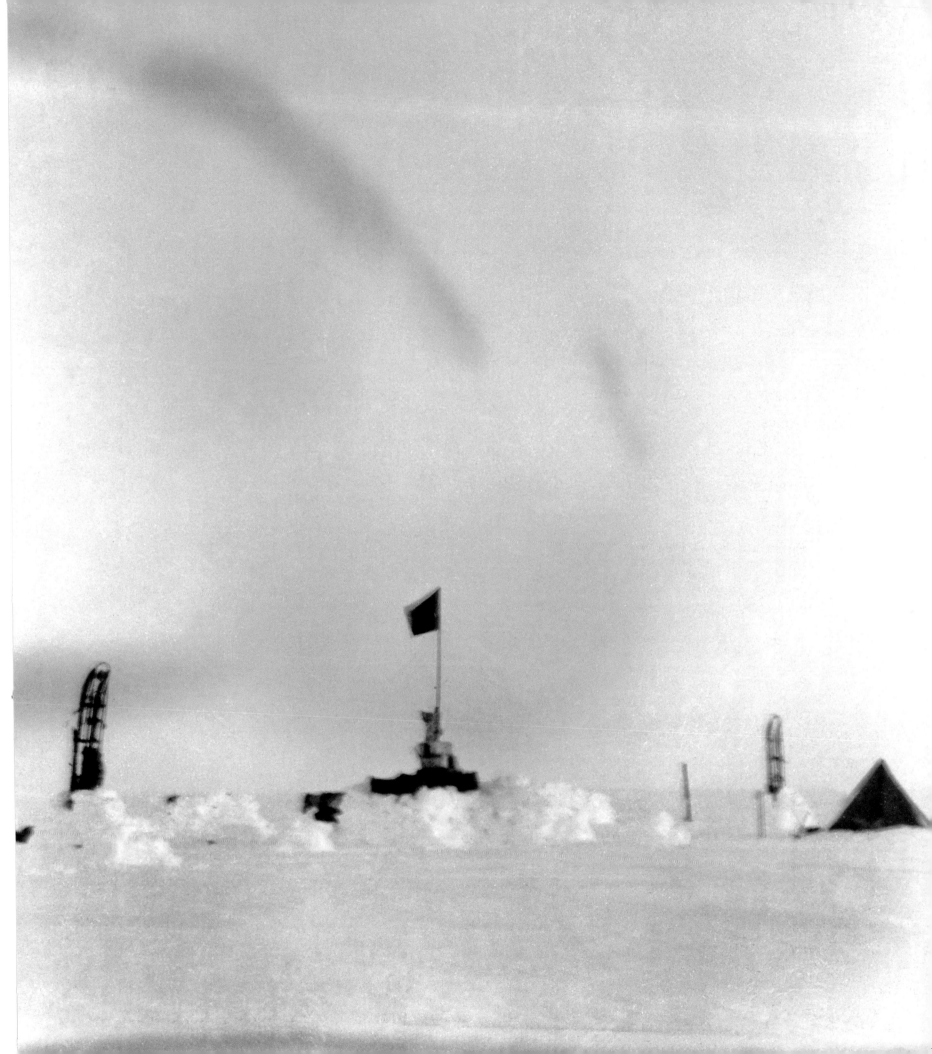

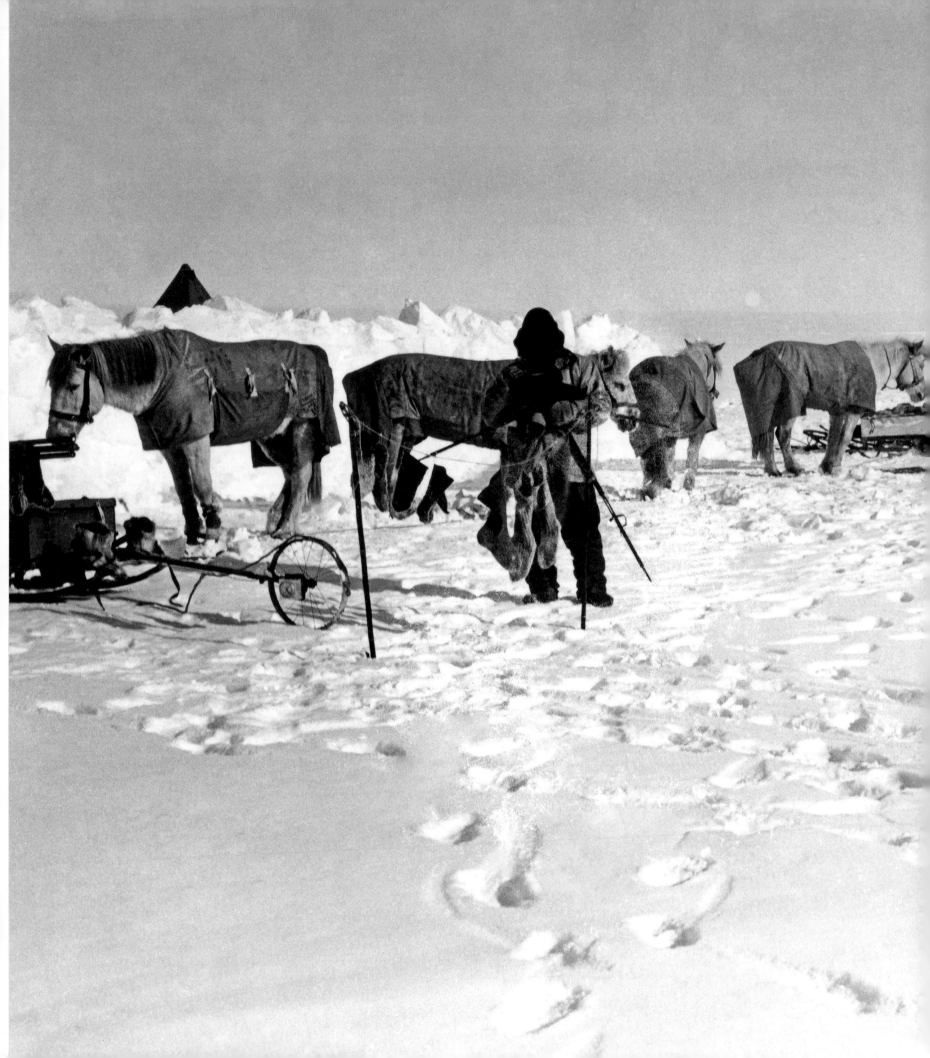

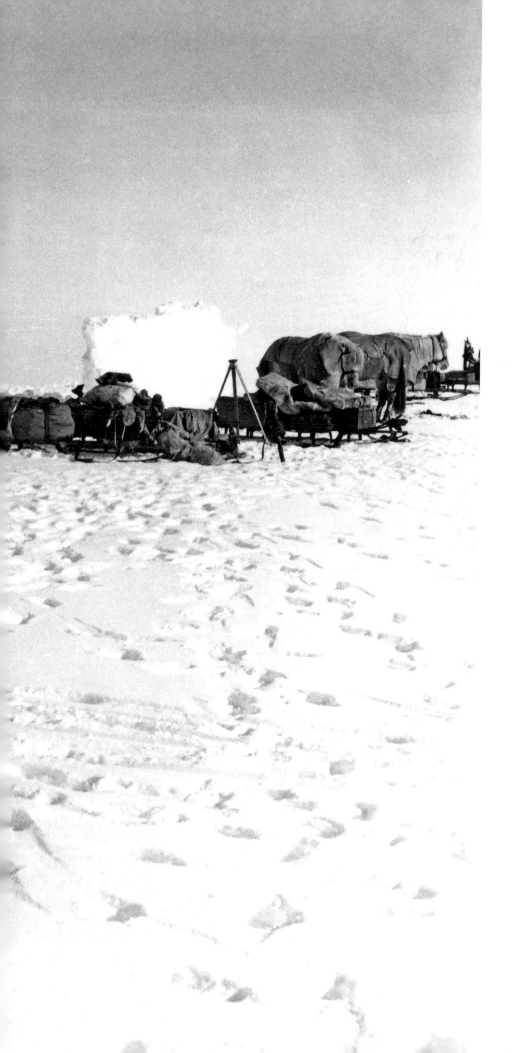

considerably, bogging down men, skis, dogs and sledges alike. The rarity of these sorts of conditions caused considerable comment in the diaries of the party. Nevertheless, uncommon or not, the challenge had to be met if the pole were to be reached. The following day the Lower Glacier Depot was laid. It was with some relief, no doubt, that Meares and Dimitri, driving the dog teams, turned back for Cape Evans shortly afterwards, leaving men alone to make the assault on the Beardmore. Scott had brought them much further south than he had planned, because they had been pulling so well, but he still didn't want to risk them on the glacier, preferring to keep them in reserve for relieving returning parties and for what he regarded as more important scientific work the following year. Scott took some photographs, looking back down the Beardmore towards the Gateway (S52, p.142; S53, p. 143). The Southern Party was now reduced to three sledging parties, four men to each sledge. Once the dogs had gone, there was general relief to be man-hauling the sledges, rather than having to drive animals. It was not simply a rational decision, it was also a humane one. The result, however, was an exhausting ordeal and the deep snow made it doubly so. Both Scott and Wilson kept a strict eye on the men, noting which were weakening fastest and struggling the most. Such factors were to decide who was to be chosen to return and who to continue towards the South Pole.

On the favourable side, the grey, misty whiteness that had marked their progress on the Barrier was now replaced by glorious days of sunshine. Scott set out to record events with his camera, not only wishing to capture their physical ordeal but also the extraordinary depth of the unusual snowfall. He was curious about the meteorological absurdity of it. The results are among the most astonishing images of the entire expedition, bringing alive the diary entries of the men who participated in the events of these few days. In particular, the sequence of photographs from the lunch camp on 13 December are some of Scott's best.

A most damnably dismal day. We started at eight – the pulling terribly bad, though the glide decidedly good; a new crust in patches, not sufficient to support the ski, but without possibility of hold. Therefore, as the pullers got on the hard patches they slipped back. The sledges plunged into the soft places and stopped dead. Evans' party got away first; we followed, and for some time helped them forward at their stops, but this proved altogether too much for us, so I forged ahead and camped at 1 p.m., as the others were far astern. During lunch I decided to try the 10-feet runners under the crossbars and we spent three hours in securing them. There was no delay on account of the slow progress of the other parties. Evans passed us, and for some time went forward fairly well up a decided slope. The sun was shining on the surface by this time, and the temperature high. Bowers

Pony Camp, camp 15: (left to right) Snippets, Nobby, Michael and Jimmy Pigg, 19 November 1911 (S21a)

..

Of all the Camp 15 photographs, this perhaps best illustrates Scott's diary entry:

'... *the weather now is glorious for resting the animals, which are very placid and quiet in the brilliant sun*'. [19 November 1911].

The quality of this image shows Ponting's remarkable influence. The peaceful comfort of the ponies' temporary residence in the sun is disturbed as the eye is led along the line of sledges and out into the great beyond.

Overleaf:
Pony Camp, Camp 15: (left to right) Jehu, Chinaman, Victor, Snatcher, Bones, Christopher, Snippets, Nobby, Michael and Jimmy Pigg, 19 November 1911 (S60)

..

Here, the remarkable physical effort made to reach the South Pole is further revealed. The ten ponies are sheltered behind high walls of snow, which had to be constructed at the end of each day's long march to protect them from the Barrier winds. In addition to the Pony Camp there were two others: the Dog Camp and the Motor Party Camp, although by this stage the latter was man-hauling its loads as the experimental motor sledges had broken down. The parties were strung out across the Ice Barrier – which is the size of France – in order to push enough supplies south to make the pole attainable.

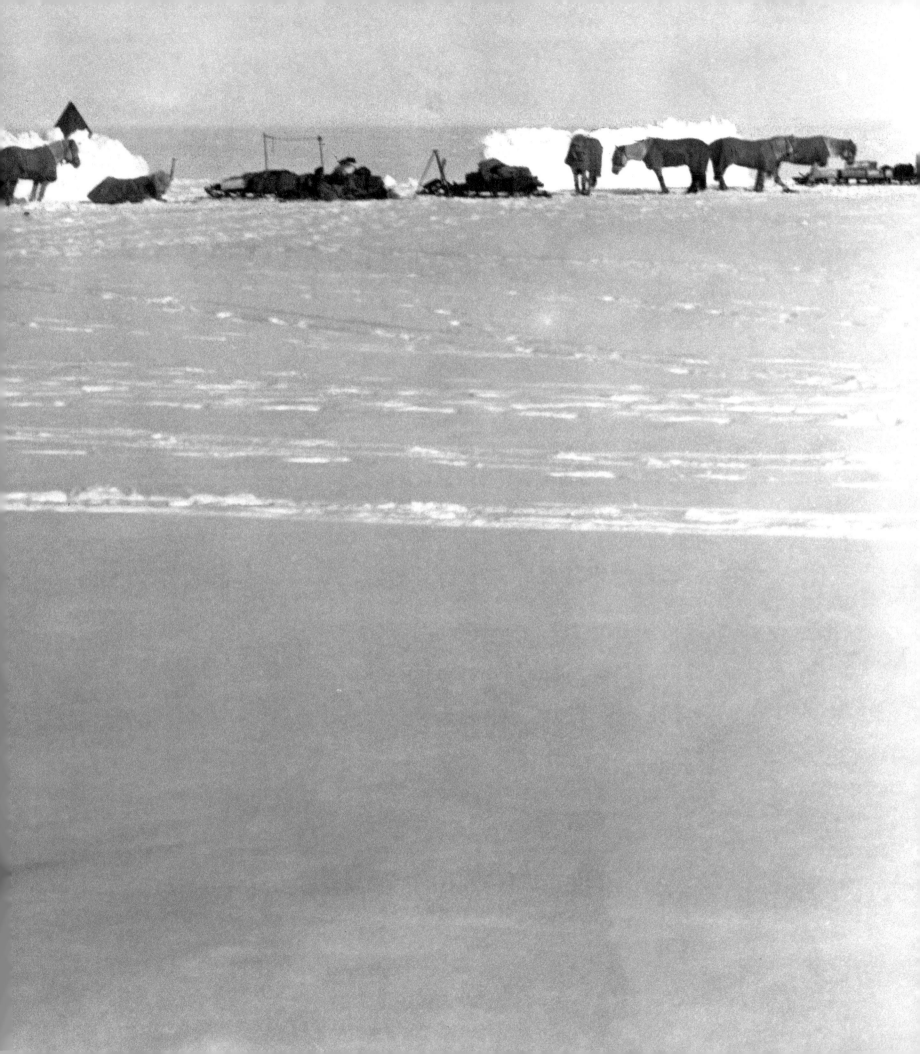

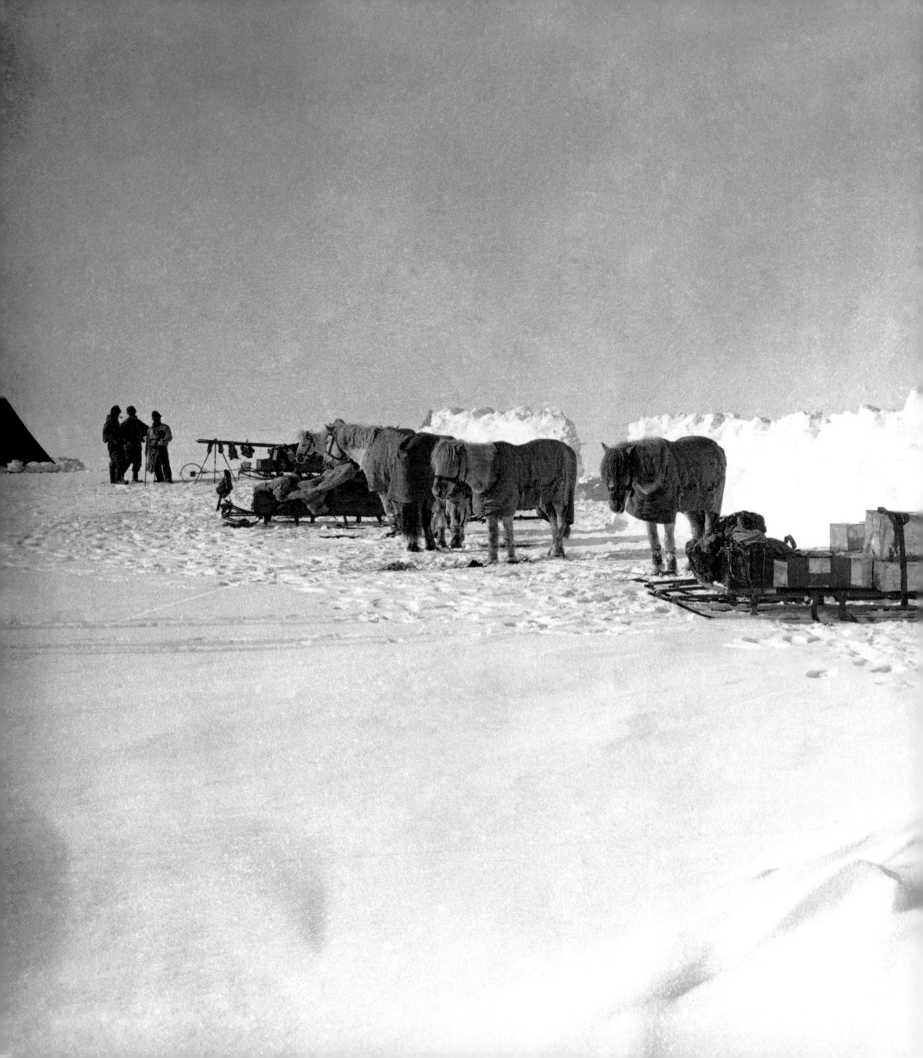

Unidentified pony camp (1), November 1911 (S36)

A group of men is relaxing after a hard day. The shorter figure is Birdie Bowers. The ponies are again sheltering behind vast ice walls, and rows of laundry can be seen drying in the sun. While the pony walls look much the same as in the previous photograph, the arrangement of the tents here suggests that this is not Camp 15.

Despite these photographs of ponies resting, they were finding the Barrier hard going and their condition was starting to deteriorate.

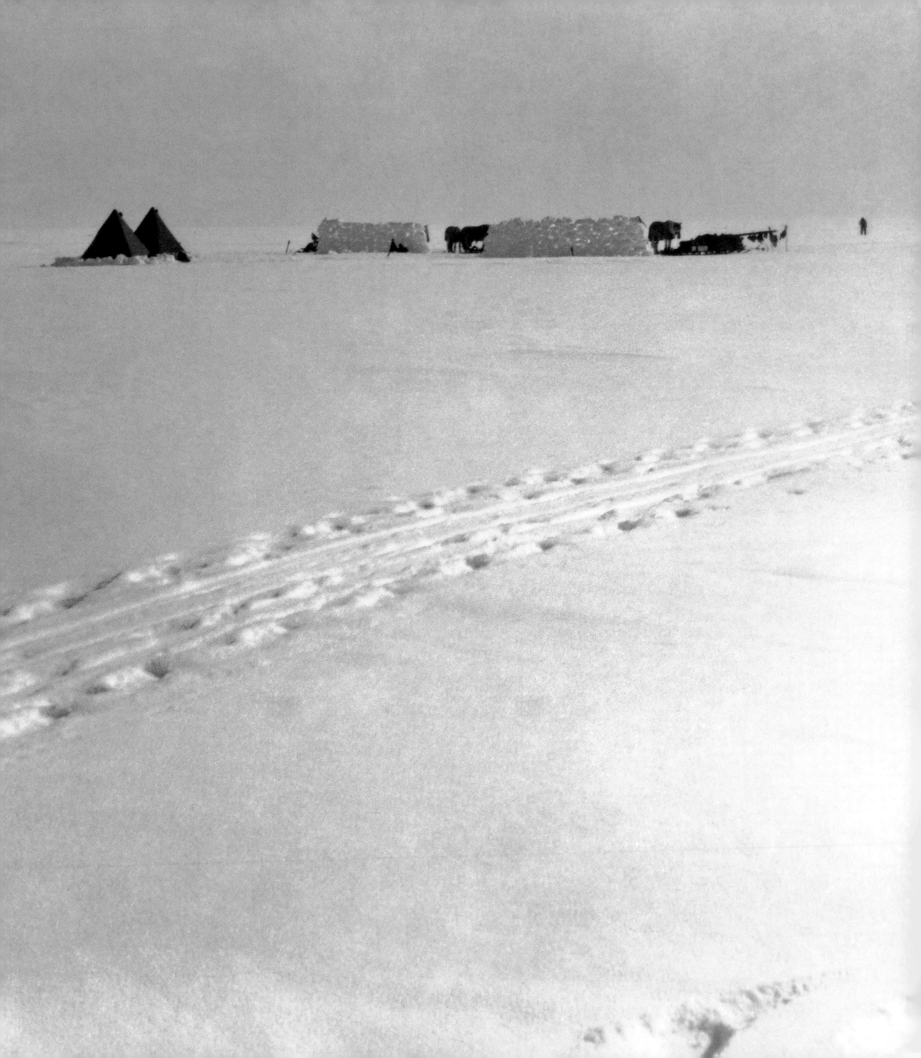

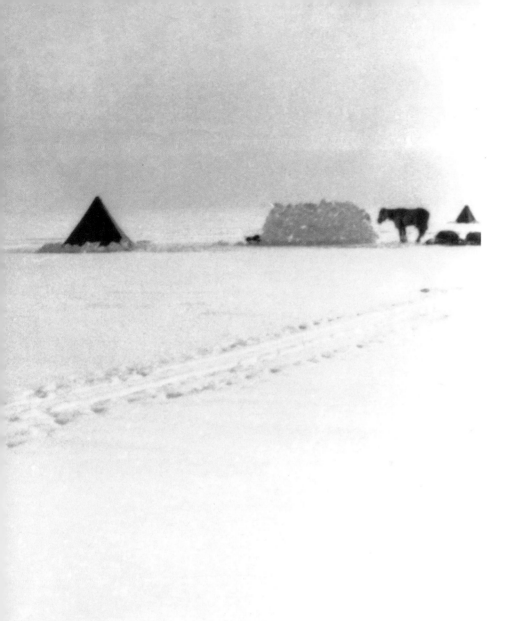

Distant view of unidentified pony camp (1),
November 1911 (S15)

Another image from the series Unidentified Pony Camp.
Scott has taken this from a significantly greater distance,
conveying the complete isolation of the men on the vast white
plain of the Ice Barrier. Sledge tracks lead the eye across it
and into the camp. It is probable that the furthest tent is the
edge of the dog Camp, which had to be some way away from
the ponies to avoid violent attacks on them by hungry dogs.
The lone figure is probably Birdie Bowers.

These are among the last photographs of the complete Pony
Party. From 28 November, weaker ponies were shot on a
regular basis to feed man and dog. It was hoped that the
fresh meat would ward off scurvy.

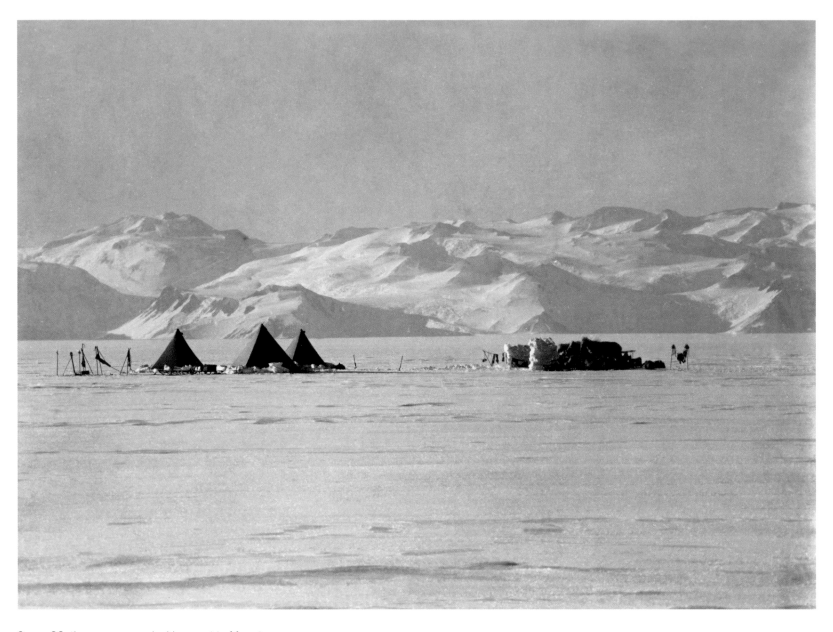

Camp 26, the pony camp, looking west to Mount
Longstaff, 1 December 1911 (S45)

Camp 26, the dog camp, looking north-west to Mount Markham, 1 December 1911 (S47)

When they camped on 30 November, the Southern Party was enveloped in the dull whiteness that had shadowed so many days across the Barrier. When the men awoke on 1 December, however, it was to glorious sunshine and stunning views of the coastline which they were now approaching. They stopped for some hours to take angles, to draw and take photographs.

Scott took photographs of the Pony Camp and the nearby Dog Camp. These two shots provide a stunning panorama, although the two halves do not quite join.

The Southern Party camps reflect the outline of the Trans-Antarctic Mountains, emphasizing the smallness of the Southern Party against the magnificence of the Antarctic.

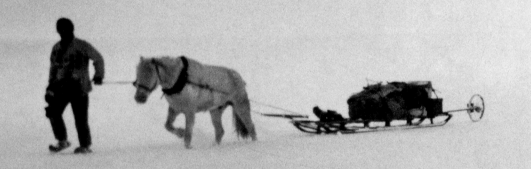

Ponies on the march, 2 December 1911 (S96a)

The first of Scott's major action sequences on the Southern Journey features the rapidly dwindling ponies. They were now down to seven animals, all of them struggling on increasingly infirm snow crust that gave way beneath their hooves, leaving them stumbling through the snow. The dull whiteness had enveloped the Southern Party again, providing difficult light for photography.

Scott wrote in his diary that evening that it had been 'dreadfully dismal work marching through the blank wall of white'. (2 December 1911).

This sense of a grinding plod through the enveloping wanness of the landscape is captured well in this photograph, along with the struggle of the ponies.

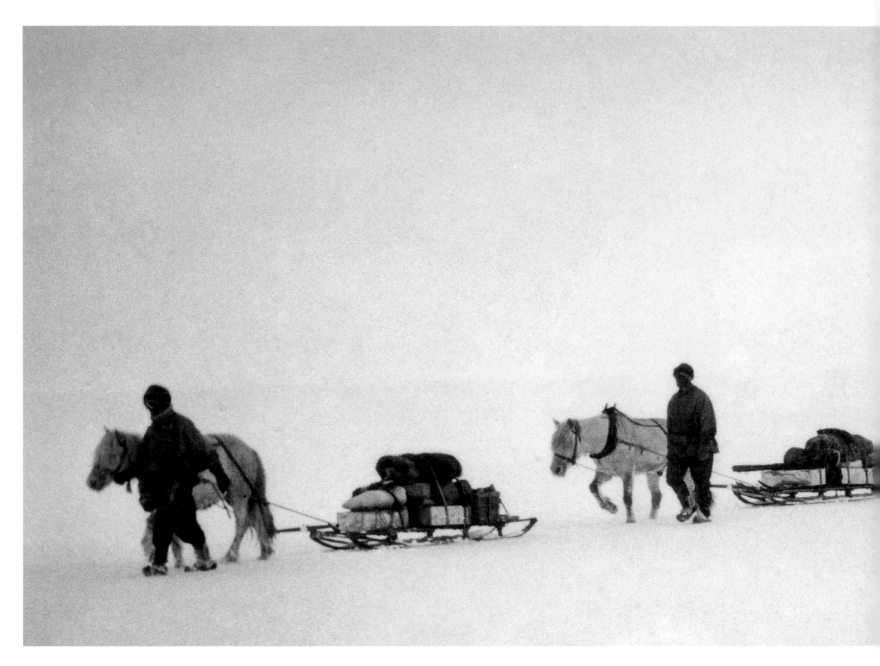

Ponies on the march, 2 December 1911 (S95)

The reduced number of ponies meant that those not leading animals could move more freely. Scott offered Oates the opportunity, but he declined it, preferring to lead an animal. So Scott took the chance to roam himself and photograph the progress of the party. As the entire column crossed in front of his lens, Scott captured the loneliness of their daily trudge across the snowy waste of the Great Ice Barrier.

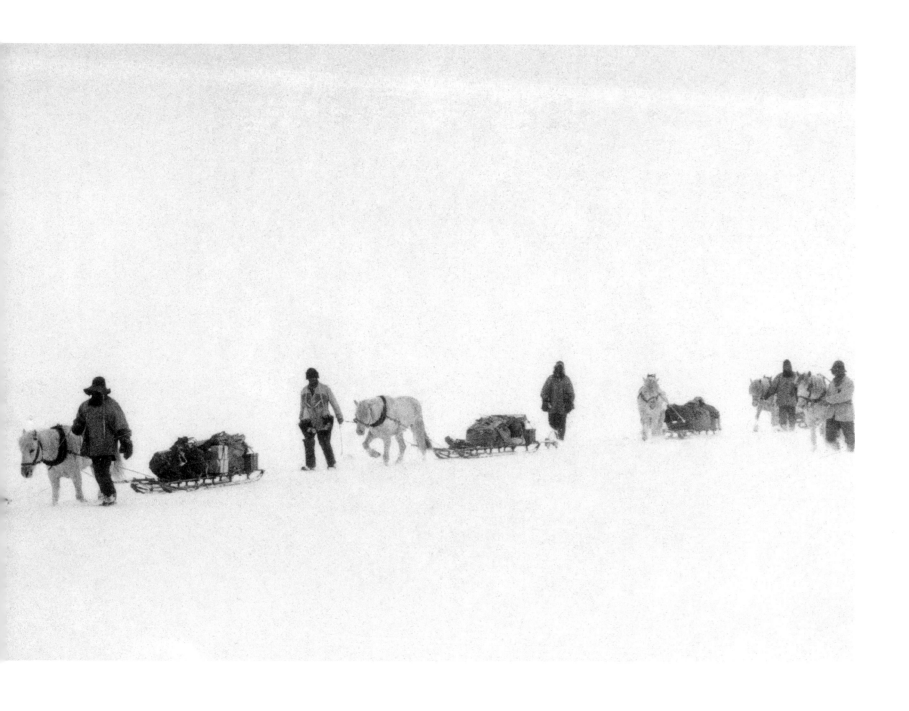

Overleaf:
Ponies on the march, 2 December 1911 (S91)

The bright but dull conditions of the day posed technical problems for the cameras. Scott was clearly using different filters and exposures to ensure at least some competent images. Even those where the exposures might be deemed less good have provided extraordinarily evocative images.

In this photograph, the sense of isolation on the march, each man alone with his thoughts and his pony, is almost excruciating; and the Antarctic whiteness overwhelming.

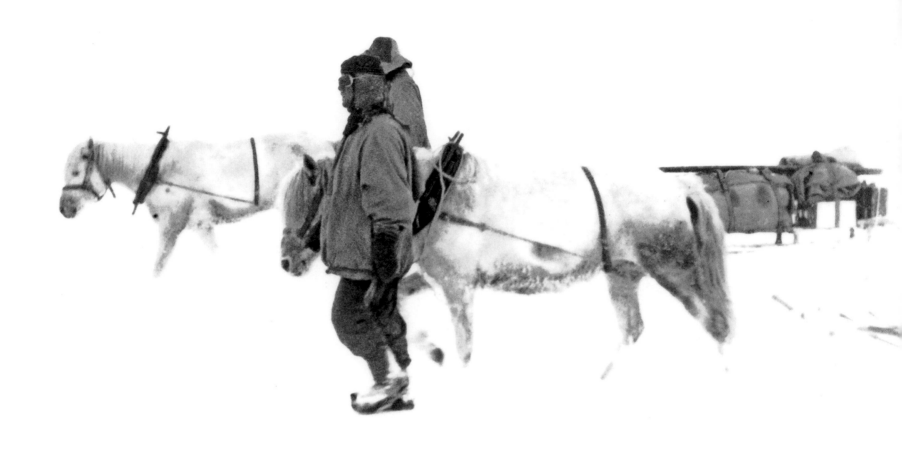

Ponies on the march, 2 December 1911 (S92)
···

The feeling of movement on the pony march is perhaps
best conveyed here. The rear pony is sinking through the
surface crust and is kicking up large quantities of snow as
it lifts its leg. The backs of its legs and its belly are covered
in freezing snow.

Overleaf:
Ponies on the march, 2 December 1911 (S93)
···

As the pony column disappears into the distance, the
'sledgeometer' on the final sledge clicking the mileage as
it goes, the straggle of ponies becomes veiled in the icy
wilderness. Many of the men in this image would return, but
not all. None of the ponies would: within a few days they
would be shot.

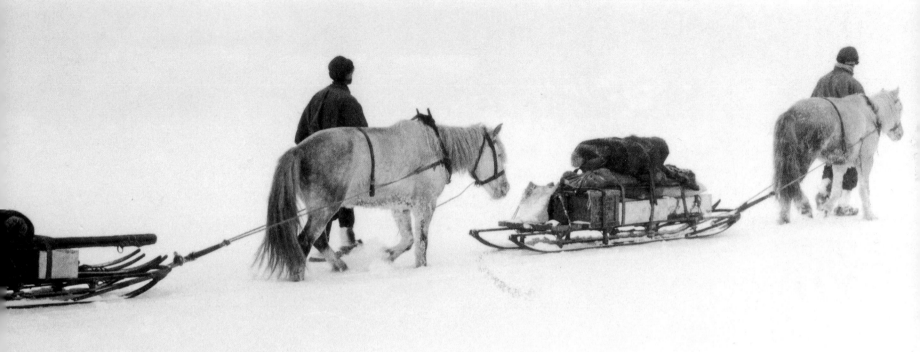

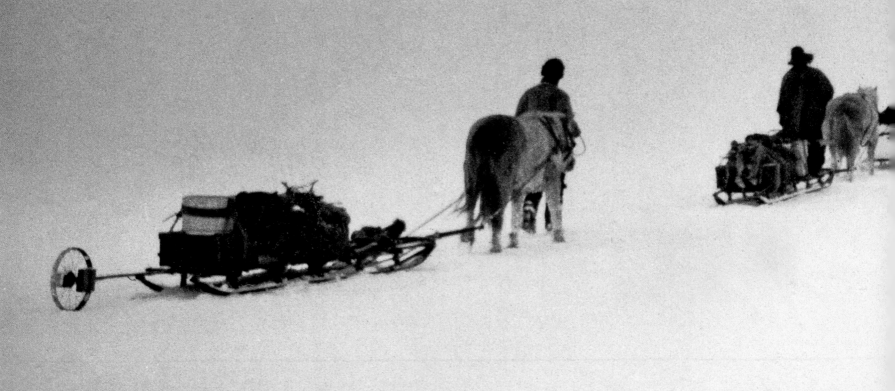

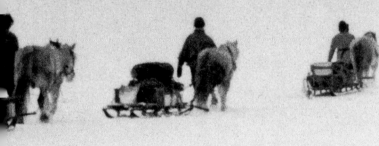

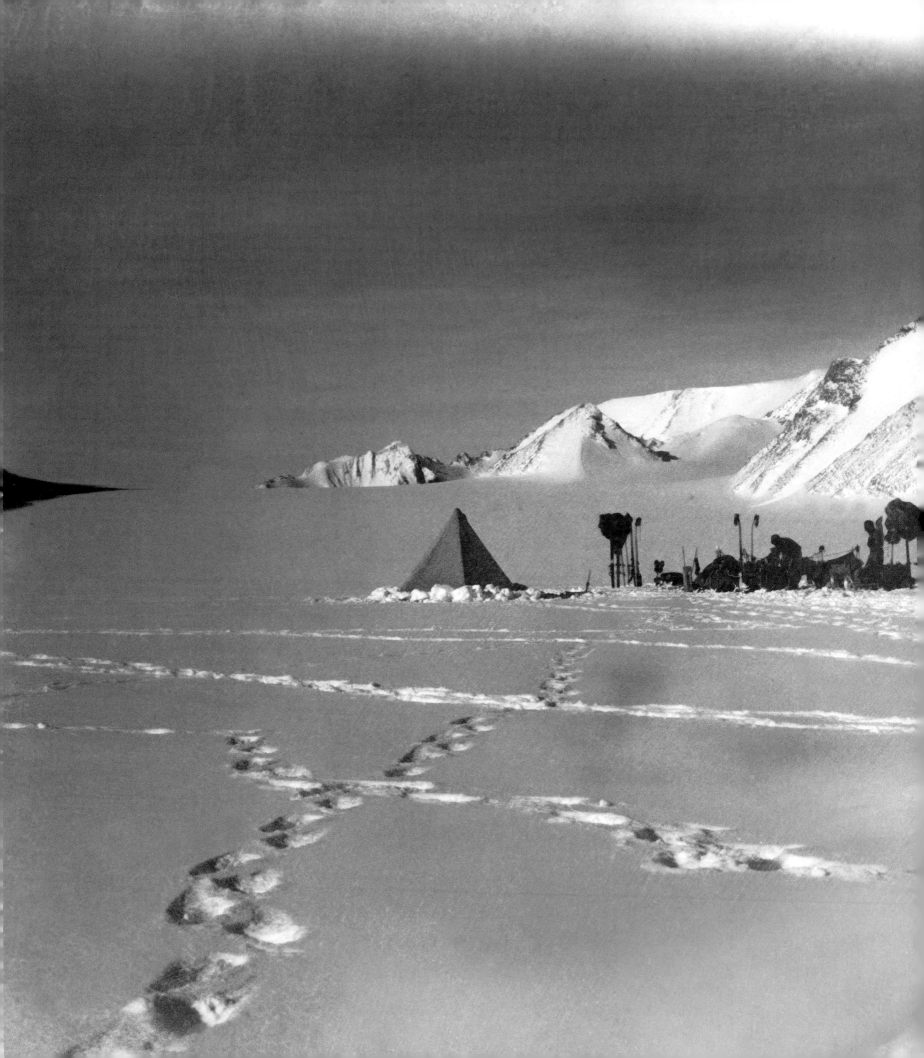

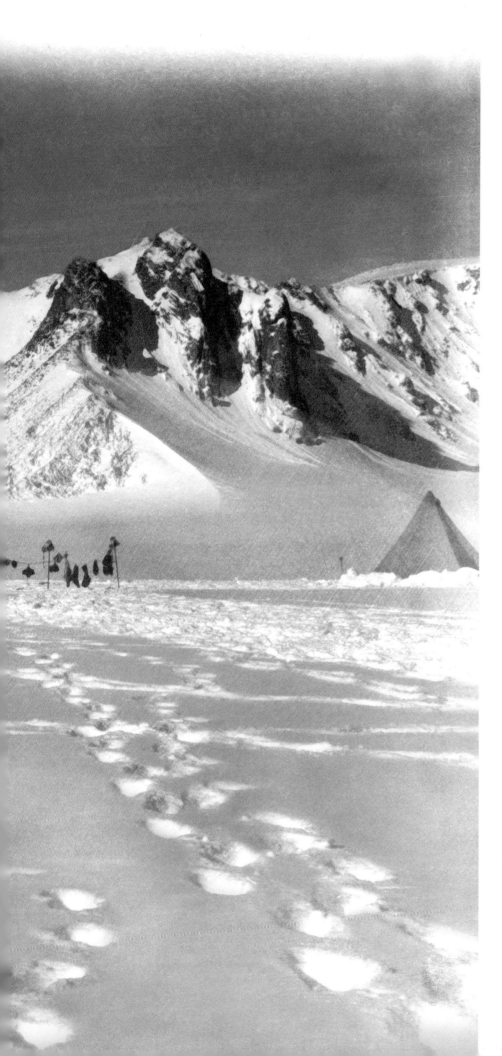

Looking up the Gateway from Camp 31, Shambles Camp,
9 December 1911 (S48)

..

The difficulties the ponies encountered on the Barrier
surface were nothing compared to those encountered by the
Southern Party after it was held up in an unusually warm
blizzard. The ponies sank up to their bellies in the deep snow
and were finally shot at Shambles Camp. This was at the end
of the crossing of the Great Ice Barrier and the start of the
ascent of the Beardmore Glacier. Now, as they stood before
the Gateway at the mouth of the glacier, the weather finally
cleared, giving bright and sunny conditions for photography.

Overleaf:
Looking up the Gateway to Mount Hope from Camp 31,
Shambles Camp, 9 December 1911 (S49; S50)

..

The improving weather allowed Scott to capture the grandeur
of the scenery as the party ascended the Beardmore Glacier.
Scott carefully composed this panorama of the Gateway:the
formation of the mountains is echoed by the camp in front.
Judging from his footprints, Scott has walked some way to
achieve this; they also show the awful snow conditions that
the men would have to pull the sledges through.

139

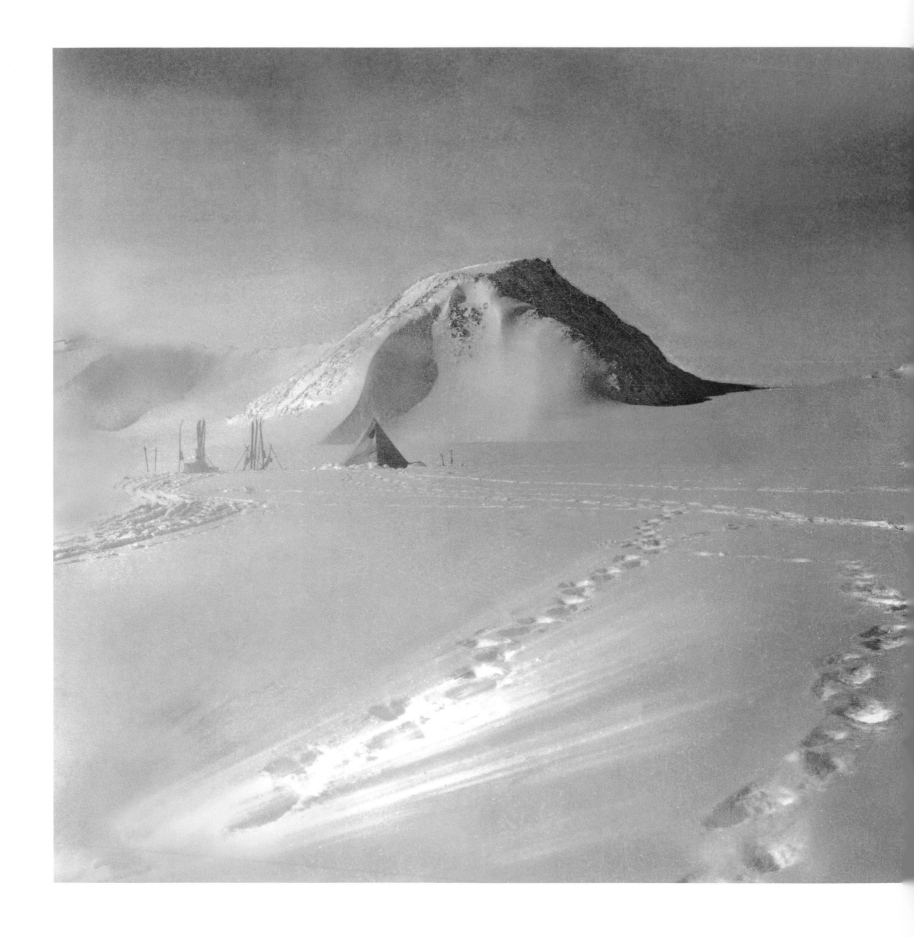

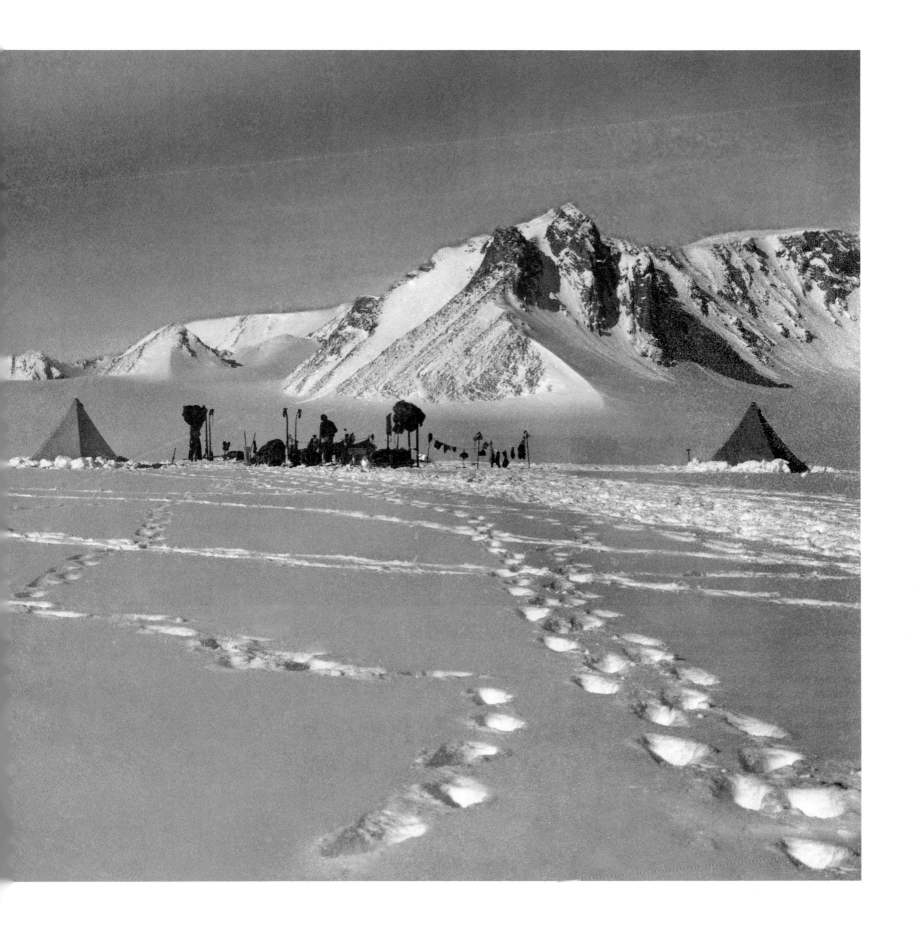

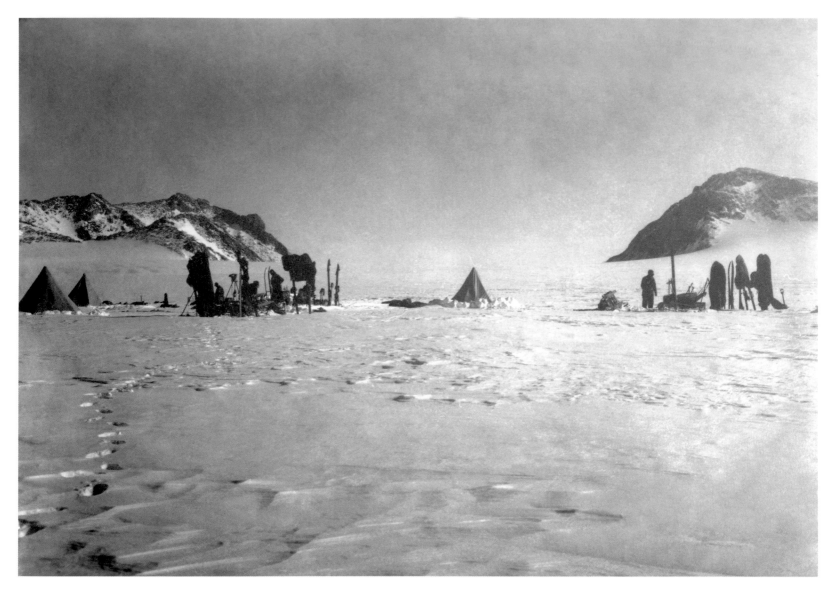

Looking north, back towards the Gateway from the Lower
Glacier Depot, 11 December 1911 (S52)

The Southern Party passed through the Gateway and onto
the Beardmore Glacier, where the Lower Glacier Depot was
laid, and from where the dog teams returned to Cape Evans.
From now on the men would pull their own sledges.

Scott took this photograph of the camp, looking north, back
the way they had come through the Gateway, the mountains
framing the expanse of the Great Ice Barrier beyond – and
the way home.

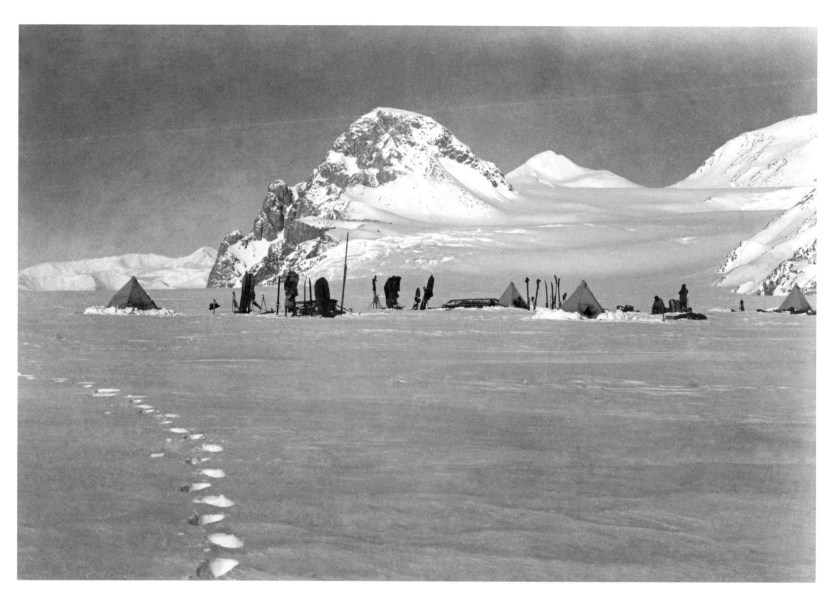

Looking south south-west towards the Granite Pillars from the Lower Glacier Depot, 11 December 1911 (S53)

Scott also took this image from the Lower Glacier Depot in the direction of their journey towards the pole. The stunning scenery and good weather may have lifted the men's spirits after the dullness of the Barrier but the depth of the snow they were encountering from the warm blizzard proved an even greater challenge.

Looking north-west towards the Granite Pillars (centre) and Mount Smith (extreme left). Lunch camp, 12 December 1911 (S34)

Having passed the Granite Pillars the Southern Party made their way slowly up the glacier in heavy snow. Some of Scott's most successful images were taken at the lower end of the Beardmore Glacier. Here he photographs their lunch camp, probably in the process of being dismantled. The frame of the pyramid tent reflects the stark isolation of the explorers against the grandeur of the rock pillars behind, which gave the landmark its name. The deep footprints in the snow lead the eye into the camp, showing the dreadful snow conditions they encountered.

This is one of a handful of Scott's photographs to have been previously published. In common with the others, the location was generally mistaken and the photographer misattributed.

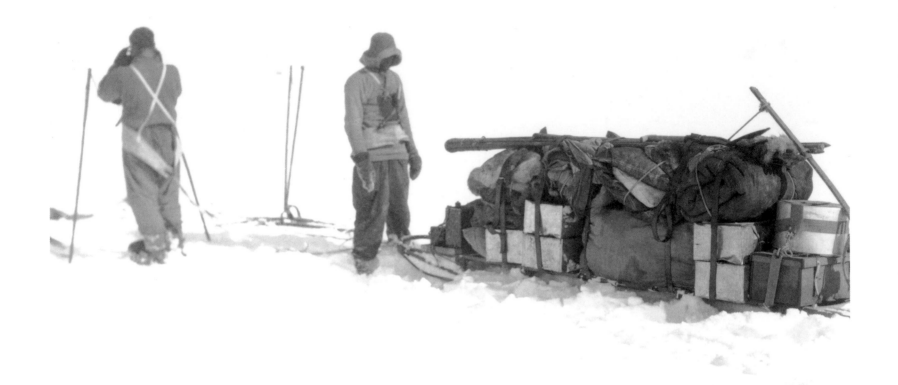

Waiting to depart, lunch camp, 13 December 1911 (S67)

···

The lunch-camp series is one of the most astonishing action
sequences photographed during any Antarctic expedition.
Scott called it 'A most damnably dismal day', as the teams
floundered in the deep, soft snow left by the recent blizzard.

According to Scott's diary, his team (Scott, Wilson, PO Evans
and Oates) went ahead, stopping for a three-hour lunch to
make alterations to their sledge to cope with the appalling
conditions. They were passed during their stop by Lieutenant
Evans' party (Evans, Atkinson, Wright and Lashly), who
forged on ahead. Bowers' party (Bowers, Cherry Garrard,
Crean and Keohane), who followed, evidently stopped for a
while before continuing. During the break, Scott was busy
with his camera.

This photograph is to the left of the lunch-camp scene and
shows two of Bowers' sledge party, probably Keohane and
Crean, waiting to depart.

Making alterations to a sledge, lunch camp,
13 December 1911 (S68)

In the centre, PO Evans and Oates are making alterations
and repairs to Scott's sledge. To the left, the rear of Bowers'
waiting sledge is clearly visible (S67, pp. 11, 146). To the
right of the sledge under repair, a pile of fuel containers can
be seen. (S32, pp. 21, 149; S33, pp. 20, 148)

Dr Edward Wilson sketching on the Beardmore Glacier, lunch
camp, 13 December 1911, (S33; S32)

To the right (linked via the fuel containers on the left), Wilson
is sitting quietly, sketching. He was one of the last artists in
the great expedition tradition in which the pencil was the
main method of making records. He produced many yards
of accurate geographical drawings, as well as extensive notes
and sketches of anything of scientific interest. Here he is
drawing the mountain ranges along the Beardmore Glacier,
from Mount Elizabeth (left) to the Socks Glacier and Mount
Fox (right).

This panorama is the finest example of Scott's remarkably
rapid mastery over his camera on the march in extreme
conditions. The combination of action and repose
– illustrative of Scott's unique pictorial understanding
– encapsulates the contrast between the Antarctic's majesty
and man's diminutive presence.

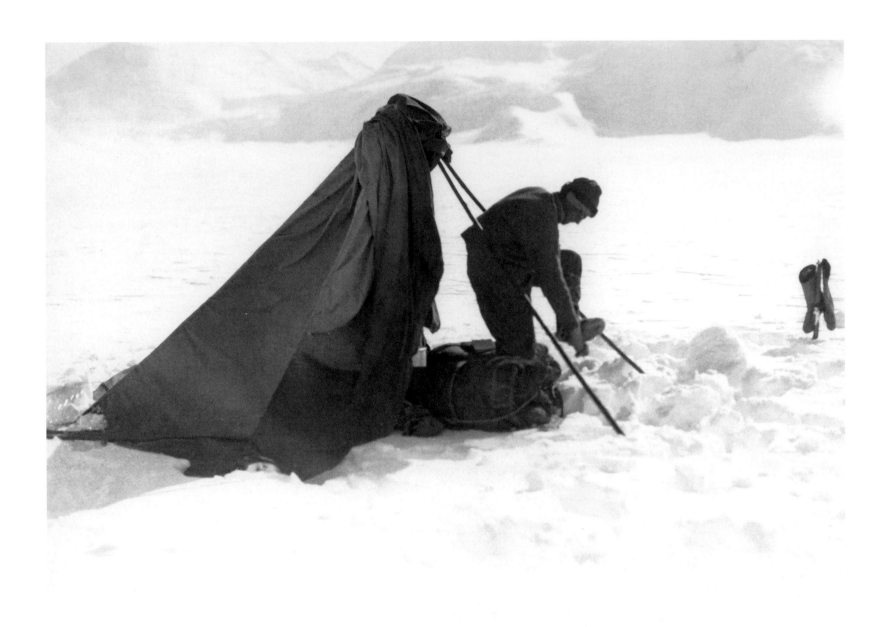

Edward Wilson at the lunch camp, 13 December 1911 (S69)

With the general lunch-camp scene having been set by Scott in a series of images (see previous pages), the action sequence now starts.

Someone appears to call Wilson away from his sketching to help with the departure of Bowers' sledge. Wilson first adjusts his footwear.

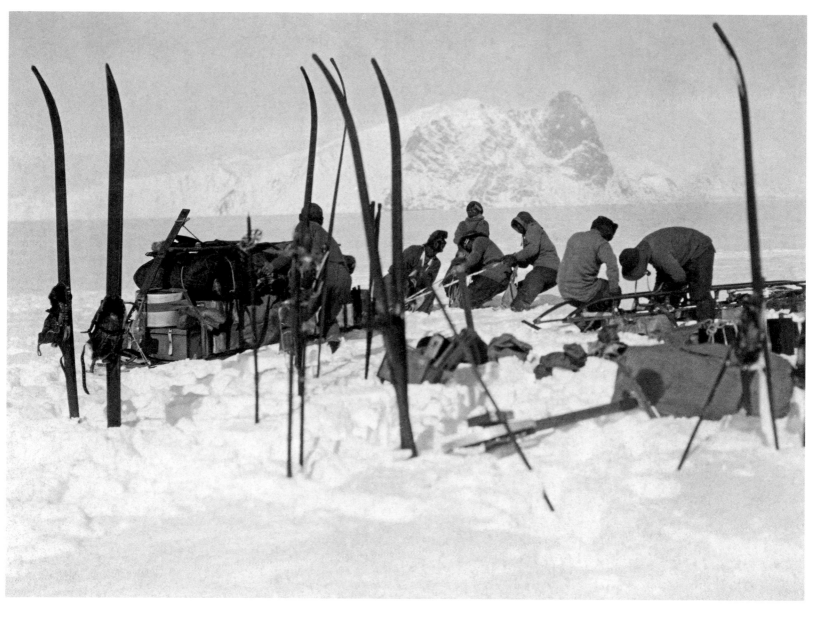

Foundering in soft snow (1), lunch camp,
13 December 1911 (S56c)

··

To the right of the photograph, PO Evans and Oates are
still working on Scott's sledge. To the left, Bowers, Cherry
Garrard, Keohane and Crean are seen trying to unstick their
sledge from where it has been resting in the snow. Wilson is
helping by pushing the sledge.

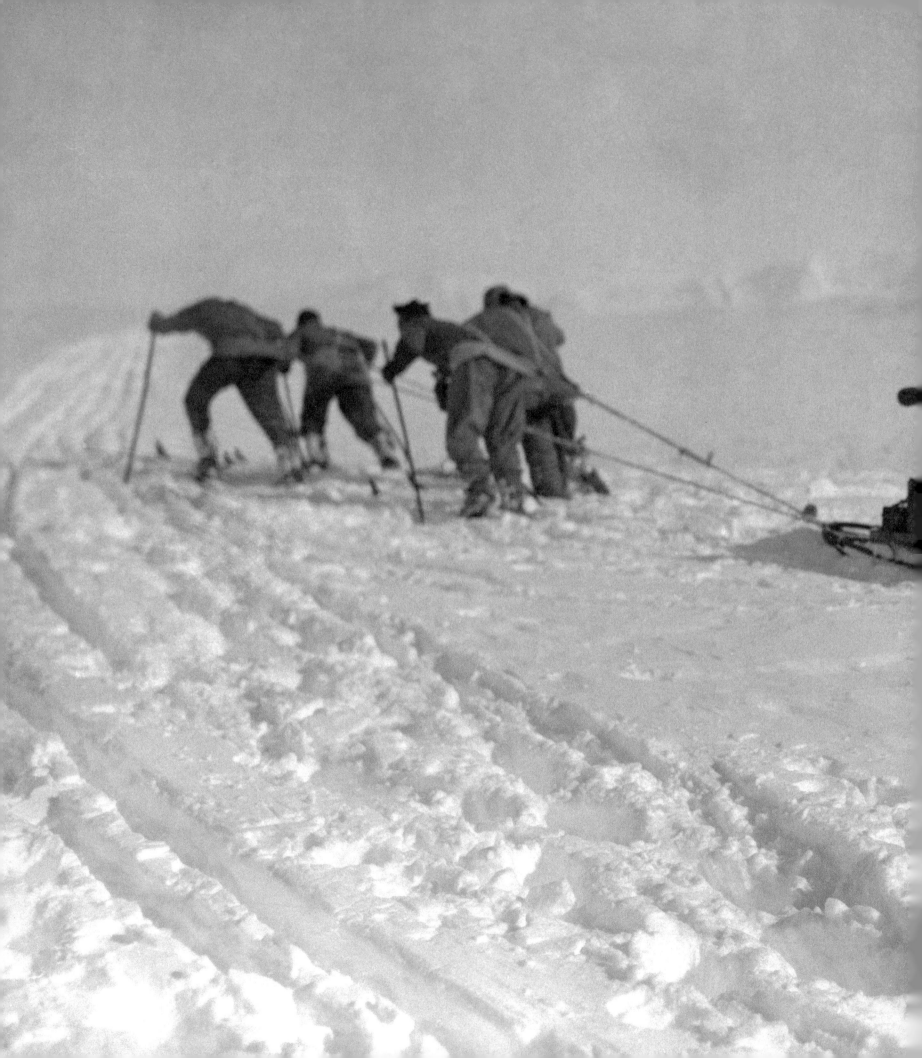

Foundering in soft snow (2), lunch camp,
13 December 1911 (S56a)

Bowers' sledge party – (front, left to right) Cherry Garrard
and Bowers (rear) Keohane and Crean – struggle in skis to
pull their sledge up the Beardmore Glacier through the deep,
soft snow. Wilson is still pushing. They are trying to reach
the tracks created earlier by Lieutenant Evans' sledge party,
which can be seen leading up the glacier.

This graphic image has often been reproduced and is
one of the most iconic pictures of the Heroic Age of polar
exploration. It is generally not attributed to Scott, nor has
it ever been reproduced in its proper context. It provides
a clear and graphic depiction of the struggle and sheer
human effort required by the men as they staggered
in the unusual snow conditions at the bottom of the
Beardmore Glacier.

Foundering in soft snow (3), lunch camp,
13 December 1911 (S56b)

As Bowers' sledge party – (left to right), Cherry Garrard,
Bowers, Keohane and Crean – reach the earlier track created
by Lieutenant Evans, the sledge plunges into soft snow and
begins to capsize. The two men at the rear, Keohane and
Crean, start to remove their skis and harnesses in order to
right the sledge.

In the distance, a dark speck can be made out higher up the
glacier; this is Lieutenant Evans' sledge party, which had long
since gone ahead.

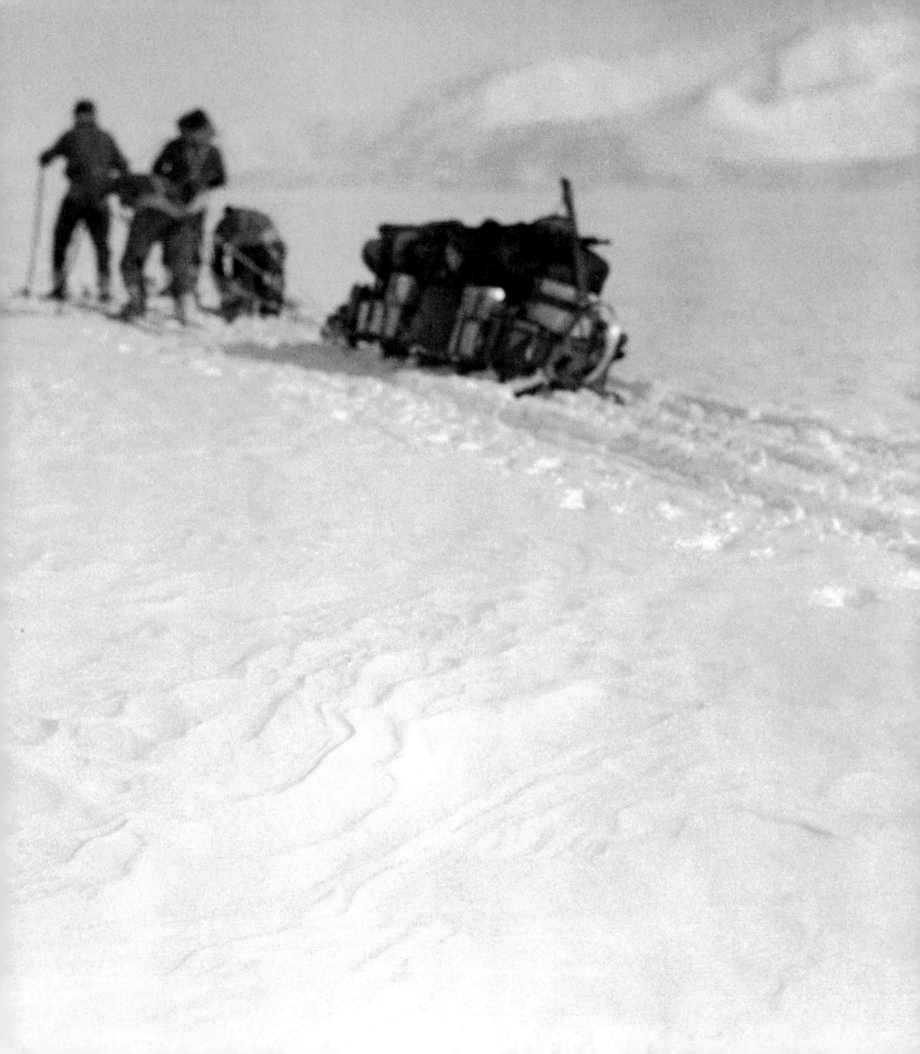

Foundering in soft snow (4), lunch camp,
13 December 1911 (S56)
...

With Keohane and Crean now pushing and Bowers and
Cherry Garrard pulling, the team continues its attempt
to move the sledge up the Beardmore and catch up with
Lieutenant Evans' team, which can be seen in the distance.
The depth of the snow in which the whole party struggled is
all too clearly shown in this image.

The photographs from the 13 December lunch-camp
action sequence bring alive the diary descriptions of all the
members of the Southern Party of these gruelling days. All
thought them among the most difficult and trying conditions
they had ever encountered, and it is not hard to see why.
They demanded an almost super-human effort.

Overleaf:
Camp under the Wild Mountains, night camp,
20 December 1911, 8 a.m. (S35)
...

After camping overnight, the early morning was spent
taking angles, photographing and sketching. Scott took
this impressive image to capture the interesting geological
features of the mountains around Mount Wild. He also made
extensive notes and sketches in his diary. All the teams of the
Southern Party had scientific objectives they were required
to meet during their transit of the Beardmore. These were
achieved, regardless of the considerable personal cost,
resulting in major scientific breakthroughs.

On the sledge in the camp, two figures can be seen
sketching. On the left, Cherry Garrard is drawing the view
towards Mount Buckley; on the right, Edward Wilson is
making detailed sketches and notes of the geological features
so clearly visible in Scott's photograph. The other figure
that can be seen is probably Bowers.

Scott returned his camera to base with the First Supporting
Party as they departed from the top of the Beardmore Glacier
towards Cape Evans. Critically, this lightened sledge loads for
the push across the Polar Plateau to the South Pole. Bowers,
with his lighter camera, was chosen by Scott to become the
photographer for the final Pole Party.

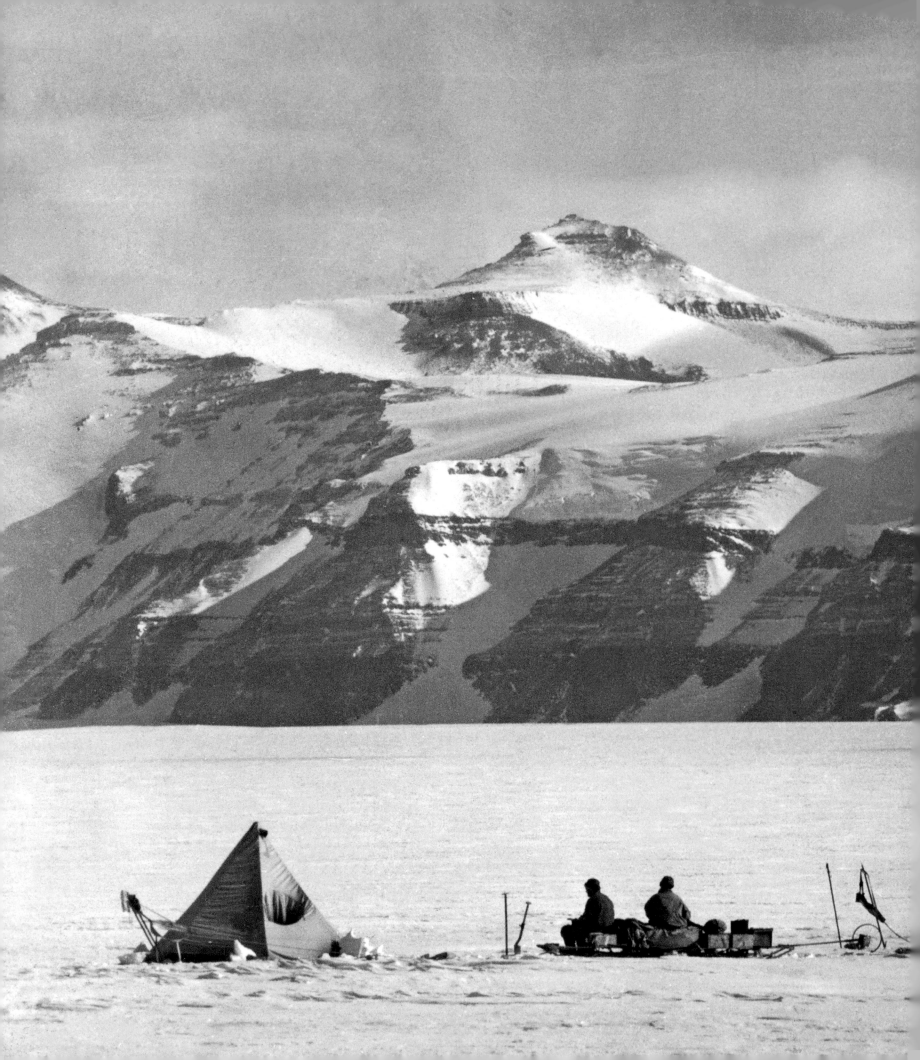

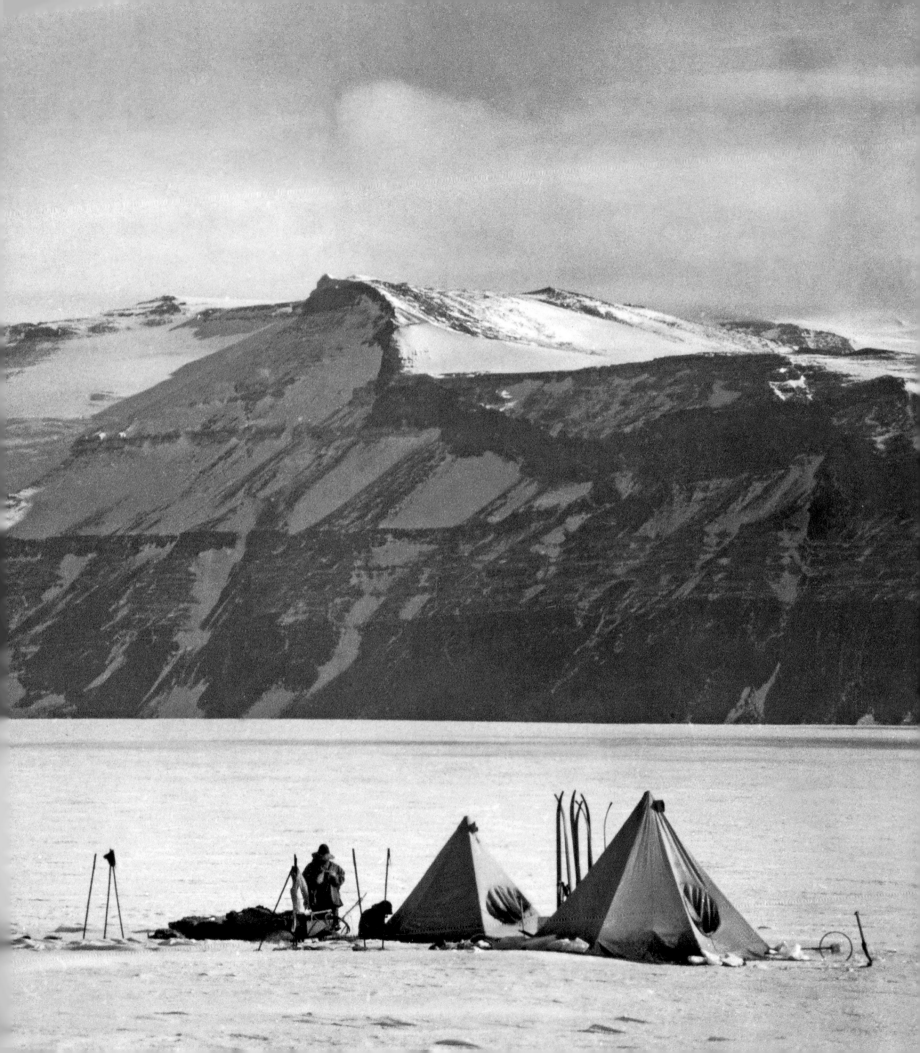

CAPTAIN SCOTT MEMORIAL SERVICE · NUMBER.

The Daily Mirror

THE MORNING JOURNAL WITH THE SECOND LARGEST NET SALE.

No. 2,906. Registered at the G.P.O. as a Newspaper. SATURDAY, FEBRUARY 15, 1913 One Halfpenny.

THE DEAD HEROES: THE KING ATTENDS THE IMPRESSIVE MEMORIAL SERVICE AT ST. PAUL'S CATHEDRAL.

A great and sorrowful congregation, whose thoughts were far away on the Antarctic wastes, assembled in St. Paul's Cathedral yesterday for the simple but deeply moving service held in memory of Captain Scott and his four brave companions, high and low being gathered together to pay their tribute to the memory of the little band who died so nobly. Dressed in the uniform of an admiral of the fleet was the King, while there were scores of distinguished people, including Mr. Asquith and members of his Cabinet. The drawing illustrates the scene in the great cathedral during the service.

LOST AND FORGOTTEN

In April 1912, as Ponting disembarked from *Terra Nova* in New Zealand, he was full of high hopes for the success of Scott and the Pole Party; the fact that they were already dead never crossed his mind. He was surprised to find news of the conquest of the South Pole awaiting: Amundsen had got there first and had seen no sign of Scott. The Norwegian was already touring the world, basking in the glory. Ponting's initial reaction was a gentlemanly one: '… we, who had spent more than a year in the Great White South could, perhaps, better than anyone else, realise the magnitude of Amundsen's achievement.'[1] He was not in any doubt that Scott had made the pole. Now, however, he knew what Scott would have found when he arrived: disappointment.

By the time he had returned to London several weeks later, Ponting had become aghast at how Amundsen's expedition was overshadowing Scott's work. The British expedition was already being portrayed in the press as part of a great 'race to the South Pole'. He wrote a long letter to *The Times*:

The popular idea that there has been a race to the South Pole is an error. Captain Scott has not been racing, nor has he been engaged in a mere 'dash to the Pole'. He is leading a great scientific expedition – perhaps the greatest ever sent out from any land – and the reaching of the South Pole was but one part of the programme laid out …[2]

He was wasting his breath. Sir Clements Markham had been heaping abuse on the use of the term for over a year:

The catch-penny expression 'race to the south pole' is much to be deprecated. The expedition which includes the south pole in its contemplated work (being the apex of the Victoria Quadrant which is Scott's allocated sphere of exploration) is a scientific one.[3]

But to no avail. Amundsen's rush for the South Pole had tarred Scott's expedition with the same brush, and, as Scott had foreseen, his not achieving the expedition's primary object of being first at the pole was undermining its other work. The rift between adventure and scientific exploration was engulfing Scott's efforts, and the expedition was being pushed into the sphere of adventurers and its scientific programme increasingly ignored. The difficulty was that in a general sense there *had* been a race to the South Pole: Scott had left British shores with the intention of being there first, even if there had not been a race in the specific sense of Amundsen and Scott pursuing each other. Scott had refused Amundsen's gauntlet, leaving him to sprint alone, but the nuance was lost in media headlines and the myth of a polar race was growing. Ponting became even more upset when he realized the effects on his own enterprise. The cinema was a new phenomenon in Edwardian England. Short films had previously been shown in theatres or lecture halls but

from mid-1910 purpose-built moving-picture houses started to open. Typically they showed a two-hour programme of mixed films, documentary, news and entertainment – the feature film was still a thing of the future. Edwardians were transfixed by the new technology. Among these films were those of Herbert Ponting. His earliest work had been sent back to civilization with *Terra Nova* when she left them in the Antarctic for the winter of 1911 and audiences were spellbound. As a result, Scott's expedition had engaged the public in a way never previously achieved.

Ponting was delighted and wanted to capitalize on his growing reputation. He set to work, now having a catalogue of over 1700 negatives and some 25,000 feet (7620 m) of film to work on. At Wilson and Scott's request he had filmed the breeding cycles of Antarctic species and, despite seal bites and nesting skua attacks, he had achieved it, revealing previously unknown behaviours in the process. His work had moved beyond the simple travelogues or 'scenics' of the period, becoming the genesis of polar wildlife documentary film-making. The contemporary work of Sir David Attenborough and others continues this use of film today; indeed, scenes in *Life in the Freezer* (1993) echo scenes from Ponting's film eighty years before.[4] Ponting was hugely excited and looked forward to sharing his biological discoveries with Wilson on his return.

In September and October 1912 the French Gaumont Film Company released the second series of his film footage, *With Captain Scott R.N. to the South Pole*. Ponting's films were again a great success, revealing a continent almost unknown fifteen years previously. However, there was a shadow. After Amundsen's successful attainment of the pole not quite so many people seemed interested in seeing film of Scott and his team: they had clearly failed to bag the pole first; it was old news. Instead, people across the world queued to hear Amundsen lecture. On top of this, Ponting found that the rights to his photographs had been sold by the expedition trustees, who had been left in charge of different aspects of expedition affairs by Scott before he went away; Reginald Smith, the publisher, was dealing with publishing and media matters. The sale apparently breached verbal arrangements that Ponting had recently made with Scott, which Ponting considered overrode an earlier agreement signed by all expedition participants, stating that photographs were to be the property of the expedition. The trustees, however, were not party to the new arrangement. Ponting felt the sums involved did not reflect the value of his work and he was incensed. He sent letters to Scott and to Wilson with the next (1913) relief voyage of *Terra Nova*, asking that the matter be sorted out at once. They were never to see them.

After his long spell working in the arduous conditions of the Antarctic and several hard months getting things ready for

Scott's return and worrying over finances, the status of the expedition and its work, it is not surprising that by the end of the year Ponting was exhausted. In December he left for a long holiday in Switzerland to be rested for Scott's expected return in the spring.

In early February 1913 Ponting was at Wengen when he received a telegram that changed the remainder of his days: 'Captain Scott and entire Pole Party perished whilst returning from the South Pole.'[5] Ponting was incredulous and wired for confirmation. It soon came. The shock to Ponting was very considerable. He returned to London at once and attended the national memorial service at St Paul's Cathedral on 14 February. In a unique gesture, His Majesty King George V led the nation in its grief. Thousands stood outside the cathedral, unable to obtain admittance. The story of the end of Scott and the Pole Party had shocked and inspired many across the British Empire and beyond.

After leaving Lieutenant Evans and the Second Supporting Party, Scott and the Pole Party had continued in good spirits, with Birdie Bowers photographing as they went. They reached the South Pole on 17 January 1912, only to find that Amundsen had beaten them to it by 34 days. It was a huge disappointment but neither was it completely unexpected. Amundsen was not interested in exploring the region, simply in putting his flag at the pole first. Scott knew perfectly well that if he met no obstacle Amundsen would reach the pole ahead of him.

They spent most of the next day in the area of the pole, making such records as they could. Scott did not take any of the photographs, leaving the job to Bowers and to Wilson, who also sketched. Under the circumstances, Ponting could not have done better himself.

On the return march, the Pole Party continued its scientific work, in particular on the Beardmore Glacier. All the returning parties had continued executing scientific and exploratory work on the journey back to Cape Evans and the Pole Party was no exception. The most quoted instance was a stop to geologize in the region of Mount Buckley. In Scott's diary entry for 8 February he makes it sound casual: '… I decided to camp and spend the rest of the day geologizing. It has been extremely interesting …'. It was, however, no whim. They had been geologizing that morning and continued the following day. The reason was simple: Shackleton had found coal in this area and the geologists wanted to know more; it was part of the planned scientific programme. The specimens they found were among the most exciting of the entire Heroic Age, including the first known specimen of *Glossopteris* from the Antarctic. This would become a key species in the development of the Gondwana theory and later of the theory of continental drift, changing the way that we understand the world.[6] Wilson recognized the importance of the specimens which were carried with them to the last, some 35 lbs (15.88 kg) of rock.

However, all was not well. On 17 February at the bottom of the Beardmore Glacier, near to where Scott had photographed the lunch camp of 13 December, the party started to encounter tragedy, with the death of Petty Officer Evans. Thought by Wilson to be the result of a brain injury sustained during one of many minor falls into a crevasse, the death of Evans has been the cause of much conjecture ever since. If the Pole Party had struggled on the return journey to navigate through the heavily crevassed areas at the top of the Beardmore Glacier, it was Evans' slow deterioration and eventual loss that seriously delayed progress and was a huge psychological blow. As was their return to the Great Ice Barrier, where instead of the expected temperatures projected by Scott's meteorologists as part of his Pole Journey planning, they encountered much lower average temperatures (around -40°F (-40°C) as opposed to the expected -4°F (-20°C)), substantially increasing their risk of frostbite. Add to these the lack of expected tailwinds and the extreme cold resulting in debilitating changes to the surface over which they had to pull the sledges, the texture becoming like dry sand. The conditions made it almost impossible to move their sledge, regardless of weight. As with the earlier warm blizzard, Scott was perplexed and frustrated by the low temperatures and resulting conditions.

A recent analysis of the contemporary meteorological record has shown that his reaction was quite reasonable.[7] Nine years out of every ten, he would have sledged into the temperatures that he was expecting. However, he had sledged into the one year when winter sets in early, which had not yet appeared in the sparse data. Bowers and Wilson had sledged in conditions as cold or colder than this, and it could certainly be done, but not at the pace required to reach safety.

What followed was a tale of extraordinary courage in the face of impossible odds. Captain Oates was the first to succumb, his feet becoming badly frostbitten, slowing their progress over many days. Having lost hope for himself and in an effort to save his companions, he finally walked out into a blizzard with the words, 'I am just going outside and may be some time.' It has become one of the most famous suicides in history.

Oates' sacrifice occurred somewhere between outward Camp 15, where Scott had photographed the ponies standing in warm sunshine only four months previously, and outward Camp 14. Here, Scott abandoned the final camera in the snow in a vain effort to lighten the sledge and ease its drag:

We are cold on the march now, and at all times except meals. Yesterday we had to lay up for a blizzard and to-day we move dreadfully slowly. We are at No. 14 pony camp, only two pony marches from One Ton Depôt. We leave here our theodolite, a camera, and Oates' sleeping-bags. [Saturday 17 March 1912]

They did not abandon the important geological specimens, though, in fact, their weight made little difference. Oates' action might have been enough to see the others through. It left three men surviving on rations and fuel for five, which, even with the loss of fuel which Scott noted from his cans, should have been sufficient. However, these were not normal circumstances.

In winter sledging conditions, as the Winter Journey to Cape Crozier in 1911 had attested, attention to detail is critical. Scott's coup de grâce came in the form of a teaspoon of curry powder:

We have had more wind and drift from ahead yesterday; had to stop marching; wind N.W., force 4, temp. -35°[F] [-37°C]. No human being could face it, and we are worn out – nearly. My right foot has gone, nearly all the toes – two days ago I was proud possessor of best feet. These are the steps of my downfall. Like an ass I mixed a small spoonful of curry powder

with my melted pemmican – it gave me violent indigestion. I lay awake and in pain all night; woke and felt done on the march; foot went and I didn't know it. A very small measure of neglect and have a foot which is not pleasant to contemplate. [Sunday 18 March 1912]

A few days later, 11 miles (20 km) short of One Ton Depot, with Scott's feet now badly frost-bitten, his chances of survival were already close to nil. However, the entire party was caught in a blizzard. Unable to reach their huge depot of supplies, the remaining three members of the Pole Party, Scott, Wilson and Bowers, died together on or about 29 March 1912, the date of Scott's last diary entry.

The following November the Search Party found their bodies and buried them where they lay. They recovered their remarkable diaries, along with Bowers' exposed films from the pole. While the Search Party recorded finding Oates' sleeping bag and the abandoned theodolite, no mention is made of the pole camera and it appears that it was never recovered from Pony Camp 14.[8] The ice holds it, and, with the bodies of Scott and his companions, it is slowly drifting through the ice shelf until it meets the open ocean. There, if the sailors were right, the Jonah will finally be cast out, to find its resting place in Davy Jones' Locker, while the Pole

A tribute to the heroes of the Antarctic.

.......................................

A penny pamphlet was published to raise money for the Lord Mayor of London's Fund for the widows and orphans. Enough funding was raised to provide pensions for the dependants and to pay off the expedition debts. It also paid for the publication of the expedition's scientific reports, and the founding endowment of the Scott Polar Research Institute in Cambridge, which continues the expedition's purpose of the study of the polar regions a century later.

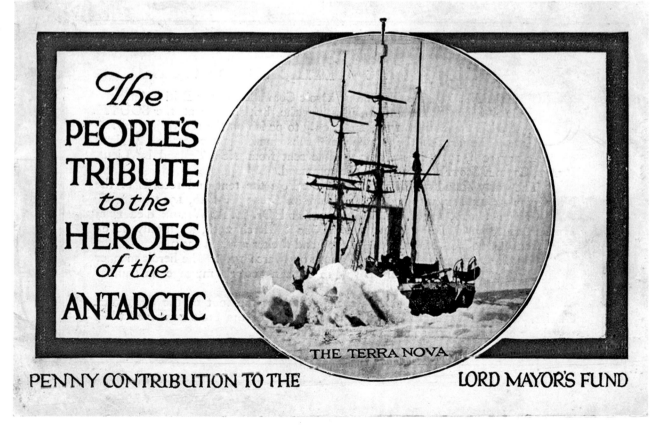

The PEOPLE'S TRIBUTE to the HEROES of the ANTARCTIC

THE TERRA NOVA

PENNY CONTRIBUTION TO THE LORD MAYOR'S FUND

Party will receive a final committal to the deep, Oates and Evans following Scott, Wilson and Bowers some years later.

Scott never wanted his fate to be seen as a tragedy, as he wrote to his widow. To the wider world he addressed his famous 'Message to the Public' at the end of his diary, in which he made plain:

… we took risks, we knew we took them; things have come out against us, and therefore we have no cause for complaint, but bow to the will of Providence, determined still to do our best to the last …

It was, however, greeted as a tragedy, giving birth to the myth of Scott of the Antarctic. Over £75,000 was subscribed to the memorial appeal for Scott and the Pole Party, equivalent to some £4.5 million today, the appeal having been raised in response to Scott's appeal to the country: 'For God's sake look after our people.'

The scale of the reaction was overwhelming. Yet death in exploration is not unusual; it continues to this day. Almost every Antarctic expedition of the period had casualties which were not seen as particularly tragic. Five deaths, while more than other expeditions, was not out of scale; between one and three was typical. Nor was this a tragedy on anything like the scale of Arctic exploration, where entire ship's companies were lost. Death in such pioneering enterprise does not generally bestow special accolade, nor special vitriol for incompetence. It is hard not to conclude that something far more complex was and is at work in the reactions to the death of Scott and his companions.[9]

In part it was a recognition from the British people and press that Scott died keeping his promise to deliver them the pole; in part it was because Scott was very well known to many thousands of ordinary Britons, not least because of the success of Ponting's films; and in part the deaths resonated with numerous ideals of British Edwardian culture, as well as classic Homeric themes – an Achilles dying at the height of his human achievement but due to his human flaws.[10] No doubt it was also down to Scott's talent as a writer, whose diary account was published with only minor editing to protect the feelings of the living.[11] His inner thoughts were exposed to the world in a way that never occurred for his peers. It is a testimony that digs deep into the meaning of the human condition, facing readers with their own mortality, their own successes and their own defeats.[12] For these reasons, and for many more, Scott and his companions came to represent in their deaths far more than they ever had in their lives. Their myth became a cultural icon.

While the myth of the expedition and the race to the pole grew on a tangent increasingly divorced from its reality, a large number of Scott's men quietly carried on with the work of the expedition. Scott had made it clear where his interests lay in his last letter to his wife, which revealed his wishes for his son, Peter. He could have written, 'Send the boy to Eton', or 'Make sure he enters the Royal Navy' or 'Make him a great explorer'. Instead, partly inspired by the life of Wilson, who lay dying by his side, he wrote:

Make the boy interested in natural history if you can; it is better than games; they encourage it at some schools. I know you will keep him in the open air. Above all, he must guard and you must guard him against indolence. Make him a strenuous man …

In his dying wish for his son, it is quite apparent on which side of the rift between the explorer-scientists and adventurers Scott's heart lay: in science. It was not a message lost on his team, or his family. Thanks to a friendship forged on the ice, Peter Scott went on to inspire the twentieth-century conservation movement, founding the World Wide Fund for Nature and the Wildfowl and Wetlands Trust, among many achievements. With the help of Raymond Priestley and Charles Wright, Frank Debenham conceived and founded the Scott Polar Research Institute in Cambridge, which continues the multi-disciplinary work of the expedition to this day. The Institute is also the national memorial to Scott and the Pole Party, being partly founded with monies from the public appeal. Its influence on the study and governance of the polar regions is extensive. Murray Levick went on to found the British Schools Exploring Society, touching the lives of thousands of young people and guarding them against indolence. The cultural and scientific legacy of the expedition is immense. However, it remains largely unsung.

Ponting also continued with his work. Little research has been done on the effects of the tragedy on the lives of those who survived, but it was often profound. Personal grief compounded by that of the public reaction caused emotional turmoil. Ponting had lost two men whom he had come to consider his close friends, and while other survivors of the expedition came to resent his claims of having had a special relationship with Wilson and Scott, there is no doubt that it was true. Together they had worked on the most ambitious imaging programme of the polar regions conceived at the time. Now Ponting was the only one of the three left to deliver it. He became determined to do his utmost to fulfil the vision that Scott had first described to him. Further, Ponting thought them examples for the Empire and martyrs to science. He dedicated the rest of his life to telling and retelling their story and never seriously photographed again.

The affairs of the expedition had also been plunged into confusion. In addition to the expedition trustees, there was also an executive committee. Lieutenant Evans had

Captain Scott's camera

..

Current evidence suggests that
this is Captain Scott's own camera,
rather than the camera used by
Birdie Bowers at the South Pole,
as has sometimes been asserted.
It was donated by the Scott family
to the Scott Polar Research
Institute's Museum in 2006.

recovered his health in time to head south with *Terra Nova*
on her relief voyage to the expedition in 1913. On hearing the
shocking news of the death of the Pole Party on his arrival at
Cape Evans, he had, as second-in-command, immediately
assumed leadership of the expedition, appointing an
executive committee of lieutenants Campbell, Pennell and
Bruce, Dr Atkinson and Francis Drake, the expedition
secretary, to help him wind up the affairs of the expedition.[13]
The executive committee placed Frank Debenham in charge
of the Western Party geological specimens at the end of
January. On 11 February 1913, the day before *Terra Nova*
arrived back in Lyttelton, New Zealand, he was also given
charge of 'all the photographic apparatus and records of this
Expedition' and the authority to make any necessary copies
of photographs at his discretion.[14]

Debenham had previously been left in charge of the
photographic programme by Ponting. He had worked hard at
it over the second season. All negatives not catalogued by
Ponting had been compiled by Debenham over the previous
winter: S-numbers for Scott, B-numbers for Bowers, G-
numbers for Gran, and so on, with the number being written
onto the negative. This completed the Ponting-Debenham
Index to the expedition photographs. It was Debenham, too,
who had developed the all-important pole photos taken by
Bowers. It might have been expected that Ponting would be
given control over the entire photographic department upon
the return of the expedition. However, this order gave
Debenham authority over all expedition images, including, by
implication, those of Ponting. It therefore seems likely that it
was Debenham who made copies of many of the
photographs released to the press during the days which
followed the arrival of the expedition in New Zealand.

The precise details of what happened next are lost in time.
Terra Nova returned to Cardiff sailing via South America;
Debenham and Wright returned to Cambridge via Wright's
home in Canada. By one means or another, the expedition
photographs returned home, including Scott's negatives. The
working arrangements and remits between the existing
expedition trustees and the executive committee are unclear,
but presumably the executive committee assumed Scott's
command (subordinating the trustees) and worked out
expedition affairs accordingly. Nor is it clear precisely how
Debenham's authority affected Ponting. What is clear is that
the photographic department soon devolved into a
considerable mess. It was during a visit to the United States
in March 1913 that Ponting agreed to sell the rights to
expedition pictures for $10,000, only to be told that they had
already been sold elsewhere by Reginald Smith for a mere
£100.[15] He soon fell out with the executive committee and
other members of the expedition, and in particular Lieutenant
Evans, in a feud over the use of his photographs which lasted
for the next twenty years. While it was clear that the

expedition had the use of Ponting's images for, he claimed,
the next two years, this did not, Ponting asserted, include
Lieutenant Evans using them for his lectures. Ponting lost
the argument.

The mess ran deeper than rights. All the images taken by
members of the expedition had been handed over to the
executive committee. It is doubtful that Ponting parted with
his negatives, instead submitting prints, but likely that the
others did so. From the assembled pictures, a selection of
'interesting' images was made for exhibition and publication,
including a number of Scott's own photographs.

It was from this selection that many private albums of
images were made, and distributed to editors, expedition
participants, relatives and friends of the expedition.
Applicants were given clearance to apply to Messrs
Raines and Co., of Ealing, the noted photographic
reproduction studio, which produced the images for
such albums and presumably also for the forthcoming
exhibitions, as photographic reproduction and display
was their particular expertise.[16]

At some point in the reproduction process, rather
inexplicably, images other than Ponting's became muddled
up. It is unclear whose responsibility the photographs were
or how it happened, but the results are still apparent. The
same series of Scott photographs, sometimes correctly
attributed but more often not, resurfaces time and again.
Some later made their way into archives, where they may or
may not be recognized among larger collections.[17] More
seriously, the confusion often apparent in the photograph
albums of the time was carried on into publication.

With interest in Scott's death running high, media demand
for expedition images was intense. As expected for the
official expedition photographer, Ponting's images were the
main focus of publication efforts by the executive committee.
From July 1913, the *Strand Magazine* published lengthy
extracts from Scott's diary, along with a selection of Ponting's
photographs; eight of Scott's own photographs were also
included.[18] In this first publication, the photographs seem to
be correctly attributed. By November 1913, however, when
Scott's diary was published as *Scott's Last Expedition*, the
non-Ponting photographs were a morass of confusion.[19] The
publication of the sensational panorama of Wilson sketching
on the Beardmore (S32, pp. 21, 149; S33, pp. 20, 148) was
only half published and quite how Scott's photograph of
ponies on the march (S55a, p. 187) was published under the
name of Frank Debenham, when he could not possibly have
taken the photograph, remains perplexing. Another Scott
photograph was published under the name of Bowers (S34,
p. 144). The only likely explanation is that poorly labelled
prints had become detached from well-labelled negatives

and from the Ponting-Debenham Index. Five Scott photographs were published in all in the diaries but only three were correctly attributed; photographs were also incorrectly labelled, setting a standard for the use of the images from the expedition which has not been corrected in a hundred years.

That the muddle of the images has not been corrected by numberless researchers over the past hundred years is bewildering. In 1914 the first biographical work on Scott was written by Charles Turley. *The Voyages of Captain Scott* made extensive use of the Scott photographs, reproducing ten of them in the book, many labelled in some detail.[20] It makes the earlier messy publication of *Scott's Last Expedition* all the more bizarre. Even less comprehensible is that no subsequent biographers followed his lead, instead following the errors of the earlier debacle and compounding them.

Ponting himself, being at loggerheads with the expedition committee, would appear to have been somewhat detached from this process, but, in any case, he was by now enjoying great personal success. An exhibition of a selection of his photographs was held by the Fine Art Society in London in December 1913.[21] This was not quite the joint exhibition with the other photographers and with Wilson that he had hoped for. The trauma of Wilson's death was too much for his widow, who blocked any such event, holding a separate exhibition of his paintings at the Alpine Club.[22] Both exhibitions subsequently toured the country. As a result, the expedition's full imaging programme was never exhibited.[23] Nevertheless, the deaths of the Pole Party had reignited interest in Ponting's films and pictures across the world. Despite the embarrassment over the rights issue, Ponting's work had been widely recognized in the United States. *Scientific American* hailed the photographic work and in particular the moving film of the expedition as a major scientific and pictorial breakthrough, with the standard of imaging achieved now justifying the risk of such polar expeditions:

Time was when the results of the perilous voyages of discovery were scarcely thought worthy the cost. Nowadays, however, when the pioneer may train the eyes of all the world upon the windows which he is laying here for the first time by his efforts, the risk is justified. He is not storing up experience for himself, alone, but for the whole of mankind. His success becomes a matter of paramount interest and importance to everybody, because it is a success in whose benefits we can all now share.[24]

A new era of polar illustration was under way. This may also be seen from the work of Ponting's contemporary, the Australian Frank Hurley, a professional photographer who participated in Mawson's Australasian Antarctic Expedition of 1911–14. His work was better than average but was not

bold enough to redefine the genre. It was with Ponting's techniques and inspiration that Hurley headed to the Antarctic once more in 1914 to photograph for Shackleton's Imperial Trans-Antarctic Expedition aboard *Endurance* and emerge with images and film of comparable quality.[25] Hurley later saluted Ponting as 'the leader in Antarctic photography' and Ponting in return would admire Hurley's later work.[26]

From early 1914 Ponting commenced a series of lectures to accompany his films at the Philharmonic Hall in London, attracting huge audiences. The press reported that all society was attending, including luminaries such as United States President Theodore Roosevelt. Over 120,000 people attended between January and March 1914. Ponting's work was moving an entire generation. In May, in a revolution for film, he was summoned to lecture for the King and court:

… for the first time in the brief history of living pictures, one film, already famous, has received the Royal command … Mr. Ponting has now succeeded in obtaining for photography all the acknowledgements which were reserved for drama, painting and literature.[27]

Ponting's film had become one of the great achievements of British cinema. Alongside his films he produced a cuddly toy, 'Ponko' the Adélie penguin, in one of the earliest examples of merchandizing alongside a film.[28] Ponting's success, however, was starting to attract envy from other expedition survivors, who thought he was raking in a vast personal profit. This was not entirely the case. A lot of the money went to pay off expedition debts and to the national Scott Memorial Appeal, and his lecturing expenses were high. He even bought out Gaumont's rights in the film to ensure better control of it for posterity. He was not making as much personally as his colleagues seemed to think. Ponting was unmoved, determined to tell the story of his friends and their work. Additionally, he was now spurred on by royal command: the King had expressed the wish to Ponting that every British schoolboy should see his pictures, as it would help to promote the spirit of adventure which had made the Empire. Few could have guessed that the work of the Scott expedition and its imaging programme in particular was about to suffer a worse calamity than the death of Scott.

If the deaths of Scott and the Pole Party had revived interest in Scott and his work, retrieving the expedition from the tarnish of simple adventurism, it was nevertheless a precarious balance. The considerable emphasis being placed on Scott's scientific work by the expedition survivors and the learned societies who were making use of that work was being slowly overwhelmed by a different narrative of adventurism: the view that Scott's death in the service of his country was an example for the Empire – Scott the hero.

A programme for Ponting's lectures on Captain Scott
..................................

Ponting's lectures, which accompanied his silent films at the Philharmonic Hall in London, were a huge success, with over 100,000 people going to hear him, including leading politicians and celebrities of the day. His films were a significant milestone in the history of the cinema.

MR. HERBERT G. PONTING'S CINEMA LECTURE

"With Captain Scott in the Antarctic"

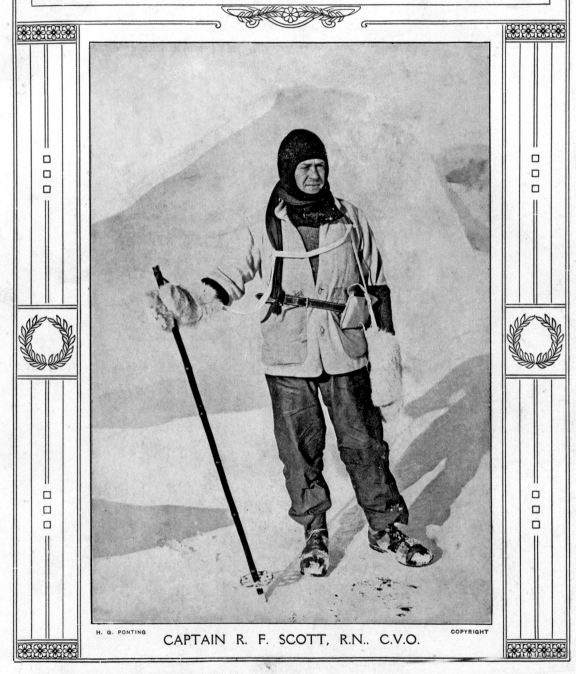

H. G. PONTING

CAPTAIN R. F. SCOTT, R.N., C.V.O.

COPYRIGHT

Scott's achievements in science and exploration were slowly swallowed by his own romantic myth.

The outbreak of the First World War in August 1914 would destroy the cultural values of Edwardian England, alongside those of much of Europe. Many of Scott's men became embroiled in the trenches, or in the great naval battles of the war, and some did not return. Copies of Ponting's films were distributed at the front, where over 100,000 men would see the story of Scott and his men presented as a glowing example of the heroic self-sacrifice now expected of them. It was an extraordinary representation of Scott's work, not to mention Ponting's films, which, while apparently inspiring the troops, was increasingly likely to be seen as establishment propaganda, rather than as pioneering film. The First World War was devastating to Ponting's legacy in other ways, too. Ponting was unable to see that there were now a million other Empire heroes and that the story of Scott had been superseded on the fields of Flanders. During a second lecture series at the Philharmonic Hall in 1917, Ponting faced ruin, as audiences failed to materialize and his losses mounted. Another attempted lecture run in 1919 was equally dire. His position wasn't helped by the arrival of a new Antarctic film, equal to his own, of the adventures of Shackleton's latest expedition, shot by his admirer Frank Hurley.

At some point during these tumultuous years, the expedition rights in the photographs expired and they were returned to their respective photographers. It is unsurprising, perhaps, that in confused times the precise details are lost. It was an act which would destroy for ever the ambitions of the correlation of images of Scott's expedition. When the *Discovery* expedition had reached the stage where the photographs had to be returned, copies of most of the images were made and the core collection kept together. With Scott gone, in the chaos of the war and with Ponting's relationship with the executive committee at best strained, nobody thought to do this for the *Terra Nova* expedition. The result was that the images were spread far and wide across the world, becoming almost impossible to reassemble. The scale of the photographic programme became increasingly difficult to appreciate. Researchers began to forget the importance of any images, save those taken by Ponting, as the photographic record became diminished and lost.

Precisely what happened to Captain Scott's own photographs at this point is also unclear. All that can be said with certainty is that the photographs of Birdie Bowers and Captain Scott were not returned to their families. The balance of probability is that instead they were passed to Ponting. Who took this decision, if it was ever made, rather than being a simple muddle, is unknown. The fate of Scott's own photographs became tangled with that of his photographer. Ponting was always very conscious of his duty to Scott and also to copyrights and he jealously guarded them for the remainder of his life.

Ponting busied himself with numerous business ventures, almost all of which failed. The exception was his book *The Great White South* in 1921, which included three of Scott's photographs and was a huge commercial success, running to eleven editions during his lifetime. A selection of Scott's images was also used in Wright's *Physiography of the Beardmore Glacier* in 1923. The photographs were from the usual collections of images, however, and the majority of Scott's pictures remained unpublished.

In 1924, in an attempt to reach a new generation, Ponting remade his films as a single long film, *The Great White Silence*, and again as *The Epic of the South Pole* in 1929, but lost large sums. The fact was that the public was satiated with film of penguins, and Ponting's film had little material relating to the Pole Party itself. It was Scott the myth that interested people now, not Scott's scientific programme, which was being slowly overtaken by further discoveries in the polar regions.

With the King's exhortations in his mind, Ponting did manage to persuade the fledgling British Empire Film Institute to purchase a copy for the nation, although he was never paid the sum agreed for it. The film remained in its archives for seventy years until its successor, the British Film Institute, recently restored it.[29] Unsatisfied and upset, Ponting converted the film into a 'talkie' in 1933, with an introduction by himself and Lieutenant Evans, by now an admiral and First World War hero, with whom Ponting had finally made peace. The production of *Ninety Degrees South* cost Ponting over £10,000 and many hours of work. But it wasn't a commercial success and its failure broke him on many levels.[30]

It was during his work on this final version of his film that the question of the Scott photographs arose again, with Ponting intending to use some of the Scott and Bowers photographs in it. From correspondence with Frank Debenham at the Scott Polar Research Institute in 1931, it is clear that the question of the custodianship of Scott's negatives was raised; it is not clear that it was ever resolved. Instead the correspondence came to focus more on sorting out the mess that the Scott negatives were now in, as Ponting requested Debenham's help to identify them:

Many thanks for your letter. I should, of course, have explained to you in my own that these cuts from the new film were taken from film reproductions which I have made to illustrate the ascent of the Beardmore. This is quite easy to do, as it only means copying a good print of the subject onto a

sufficient footage of film. I bring it in this way: first showing a picture of Captain Scott and his camera. 'And Captain Scott himself photographed some of the mountains which border the Pass', then follow some of the pictures, which I made from the negatives that were found and which you developed. I have got the Wild Mountains and the Cloudmaker and these two which you think may be Cathedral Rocks. Unfortunately, some of the original negative envelopes got destroyed, but I have since found one which does conclusively prove that at least one of them is Cathedral Rocks … Incidentally, I have in my possession all the negatives which Bowers and Scott made, except those formerly sent to you some time ago. As soon as I have got this job done I propose to send them all to you as the Institute is the right place for them I think …[31]

The letter raises so many questions. Had Ponting suffered a disaster, or was this mess inherited from the executive committee and simply not sorted out until now? Is this the point at which Ponting made a set of positives from the Scott negatives, or had he done this earlier? Up to this date the scant archive material refers to negatives, but, in the letter, prints of the Scott photographs are now mentioned. All that can be said with certainty is that Ponting at some stage developed a set of positives as his working set of Scott's

images, which now form the only known significant collection of Scott's own photographs. The quality of the images makes it unlikely that they were developed by any other hand. Ponting even wrote occasional notes on the back of the images. On the photograph of Wilson pushing Bowers' sledge (S56a, p. 152) he wrote: 'Base Glacier. Scott pushing.' It was a misidentification and led to the mislabelling of this well-known photograph in some publications for years to come. However, it helps to tie the origin of the extant Scott photographs to Herbert Ponting himself.

In the process of trying to resolve the confusion which already surrounded the photographs, an increasingly unwell Ponting promised Debenham several times that he would give his photographs to the archive of the Polar Research Institute, along with the Bowers and Scott photographs. Only the photographs taken by Birdie Bowers on the Polar Plateau and at the pole were ever delivered.

On 7 February 1935 Herbert Ponting died at his London home. Unfortunately, his business affairs were as confused as always. As far as can be ascertained, he left two contradictory wills, the earlier of which had left the photographs to the Polar Research Institute; it is unclear

MEMBERS OF THE TERRA NOVA EXPEDITION 1910–1913

SHORE PARTY (Cape Evans)

OFFICERS AND SCIENTISTS

Edward L. Atkinson	1882–1929	Surgeon, RN/Parasitologist
Henry R. Bowers	1883–1912	Lieutenant, Royal Indian Marine
Apsley Cherry Garrard	1886–1959	Assistant Biologist
Bernard C. Day	1884–1952	Motor Engineer
Frank Debenham	1883–1965	Geologist
Edward E. R. G. Evans	1881–1957	Lieutenant, RN
Tryggve Gran	1889–1980	Ski Instructor/Sub-Lieutenant, Royal Norwegian Navy
Cecil H. Meares	1877–1937	Dog Handler
Edward R. Nelson	1883–1923	Biologist
Lawrence G. Oates	1880–1912	Captain, Inniskilling Dragoons
Herbert Ponting	1870–1935	Photographer
Robert Falcon Scott	1868–1912	Captain, RN
George C. Simpson	1878–1965	Meteorologist
T. Griffith Taylor	1880–1963	Geologist
Edward A. Wilson	1872–1912	Chief of Scientific Staff, Doctor, Artist
Charles S. Wright	1887–1975	Physicist

CREW/BLUE JACKETS

William Archer	1871–1944	Chief Steward (second season only)
Thomas Clissold	1886–1964	Cook
Thomas Crean	1876–1938	Petty Officer, RN
Edgar Evans	1876–1912	Petty Officer, RN
Robert Forde	1887–1959	Petty Officer, RN
Demetri Gerof	1889–1932	Dog Driver
Frederick Hooper	1889–1955	Steward
Patrick Keohane	1879–1950	Petty Officer, RN
William Lashly	1867–1940	Chief Stoker, RN
Anton Omelchenko	1883–1932	Groom
Thomas Williamson	1877–1940	Petty Officer, RN (second season only)

SHORE PARTY (Eastern/Northern Party)

OFFICERS AND SCIENTISTS

Victor L. A. Campbell	1870–1956	Lieutenant, RN
Murray Levick	1877–1956	Surgeon, RN
Raymond Priestley	1886–1974	Geologist

A group of officers and crew from the *Terra Nova*, 1912 (Ponting 562)

Left to right: Dennistoun, Cheetham, Rennick, Drake, Williams, Pennell, Bruce, Lillie

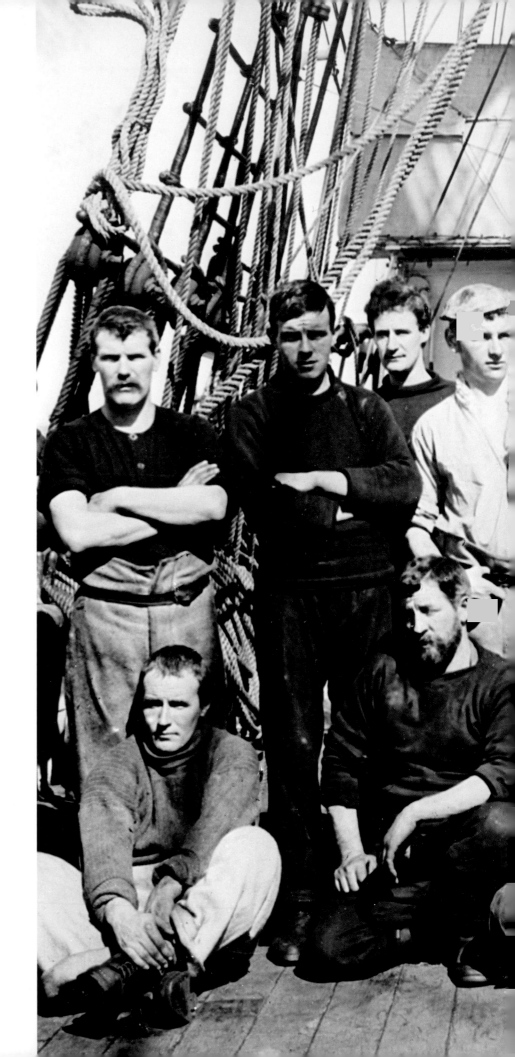

CREW/BLUE JACKETS

George P. Abbot	1880–1923	Petty Officer, RN
Frank V. Browning	1882–1930	Petty Officer, RN
Harry Dickason	1885–1944	Able Seaman, RN

TERRA NOVA

OFFICERS AND SCIENTISTS

Wilfred M. Bruce	1874–1953	Lieutenant, RN
Francis H. R. Drake	1878–1936	Paymaster, RN/ Expedition Secretary
Dennis Lillie	1884–1963	Biologist
Harry L. L. Pennell	1882–1916	Lieutenant, RN
Henry E. Rennick	1881–1914	Lieutenant, RN

CREW/BLUE JACKETS

Arthur S. Bailey	?	Petty Officer, RN
Albert Balson	d. 1950	Leading Seaman, RN
Robert Brissenden	1879–1912	Leading Stoker, RN
William Burton	1889–1988	Leading Stoker, RN
Alfred B. Cheetham	1868–1918	Boatswain, RNR
Francis E. C. Davies	b. 1885	Leading Shipwright, RN
James R. Dennistoun	?	Mule Driver
William L. Heald	1876–1939	Petty Officer, RN
William A. Horton	d. 1939	Engine Room Artificer, RN
William Knowles	b. 1875	Able Seaman, RN
Charles Lammas	b. 1885	Fireman
Joseph Leese	1884–1948	Able Seaman, RN
John H. Mather	1887–1957	Petty Officer, RNR
Mortimer McCarthy	1878–1967	Able Seaman, RN
Angus McDonald	b. 1877	Fireman
William McDonald	1892–1978	Able Seaman, RN
Thomas McGillion	b. 1877	Fireman
Edward A. McKenzie	1888–1973	Leading Stoker, RN
Thomas McLeod	1887–1960	Able Seaman, RN
William H. Neale	?	Steward
Roger Oliphant	?	Able Seaman, RN
Frederick Parsons	1879–1970	Petty Officer, RN
James Paton	1869–1917	Able Seaman, RN
James Skelton	1882–1951	Able Seaman, RNR
Bernard J. Stone	?	Leading Stoker, RN
Charles Williams	1881–1919	Able Seaman, RN
William Williams	b. 1875	Chief Engine Room Artificer, RN

There were minor alterations to crew for different voyages of the ship during the expedition. For a full account, please see Michael C. Tarver, *The S.S. Terra Nova (1884–1943)* (Pendragon, Brixham, 2006).

Some of the crew of the *Terra Nova*, 1910 (Ponting 563)

..

Left to right, back: Horton, Brissenden, Parsons, Heald, Neale, Balson, McCarthy; centre: Stoker McDonald, AB McDonald, Burton, McGillion, McKenzie, Omelchenko, Clissold, Mather, Davies front: Skelton, McLeod, Bailey, Forde, Leese

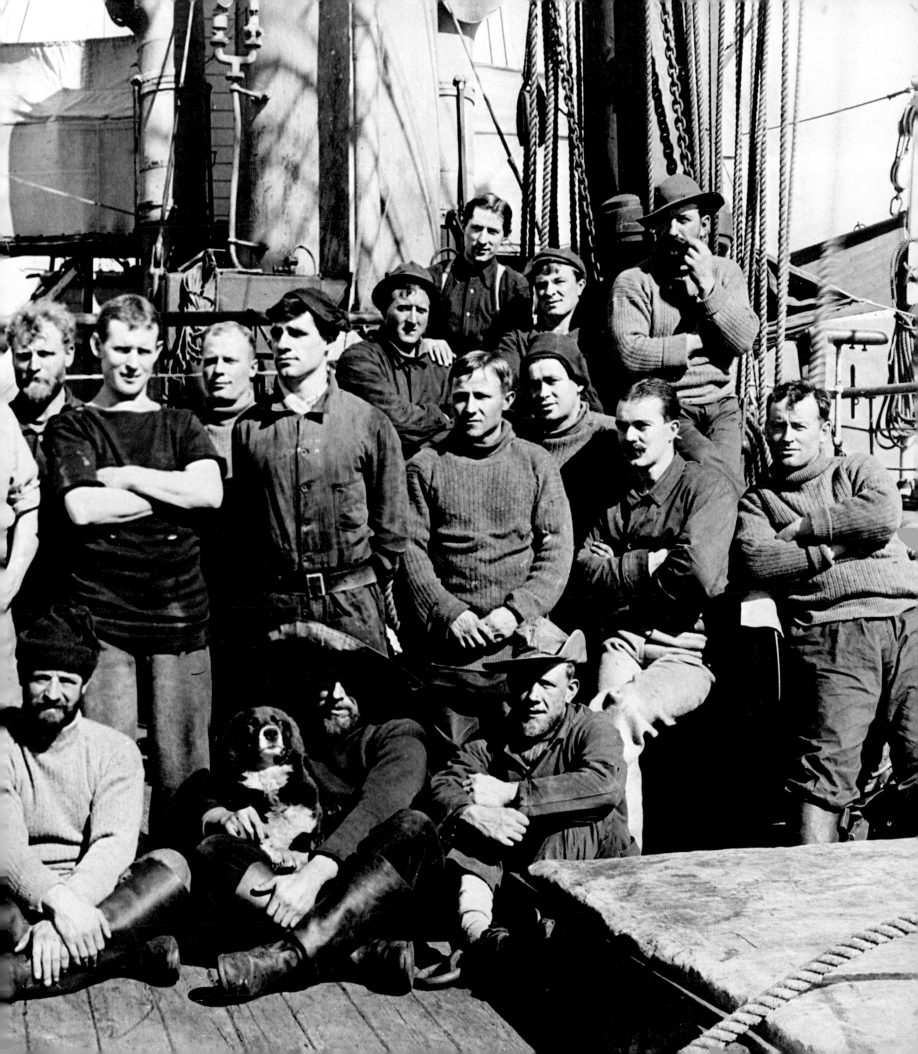

NOTES

..

EPIGRAPH

[1] Jonah 1: 15–16, translation of the Revised Standard Version of the Holy Bible (Collins, 1973).

PROLOGUE

[1] Quotations from Scott's diary will not be footnoted but the date of the diary entry given. Scott's diary is widely published under a variety of titles, most commonly in the form of *Scott's Last Expedition* (Smith, Elder and Co., London, 1913). It is suggested that readers will obtain fuller enjoyment throughout *The Lost Photographs of Captain Scott* by reading the complete diary entry.

[2] See Kløver, Geir O. (ed.), *The Roald Amundsen Diaries: The South Pole Expedition* (Fram Museum, Oslo, 2010), entry for 5 December 1911.

[3] In keeping with the period, most distances in this book are given in imperial measures, with the metric conversion in brackets. In keeping with Scott's own records, distances are given in nautical or geographical miles, unless otherwise specified. One nautical mile = 1.15 statute miles or 1.852 kilometres, being equivalent to one minute of arc of latitude.

[4] For a fuller description of these events see Evans, E. R. G. R., 'My Recollections of a Gallant Comrade', *Strand Magazine* (London), December 1913.

[5] In the Old Testament story of Jonah, Jonah refuses to obey God's specific command to travel to Nineveh and preach his word. Instead, Jonah tries to flee by taking a ship to Tarshish. God, however, sent a great storm and the sailors, in panic, cast lots to determine who had brought the displeasure of God upon them. The lot fell upon Jonah, who confessed that he was fleeing from God and suggested that the only way to stop the storm would be to cast him into the sea. In great fear, and with appropriate offerings to God, the sailors did precisely that and the storm ceased. Jonah was famously swallowed by a whale shortly thereafter. It therefore became a tradition among sailors, in times of ill luck, particularly in the form of bad weather, to try to ascertain who was 'the Jonah' and, if they could do so, to cast him out and so reverse their fortune.

[6] Cherry Garrard, Apsley, *The Worst Journey in the World* (Penguin, London, 1922; the edition referred to throughout the notes is the 1994 edition, Picador, London), p. 354.

INTRODUCTION

[1] The Ponting-Debenham Index refers to the catalogue which listed all of the photographs taken on Scott's *Terra Nova* expedition as compiled by Herbert Ponting and the geologist Frank Debenham, who became Ponting's photographic deputy during the second season, when Ponting had already returned home. No complete copy is known to have survived. Ponting's cataloguing is still extant for his photographs but only parts of the catalogue remain for photographs taken by Ponting's pupils.

[2] Admiral John Arbuthnot 'Jacky' Fisher was appointed First Sea Lord in 1904 to reduce naval budgets and to reform the navy for modern warfare. In the face of great opposition from traditionalists he did just that, pioneering the development of the new Dreadnought class of battleship and weaponry such as torpedoes. He is celebrated as one of the great innovators in the history of the Royal Navy, having prepared it for the First World War.

[3] *The Apollo 11 Telemetry Data Recordings: A Final Report* (NASA, 2009).

CHAPTER 1 – PRELUDE TO THE POLE

[1] *Report of the VI International Geographical Congress*, July 1895.

[2] On 25 May 1961, President John F. Kennedy announced before a special joint session of the Congress of the United States of America the goal of sending an American to the Moon before the end of the decade.

[3] Wilson, Edward, *Diary of the "Discovery" Expedition to the Antarctic Regions 1901–1904* (Blandford, London, 1966), entry for 17 December 1902. Wilson's diary is full of similar descriptions of the experience of snow-blindness from sketching.

[4] For a considered discussion on Hodges and the imaging of the Antarctic see Fox, William L., *Terra Antarctica: Looking into the Emptiest Continent* (Trinity University Press, San Antonio, 2005), especially p. 96 ff.

[5] Scott's midshipman's log resides in the archive of the Scott Polar Research Institute (SPRI), Cambridge, UK: SPRI MS 1940:BJ. The archive also contains later cartoons by Scott; see especially Y78/7 and Y2007/32/1.

[6] Skelton, Judy (ed.), *The Antarctic Journals of Reginald Skelton: 'Another Little Job for the Tinker'* (Reardon Publishing, Cheltenham, 2004), p. 9.

[7] The Skelton Index now resides in the archive of the Royal Geographical Society (RGS), London: MS list of photographs/negatives in Picture Library Album CO48 (*Discovery* Expedition), AA/13/2/15.

[8] R. F. Scott, letter to Sir Clements Markham, 17 March 1905 (sold at Christie's, London, lot 324, September 2007).

[9] *National Antarctic Expedition 1901–1904: Album of Photographs and Sketches with a Portfolio of Panoramic Views* (Royal Society, London, 1908).

[10] The most comprehensive account of the British National Antarctic Expedition is given in Yelverton, David E., *Antarctica Unveiled* (University Press of Colorado, Boulder, CO, 2000).

[11] My thanks to R. K. Headland, retired archivist at the Scott Polar

Research Institute, for his assistance with my enquiries into the Scientific Reports and their associated facts and figures.

[12] Skelton (ed.), *The Antarctic Journals of Reginald Skelton*, entry for Sunday 2 November 1902.

[13] See Scott's own account in Scott, R. F., *The Voyage of the Discovery* (Smith, Elder and Co., London, 1905).

[14] It was a round trip of some 700 miles, made in fifty-nine days at an average of 14 miles per day, and thus better than they had achieved on the previous Southern Journey with dogs.

[15] R. F. Scott, letter to Scott Keltie, 28 January 1907, RGS RFS/4a: 'There cannot be a doubt that the thing ought to be done. There is the finest prospect of a big advance in latitude that has ever been before a polar explorer.' See also SPRI MS 342/30/D: 'The Sledging Problem in the Antarctic, Men Versus Motors' (1908).

[16] For a longer discussion on this subject see Barczewski, Stephanie, *Antarctic Destinies: Scott, Shackleton and the Changing Face of Heroism* (Hambledon Continuum, London, 2007), especially p. 186 ff.

[17] Sir Clements Markham, 13 April 1909, RGS Markham Correspondence CB4.

[18] For a more complex discussion of this period see Crane, David, *Scott of the Antarctic: A Life of Courage* (HarperCollins, London, 2005), p. 388 ff.

[19] SPRI MS 91 (08):*7

[20] Interview by Frank Debenham with Bill Herbert (1962), SPRI Tapes RS2003/10.

[21] Ponting, Herbert, *The Great White South* (Duckworth, London, 1921; the edition referred to throughout the notes is the 4th edition, 1923), p. 2.

[22] 'To the South Pole with the Cinematograph: Film Records of Scott's Ill-fated Expedition', *Scientific American* (New York), 21 June 1913, Vol. CVIII, No. 25, p. 560.

[23] Ponting, *Great White South*, p. 3.

[24] 'The Photographic Equipment of the British Antarctic Expedition', *The British Journal of Photography*, 3 June 1910.

[25] There was more interaction between these several expeditions than was generally understood. Scott met and discussed mutual endeavours with Mawson (Australian Antarctic Expedition 1911–14), Filchner (German Antarctic Expedition 1911–13) and Charcot (French Antarctic Expedition 1908–10); while Shirase (Japanese Antarctic Expedition 1910–12) seems to have headed south as a result of discussions with other scientific societies. Only Shirase was intending to head for the South Pole but he abandoned his efforts. It was, in part, the cooperative, if also competitive, nature of Antarctic exploration to this date that made Amundsen's dissembling particularly shocking.

[26] Ponting, *Great White South*, p. 14.

[27] Ibid., p. 29.

[28] Ibid., p. 37.

[29] 'To the South Pole with the Cinematograph: Film Records of Scott's Ill-fated Expedition', *Scientific American* (New York), 21 June 1913, Vol. CVIII, No. 25, p. 560.

[30] Ponting, *Great White South*, p. 55.

[31] Interview by Sir Charles Wright with Bill Herbert (1962), SPRI Tapes RS2003/10.

[32] Ponting, *Great White South*, p. 65.

[33] Shackleton, E. H., and Bernacchi, L. C. (eds.), *The South Polar Times*, Vols. I and II (Smith, Elder and Co., London, 1907); see Part VII, June 1903, p. 67.

[34] Ponting, *Great White South*, p. 182.

[35] Ibid., p. 198.

[36] 'To the South Pole with the Cinematograph: Film Records of Scott's Ill-fated Expedition', *Scientific American* (New York), 21 June 1913, Vol. CVIII, No. 25, p. 561.

[37] Elder, David, 'Edward T. Wilson (1832–1918) Co-founder of the Cheltenham Photographic Society', *Cheltenham Local History Society Journal* 24, 2008, pp. 3–9.

[38] Seaver, George, *Edward Wilson of the Antarctic* (John Murray, London, 1933), p. 84.

[39] Interview by Frank Debenham with Bill Herbert (1962), SPRI Tapes RS2003/10.

[40] Taylor, Griffith, *With Scott the Silver Lining* (Smith, Elder and Co., London, 1916), p. 240.

[41] The lecture was given at Cape Evans, June 1911, and published in the *Geographical Journal* 46, pp. 436–46.

[42] Interview by Frank Debenham with Bill Herbert (1962), SPRI Tapes RS2003/10.

[43] Ponting, *Great White South*, p. 166.

AN ILLUSTRATED CATALOGUE OF CAPTAIN SCOTT'S PHOTOGRAPHS

The Scott photographs represent the largest known collection of images taken by Captain Scott on his expedition to the South Pole. The prints originate from the collection of the expedition photographer Herbert Ponting. The series is no longer complete but is reproduced here in full, in the hope that future scholarship might recover more lost images, the original indexing and further identification.

The original S-numbers were given to the Scott photographs by Frank Debenham over the winter of 1912, as he continued cataloguing the expedition photographs. These were written on the negatives. As a result, some of the original numbering may be seen on some of the images. However, the negatives are now lost, along with any lists of the Ponting-Debenham Index, and the visible numbers are insufficient to reinstate the original catalogue. On three occasions someone has tried to rectify the confusion by writing S-numbers on the backs of the existing set of contact prints; instead they have seriously confused the ordering of the photographs. One series is in pencil, one in blue ink and one in purple ink. Although some numbers are from the original sequence, many are not. With the purple notation being the most complete, this is the S-number order currently followed. Where duplicate numbers have been given, a, b, c, etc. have been added in order to differentiate them, but it is reasonable to assume that they would have had their own S-numbers in the original index.

S2 View from sea ice, Blue Glacier to Kukri Hills, Ferrar Glacier (p. 98)
25 September 1911
Panorama with S9; S122

S2a Duplicate of S2
25 September 1911
Panorama with S9; S122

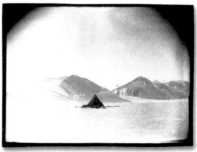

S3 Camp on the Ferrar Glacier, Overflow Glacier and Royal Society Range (p. 10)
September 1911

S4 Camp on the Ferrar Glacier, Descent Glacier and Cathedral Rocks (pp. 88–9)
September 1911

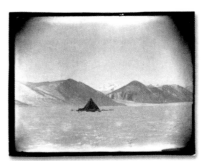

S6 The Kitticarrara Glacier, Ferrar Glacier (p. 93)
September 1911

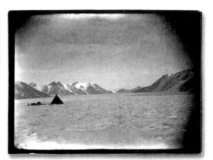

S7 Camp under Cathedral Rocks, Ferrar Glacier (pp. 95)
September 1911

S8 Camp on the Ferrar Glacier, Overflow Glacier and Royal Society Range
September 1911

S9 View from sea ice, Kukri Hills to Victoria Lower Glacier, Ferrar Glacier (pp. 98–9)
25 September 1911
Panorama with S2; S122

 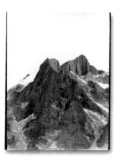

S10 Unidentified pony camp (2), Great Ice Barrier
November 1911

S11 Unidentified peak, Ferrar Glacier (p. 92)
September 1911

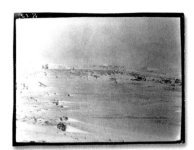 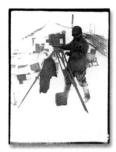

S12 View of Cape Evans from the Ramp, Cape Evans (p. 54)
October 1911

S13 Herbert Ponting working in Antarctic conditions, Cape Evans (pp. 11, 58)
October 1911

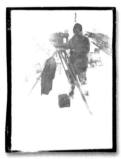 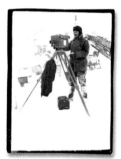 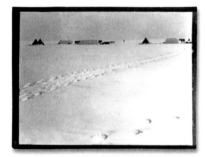

S13a Herbert Ponting working in Antarctic conditions, Cape Evans (pp. 11, 58)
October 1911

S13b Herbert Ponting working in Antarctic conditions, Cape Evans (pp. 29, 58)
October 1911

S15 Unidentified pony camp (1), Great Ice Barrier (pp. 120–1)
November 1911

S16 PO Edgar Evans with the pony Snatcher, Cape Evans (p. 62)
October 1911

 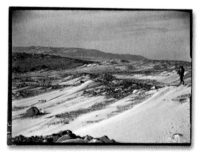 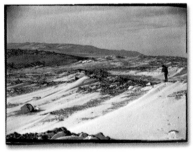

S17 PO Patrick Keohane with the pony Jimmy Pigg, Cape Evans (pp. 11, 62)
October 1911

S18 Herbert Ponting photographing on the lower slopes of Mount Erebus, Cape Evans (p. 10)
October 1911

S19 Herbert Ponting photographing on the lower slopes of Mount Erebus, Cape Evans (p. 34–5)
October 1911

S20 View of Cape Evans from the Ramp, Cape Evans (p. 12, 52–3, 55)
October 1911

 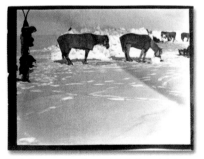 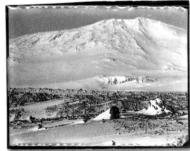

S21 Pony camp, Camp 15, (left to right) Snippetts, Nobby, Michael and Jimmy Pigg, Great Ice Barrier
19 November 1911

S21a Pony camp, Camp 15, (left to right) Snippetts, Nobby, Michael and Jimmy Pigg, Great Ice Barrier (pp. 11, 114–5)
19 November 1911

S21b Pony camp, Camp 15, (left to right) Jehu and Chinaman, Great Ice Barrier
19 November 1911

S22 Mount Erebus from the Ramp, Cape Evans (pp. 10, 76–7)
October 1911

S23 Dr Edward Wilson with Nobby,
Cape Evans (p. 63)
October 1911

S24 Portrait of Henry 'Birdie' Bowers,
Cape Evans (p. 60)
October 1911

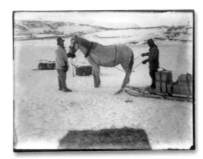

S25 Captain Oates assisting Birdie
Bowers to harness Victor, Cape Evans
October 1911

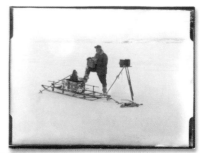

S26 Herbert Ponting at work on the
sea ice near Cape Evans (p. 74)
8 October 1911

S32 Socks Glacier (left) to Mount Fox (right),
Beardmore Glacier (pp. 21, 149)
13 December 1911
Panorama with S33

S33 Dr Edward Wilson sketching,
Beardmore Glacier (pp. 20, 148)
13 December 1911
Panorama with S32

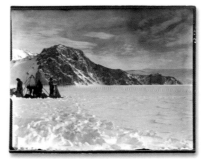

S34 Looking north-west towards the
Pillar Rocks and Mount Smith,
Beardmore Glacier (pp. 144–5)
12 December 1911

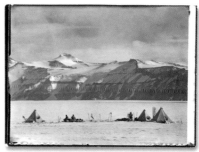

S35 Camp under the Wild Mountains,
Beardmore Glacier (pp. 157–8)
20 December 1911

S36 Unidentified pony camp (1),
Great Ice Barrier (pp. 118–9)
November 1911

S36a Duplicate of S36,
Great Ice Barrier
November 1911

S37 Unidentified pony camp (1),
Great Ice Barrier
November 1911

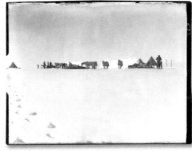

S38 Unidentified pony camp (1),
Great Ice Barrier
November 1911

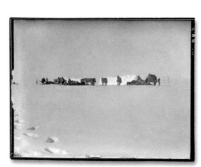

S40 Unidentified pony camp (1),
Great Ice Barrier
November 1911

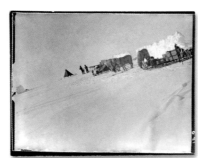

S41 Unidentified pony camp (1),
Great Ice Barrier
November 1911

S43 Unidentified pony camp (2),
Great Ice Barrier
November 1911

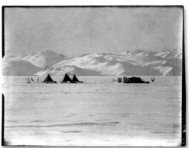

S45 Pony camp, Camp 26, looking
west to Mount Longstaff, Great Ice Barrier
(pp. 10, 122)
1 December 1911

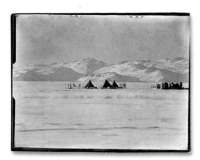

S46 Pony camp, Camp 26, looking west to Mount Longstaff, Great Ice Barrier 1 December 1911

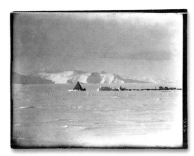

S47 Dog camp, Camp 26, looking north-west to Mount Markham, Great Ice Barrier (p. 123) 1 December 1911 Panorama with S45

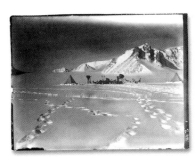

S48 Looking up the Gateway from Camp 31, Shambles Camp, Great Ice Barrier (pp. 10, 138) 9 December 1911

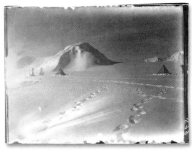

S49 Looking up the Gateway to Mount Hope, from Camp 31, Shambles Camp, Great Ice Barrier (pp.11, 140–1) 9 December 1911 Panorama with S50

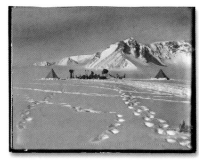

S50 Looking up the Gateway from Camp 31, Shambles Camp, Great Ice Barrier (pp. 140–1) 9 December 1911 Panorama with S49

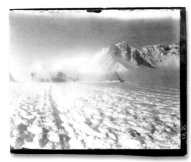

S51 Looking up the Gateway from Camp 31, Shambles Camp, Great Ice Barrier 9 December 1911

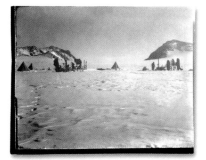

S52 Looking north, back towards the Gateway from the Lower Glacier Depot, Beardmore Glacier (p. 142) 11 December 1911

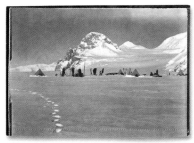

S53 Looking south-south-west towards the Granite Pillars from the Lower Glacier Depot, Beardmore Glacier (p. 143) 11 December 1911

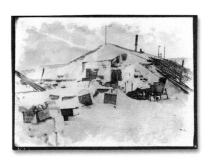

S54 Winter quarters: the expedition hut, Cape Evans (pp. 11, 56–7) October 1911

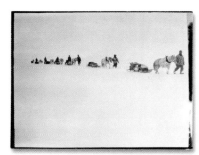

S55a Ponies on the march, Great Ice Barrier (cover) 2 December 1911

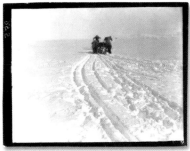

S56 Foundering in soft snow: (left to right) Cherry Garrard, Bowers, Keohane and Crean, Beardmore Glacier (pp. 156–7) 13 December 1911

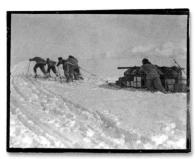

S56a Foundering in soft snow: (left to right) Cherry Garrard, Bowers, Keohane, Crean, Wilson, Beardmore Glacier (pp.152–3) 13 December 1911

S56b Foundering in soft snow: (left to right) Cherry Garrard, Bowers, Keohane, Crean, Beardmore Glacier (p.155) 13 December 1911

S56c Foundering in soft snow: Bowers' sledge team; Wilson pushing; Oates and PO Evans repairing, Beardmore Glacier (p. 151) 13 December 1911

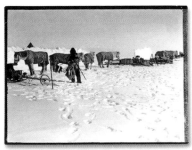

S57 Pony camp, Camp 15: probably Bowers drying out with (left to right) Victor, Snatcher, Bones, Christopher, Great Ice Barrier (pp.110–1) 19 November 1911

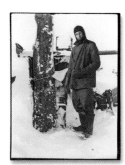

S58 Portrait of Captain L. E. G. Oates, Cape Evans (p. 61) October 1911

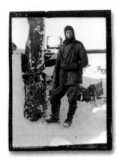

S58a Portrait of Captain L. E. G. Oates, Cape Evans (p. 11)
October 1911

S59 Unidentified pony camp (1), Great Ice Barrier
November 1911

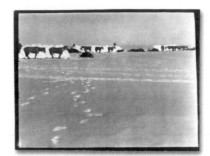

S60 Pony camp, Camp 15, Great Ice Barrier (pp. 116–7)
19 November 1911

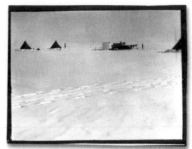

S61 Unidentified pony camp (2), Great Ice Barrier
November 1911

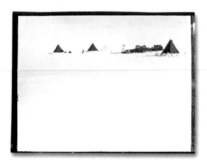

S63 Unidentified pony camp (2), Great Ice Barrier
November 1911

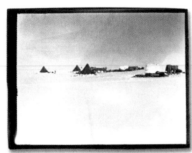

S65 Unidentified pony camp (2), Great Ice Barrier
November 1911

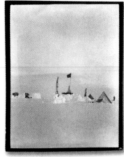

S66 Camp 12: 'One Ton Depot', Great Ice Barrier (p. 106)
16 November 1911

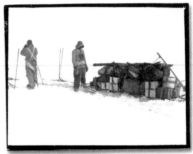

S67 Foundering in soft snow: probably Keohane and Crean waiting to depart, Beardmore Glacier (pp. 11, 146)
13 December 1911

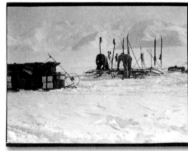

S68 Foundering in soft snow: PO Edgar Evans and Captain Oates repairing sledge, Beardmore Glacier (p. 147)
13 December 1911

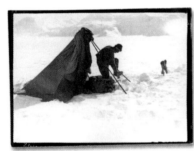

S69 After sketching: Dr Edward Wilson, adjusting footwear, Beardmore Glacier (pp. 11, 150)
13 December 1911

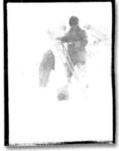

S75 Herbert Ponting working in Antarctic conditions, Cape Evans (p. 59)
October 1911

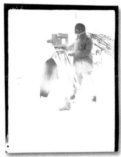

S76 Herbert Ponting working in Antarctic conditions, Cape Evans (p. 58)
October 1911

S77 The weather station at Windvane Hill, Cape Evans (pp. 10, 71)
October 1911

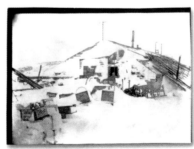

S78 Winter quarters: the expedition hut, with Birdie Bowers, Cape Evans
October 1911

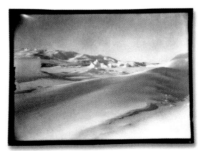

S79 Ice field on the lower slopes of Mount Erebus, Cape Evans (pp. 78–9)
October 1911

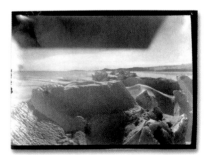

S80 Ice crack, towards Cape Barne, Cape Evans (p. 81)
8 October 1911

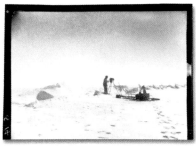 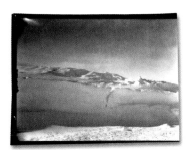 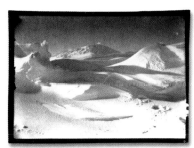 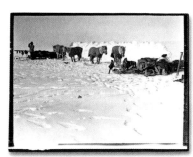

S81 Herbert Ponting photographing
ice crack, Cape Evans (p. 83)
8 October 1911

S82 Mount Erebus, from the sea ice,
Cape Evans (p. 10)
October 1911

S83 Lower reaches of Mt Erebus,
Cape Evans
October 1911
Panorama with S85

S84 Unidentified pony camp (1): Birdie
Bowers and ponies shelter behind an ice
wall, Great Ice Barrier
November 1911

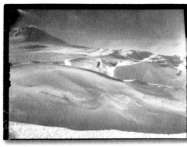 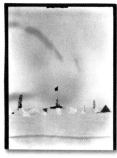

S85 Mount Erebus, Cape Evans
October 1911
Panorama with S83

S87 Camp 12, 'One Ton Depot',
Great Ice Barrier (p. 11)
16 November 1911

S88 Camp 12, 'One Ton Depot',
Great Ice Barrier (p. 107)
16 November 1911

S89 Ponies on the march, Great Ice Barrier
2 December 1911

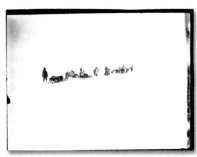 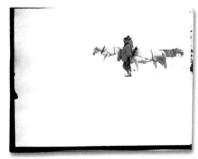 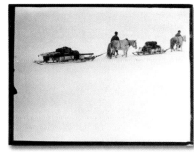

S90 Ponies on the march, Great Ice Barrier
2 December 1911

S91 Ponies on the march, Great Ice Barrier
(pp. 128–9)
2 December 1911

S92 Ponies on the march, Great Ice Barrier
(pp. 10, 130–1)
2 December 1911

S93 Ponies on the march, Great Ice Barrier
(p. 132–3)
2 December 1911

 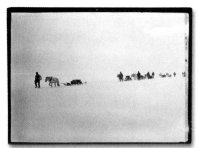 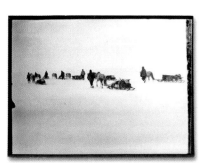

S95 Ponies on the march, Great Ice Barrier
(p. 126–7)
2 December 1911

S96 Ponies on the march, Great Ice Barrier
2 December 1911

S96a Ponies on the march,
Great Ice Barrier (pp. 124–5)
2 December 1911

S97 Ponies on the march, Great Ice Barrier
2 December 1911

S98 Probably Birdie Bowers or Anton
Omelchenko with Victor, Cape Evans
October 1911

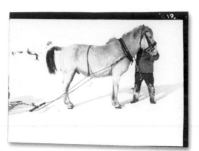

S99 Probably Birdie Bowers or Anton
Omelchenko with Victor, Cape Evans
October 1911

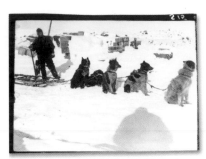

S100 Probably Demetri Gerof with dog team,
Cape Evans (pp. 11, 73)
October 1911

S101 Dog team in training, Cape Evans
(pp. 72, 12)
October 1911

S102 Probably PO Edgar Evans,
repairing a sledge, Cape Evans (p. 10)
October 1911

S102a Duplicate image (reversed)
with 102
October 1911

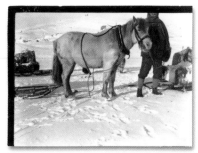

S103 Probably PO Patrick Keohane,
with Jimmy Pigg, Cape Evans (pp. 46–7)
October 1911

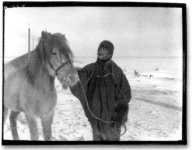

S104 PO Patrick Keohane, with Jimmy Pigg,
Cape Evans (p. 62)
October 1911

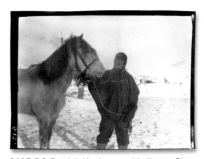

S105 PO Patrick Keohane, with Jimmy Pigg,
Cape Evans
October 1911

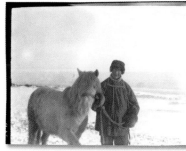

S106 Apsley Cherry Garrard, with Michael,
Cape Evans (pp. 11, 62)
October 1911

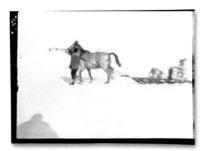

S107 Birdie Bowers and Anton
Omelchenko, chasing Victor, Cape Evans
(pp. 66–7)
October 1911

S108 George Simpson or PO Edgar Evans
in fog, Ferrar Glacier (pp. 2–3)
September 1911

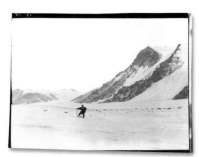

S111 George Simpson or PO Edgar Evans,
Ferrar Glacier (pp. 96–7)
September 1911

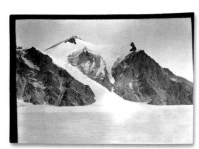

S112 The Kitticarrara Glacier, Ferrar Glacier
(pp. 90–1)
September 1911

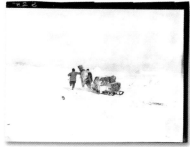

S115 Birdie Bowers and Anton Omelchenko,
chasing Victor, Cape Evans (pp. 68–9)
October 1911

S116 Probably Oates, Bowers and Anton
with Victor, Cape Evans
October 1911

S117 Birdie Bowers and probably Oates,
with Victor, Cape Evans
October 1911

S118 Tom Crean with Bones, and Wilson
with Nobby, Cape Evans (pp.64–5)
October 1911

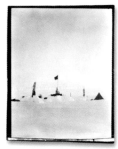

S119 Camp 12, 'One Ton Depot',
Great Ice Barrier
16 November 1911

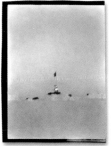

S120 Camp 12, 'One Ton Depot',
Great Ice Barrier (p. 106)
16 November 1911

S122 View from sea ice, Victoria Lower
Glacier to Cape Roberts, Ferrar Glacier
(pp. 98–9)
25 September 1911
Panorama with S2; S9

We took risks, we knew we took them; things have come out against us, and therefore we have no cause for complaint, but bow to the will of Providence, determined still to do our best to the last …

Had we lived, I should have had a tale to tell of the hardihood, endurance, and courage of my companions …

Captain Robert Falcon Scott